Cultivating Futures Th in Museums

Cultivating Futures Thinking in Museums provides examples of the active and diverse roles that museums are taking to expand futures thinking in communities, including developing capabilities to envision and enact more prosperous, equitable, and sustainable futures.

Presenting 21 examples that demonstrate how museums are cultivating futures capabilities in diverse global contexts, the volume acknowledges innovative practice, builds a foundation for growing futures work in the museum sector, and inspires others in the field to adopt futures frameworks in their practices. This realm of thinking, including components of anticipating futures by exploring drivers of change; imagining immersive experiences of futures; creating tools and methods to enable futures capability; and participatory futures informing museum design practice provides important responses to the multitude of complex contemporary problems like climate change, technological development, and social inequity. The book prompts museums to think about their role in shaping alternative and novel narratives for our future.

Cultivating Futures Thinking in Museums will primarily appeal to museum professionals, inspiring and informing them to adopt practices to further futures literacies. It will also appeal to academics, researchers, and students with an interest in museums, futures, design, contemporary art, curating, and cultural studies.

Dr Kristin Alford is the inaugural Director of MOD. at the University of South Australia.

Contributors

Luis Alberto Alcaraz, Majed Al Mansoori, Dr Rosalina Babourkova, Bruna Baffa, Dr Lisa Bailey, Dr Stefan Brandt, Camilo Cantor, Natalie Carfora, Lāth Carlson, Maria del Carmen Mesa, Seb Chan, Julyán Conde, Loes Damhof, Dr Julie Decker, Meredith Doby, Prof Kathryn Eccles, Keri Elmsly, Brooke Ferguson, Maria Isabel Garcia, Prof Dr Andreas Gundelwein, Luís Gustavo Costa Araújo, Honor Harger, Stefanie Holzheu, Dr Kathrin Kösters, Amarílis Lage de Macedo, Nicklas Larsen, Beatriz Lima Rangel Carneiro, Dr John Linstrom, Andrea Lombardi, Paul Martin, Brendan McGetrick, Dr Glyn Morgan, Mikko Myllykoski, Chelsey O'Brien, Camila Oliveira, Dr Rae Ostman, Ricardo Piquet, Nina Pougy, Michael Radke, Dr Juliana Restrepo, Catalina Rodas Quintero, Dr Fabio Rubio Scarano, Nancy Salem, Paloma Salgado, Melanie Saverimuthu, Maike Schlegel, Aron Schöpf, Dr Samira Siddique, Silvia Singer, Tina Smith, Pireeni Sundaralingam, Hanna Winker, and Dr Gabriele Zipf.

Routledge Guides to Practice in Museums, Galleries and Heritage

This series provides essential practical guides for those working in museums, galleries, and a variety of other heritage professions around the globe.

Including authored and edited volumes, the series will help to enhance practitioners' and students' professional knowledge and will also encourage sharing of best practices between different countries, as well as between different types and sizes of organisations.

Titles published in the series include:

Marketing Strategy for Museums
A Practical Guide
Christina Lister

Fundraising Management in a Changing Museum World
Kate Brueggemann and Donna McGinnis

Practitioner Perspectives on Intangible Cultural Heritage
Joanne Orr

An Introductory Guide to Qualitative Research in Art Museums
Edited by Ann Rowson Love and Deborah Randolph

Institutional Change for Museums
A Practical Guide to Creating Polyvocal Spaces
Edited by Marianna Pegno and Kantara Souffrant

Ethics of Contemporary Collecting
Edited by Jen Kavanagh, Ellie Miles and Rosamund Lily West with Susanna Cordner

Cultivating Futures Thinking in Museums
Edited by Kristin Alford

For more information about this series, please visit: https://www.routledge.com/Routledge-Guides-to-Practice-in-Museums-Galleries-and-Heritage/book-series/RGPMGH

Cultivating Futures Thinking in Museums

Edited by Kristin Alford

Routledge
Taylor & Francis Group

LONDON AND NEW YORK

Designed cover image: Traces of You, FLEX Exhibition, MOD. 2023.
Artwork: Alex DeGaris, Photo Credit: Topbunk

First published 2025
by Routledge
4 Park Square, Milton Park, Abingdon, Oxon OX14 4RN

and by Routledge
605 Third Avenue, New York, NY 10158

Routledge is an imprint of the Taylor & Francis Group, an informa business

British Library Cataloguing-in-Publication Data
A catalogue record for this book is available from the British Library

Library of Congress Cataloging-in-Publication Data
Names: Alford, Kristin, editor.
Title: Cultivating futures thinking in museums / edited by Dr. Kristin Alford.
Description: Abingdon, Oxon ; New York, NY : Routledge, 2025. |
Series: Routledge guides to practice in museums, galleries and heritage |
Includes bibliographical references and index.
Identifiers: LCCN 2024033029 (print) | LCCN 2024033030 (ebook) |
ISBN 9781032756462 (hbk) | ISBN 9781032726717 (pbk) |
ISBN 9781003474975 (ebk)
Subjects: LCSH: Museums--Planning--Methodology. |
Museum techniques--Case studies.
Classification: LCC AM5 .C79 2024 (print) |
LCC AM5 (ebook) | DDC 069--dc23/eng/20240718
LC record available at https://lccn.loc.gov/2024033029
LC ebook record available at https://lccn.loc.gov/2024033030

ISBN: 978-1-032-75646-2 (hbk)
ISBN: 978-1-032-72671-7 (pbk)
ISBN: 978-1-003-47497-5 (ebk)

DOI: 10.4324/9781003474975

Typeset in Times New Roman
by KnowledgeWorks Global Ltd.

To friends and colleagues, old and new, who connect with the shared purpose of creating meaningful futures.

Contents

Contributing authors

Luis Alberto Alcaraz is the workshop leader at Exploratorio, Colombia. He oversees technical training, workshops with educational institutions and community-based organisations and the interest groups that meet at Exploratorio. He is a mechatronics technician and currently studying Electronic Engineering.

Dr Kristin Alford is the inaugural Director of MOD. at the University of South Australia. Previously she founded Bridge8, consulting in sustainability and emerging technology futures. She is a globally recognised futurist, holding a Masters of Strategic Foresight from Swinburne University and a PhD in engineering from the University of Queensland.

Majed Al Mansoori is the Deputy Executive Director at the Museum of the Future. With a background in engineering, he established a startup driven by a desire to create meaningful change. His belief in the power of narratives is evident in his role at the Museum of the Future.

Dr Rosalina Babourkova is a Researcher and Curator at Futurium, Berlin. She is a geographer and urbanist by training and earned her PhD from University College London. Rosalina has experience in research and teaching in urban development planning and management in the UK, Bulgaria, Vietnam, and Germany.

Bruna Baffa was the Managing Director of the Museum of Tomorrow (2022–2023), at Instituto de Desenvolvimento e Gestão, with experience in consumer insights, cultural analysis, ethnography, trend forecasting, branding, content development, and innovation design. She investigates cultural codes that impact behaviours and drive change in society, to inspire better futures.

Dr Lisa Bailey has curated varied science engagement programmes for online content, events, film festivals, and exhibitions in Australia and the UK. Currently, she is the Manager: Exhibition and Experience Design at MOD. She obtained a PhD in Biochemistry and has previously lectured in Science Communication at Flinders University.

Dr Stefan Brandt is the Director of Futurium, an innovative exhibition, event and education space in Berlin. He obtained his PhD in musicology from the University of Basel. He has prior experience as the Managing Director of the Hamburger Kunsthalle and as a consultant at McKinsey & Company in Vienna.

Camilo Cantor is the Coordinator of Exploratorio, the public experimentation workshop at Parque Explora, Colombia. Camilo is a digital artist and industrial designer with experience in the development of collaborative strategies on the Internet and in the management of artistic projects.

Natalie Carfora was the Exhibitions Lead at MOD., working across concepts and design of exhibitions and projects. Passionate about creating audience-centred experiences with arts and culture, she has held roles that span exhibitions, collections, and digital at the Migration Museum, MOD. and the South Australian Museum.

Lāth Carlson, is the founding Executive Director of the Museum of the Future, Dubai. Lāth has experience at the Maxwell Museum of Anthropology, the Please Touch Children's Museum, the Franklin Institute Science Museum, The Tech Museum and Living Computers: Museum + Labs.

Maria del Carmen Mesa is a multimedia communicator and a cultural manager by conviction and passion. She manages the production of residencies, laboratories, and events at Exploratorio, Colombia. She is in charge of aligning outside and inside interests.

Seb Chan is director & CEO at the Australian Centre for the Moving Image (ACMI) and previously held senior leadership at Cooper Hewitt Smithsonian Design Museum and Powerhouse Museum. He is also currently the National President of the Australian Museums and Galleries Association and likes cats.

Julyán Conde is a plastic and visual artist and composer. He oversees methodologies for activities at Exploratorio, Colombia, that disseminate art, science, and technology with an emphasis on artistic creation. He draws on gaming as a method and philosophy.

Loes Damhof is UNESCO Chair on Futures Literacy in Higher Education at the Hanze University of Applied Science, Lecturer of the Year in The Netherlands in 2016, a Future Fellow at Hawkwood College, and a committee member of the Futures-Oriented Museum Synergies (FORMS).

Dr Julie Decker is the director/CEO of the Anchorage Museum in Alaska, a centre for scholarship, engagement, and investigation of Alaska and the North. She has a doctorate in interdisciplinary studies, a Master's Degree in Arts Administration, and a Bachelor's Degree in Design and Journalism.

Meredith Doby is Chief Creative Officer at The DoSeum, Texas, USA, leading the permanent, travelling, and Design Studios exhibits. With a Masters in Museum Exhibition Planning and Design, and experience in New York City exhibition design, her work maintains a future focus, giving children the skills necessary to create desired futures.

Prof Kathryn Eccles is an Associate Professor and Senior Research Fellow with expertise in Digital Cultural Heritage at the Oxford Internet Institute, University of Oxford. Her work focuses on how museums and cultural organisations can implement new tools and technologies to measure and enhance visitor engagement.

Keri Elmsly is the Executive Director of Programming at the Australian Centre for the Moving Image (ACMI). Keri is a global creative leader in experimental art, design, and technology practice with museums, artist studios, large-scale touring installations, and multi-disciplinary projects.

Brooke Ferguson is the Futures Officer and a Moderator at MOD., Australia. She researches futures theories, interests, and practices, and engages museum visitors in conversations about exhibitions and possible futures. Additionally, she is a multi-disciplinary artist with a Bachelor of Contemporary Art from the University of South Australia.

Maria Isabel Garcia is the Managing Director and Curator of the Bonifacio Art Foundation, Inc. in the Philippines, the foundation that conceived, designed, and operates The Mind Museum, the BGC Arts Center, and the BGC public art programme. She is a writer who has published books and over 1000 columns.

Prof Dr Andreas Gundelwein is the Director of TECHNOSEUM, the State Museum of Technology and Labour, Germany. He has a background in prehistory and earth sciences, with vast experience in exhibitions and science communication. Additionally, he is a board member of MINTaktiv, the German science and technical museums network.

Luís Gustavo Costa Araújo is an architect and urban planner with a Master's Degree in the Social History of Culture and will soon obtain a PhD in the History of Arts and Architecture. He is the leader of community relationships at the Museum of Tomorrow, Brazil and studies public perception.

Honor Harger is a curator from New Zealand, based in Singapore. She has been the executive and artistic director of the ArtScience Museum in Singapore since 2014. Her work explores cultural practice at the intersection of contemporary art, science, and education and how futures are imagined by museums and cultural organisations.

Stefanie Holzheu is a media architect, project manager, and educator with experience teaching at the Technical University Berlin and Bauhaus University Weimar. As project lead for the Mobile Futurium at Futurium Berlin, she brings futures literacies to Germany's countryside. She studied at Bauhaus University Weimar and the University at Buffalo.

Dr Kathrin Kösters studied Communication and Cultural studies, focusing on Museology and achieved her PhD from the University of Vienna. Kathrin currently works as a Research Associate at Futurium, Berlin, focusing on futures literacies, public engagement, and social inclusion.

Amarílis Lage de Macedo has a Bachelor's Degree in Journalism and a Master's Degree in Linguistics and is currently pursuing a doctorate in Language Studies. At Instituto de Desenvolvimento e Gestão, she produces content and visuals of exhibitions at Brazil-based museums, including the Museum of Tomorrow.

Nicklas Larsen is UNESCO Co-Chair in Futures Capabilities and Senior Advisor at the Copenhagen Institute for Futures Studies, Faculty at Parsons School of Design, Educational Lead for Teach the Future in Denmark and previous steering committee member of the Futures-Oriented Museum Synergies (FORMS).

Beatriz Lima Rangel Carneiro is a Geneticist, MSc in Ecology, and PhD candidate in Environmental Sciences and Conservation at the Federal University of Rio de Janeiro. Researcher at the UNESCO Chair of Futures Literacy of the Museum of Tomorrow, she studies synergies within post-development philosophies and the discipline of anticipation.

Dr John Linstrom is a Fellow in Climate and Inequality at the Climate Museum, New York. He has authored a poetry collection (Black Lawrence, 2024) and is editor of The Liberty Hyde Bailey Library for Cornell University Press. He received his PhD in English from New York University.

Andrea Lombardi is the Manager of Relationships and Sponsorships at Inhotim Institute (2023-) and played an equivalent role at the Museum of Tomorrow (2021–2023). She holds a Masters in Communication and Semiotics, several national and international specialisations and residencies, and served at the Museums of Modern Art of Rio and São Paulo.

Paul Martin is a researcher at the School for the Future of Innovation in Society, USA, and co-director of the Center for Innovation in Informal STEM Learning, USA. Paul works with cultural institutions to develop them into community-focused organisations that provide interactive and social opportunities for lifelong learning.

Brendan McGetrick is the Creative Director of the Museum of the Future in Dubai, where he oversees the storytelling and design. His work has appeared in publications in over 30 countries, including The New York Times, Wired, The Financial Times, Art Review Der Spiegel, and Vogue Nippon.

Dr Glyn Morgan is the Curatorial Lead for exhibitions at the Science Museum, London, as well as a lecturer at Imperial College, London. He completed his PhD at the University of Liverpool, studying science fiction and alternate history which engages with the Holocaust.

Mikko Myllykoski is the CEO of Heureka, the Finnish Science Centre. He studied Humanities at the University of Helsinki and innovated how interactive methods can be applied in social and cultural history exhibitions. Mikko has been a project manager for several internationally touring interactive exhibitions.

Chelsey O'Brien is a Curator at the Australian Centre for the Moving Image (ACMI). She has worked as a curator, project manager, author, and artist collaborator across large-scale, multi-disciplinary exhibitions and artists projects. She holds a Bachelor of Fine Arts and a Master's of Curatorship.

Camila Oliveira has a Bachelor's Degree in Visual Arts and a Master's Degree in Contemporary Arts. She leads the educational activities of the Museum of Tomorrow, Brazil, with projects spanning the environment, arts, science, and accessibility. She has curatorial and teaching experience in Brasília, São Paulo and Rio de Janeiro.

Dr Rae Ostman is a researcher at the School for the Future of Innovation in Society, co-director of the Center for Innovation in Informal STEM Learning, and director of the National Informal STEM Education Network, USA. Her work focuses on engaging communities in positive futures and exploring science, technology, and society.

Ricardo Piquet is the founder and chief executive of Instituto de Desenvolvimento e Gestão that manages the Museum of Tomorrow and other cultural projects in Brazil. One of the founders of FORMS and board member of the UN Live Museum, he has large experience leading cultural, educational, and environmental organisations.

Nina Pougy is a biologist with Master's degrees in Sustainable Development and Business Administration in Project Management. She is the Scientific Manager of the Museum of Tomorrow, Brazil, with previous positions at the Forestry Code Observatory, the International Institute for Sustainability, and the Rio de Janeiro Botanical Garden.

Michael Radke explores how people learn, connect, and drive large-scale social change around the world. Michael is the co-founder and Executive Director of The Ubuntu Lab – a new category of museum – leading the construction of a global network of experiences dedicated to helping people understand people.

Dr Juliana Restrepo is a physicist, fiction author, and fascinated by science engagement. After completing her PhD in Paris, she worked as a professor and researcher focusing on Open Quantum Systems. She is currently the director of Science Engagement at Parque Explora, Colombia.

Catalina Rodas Quintero is a social communicator – journalist from the UPB and a candidate for a Master's degree in Latin American Social Studies from the UBA. She has worked as a lecturer at the UPB and as a communicator in cultural spaces, such as the Museum of Antioquia and Exploratorio, and in feminist organisations, such as the Colectiva Justicia Mujer and the NGO Temas del Sur.

Dr Fabio Rubio Scarano is a Forestry Engineer with a PhD in Ecology. He is a Professor at the Federal University of Rio de Janeiro and current UNESCO Chair of Futures Literacy and Curator at the Museum of Tomorrow. He has served on United Nations panels and received two Jabuti Literature Prizes.

Nancy Salem is a doctoral candidate at the Oxford Internet Institute, University of Oxford. Her research assesses cultural institutions as spaces for public

engagement with debates and developments in AI and new technologies. Her work focuses on the public perception and user experience of emerging technologies.

Paloma Salgado is the Director of Experience Design at MIDE. She specialises in Science Communication and museum design. She has participated in national and international projects as a creative designer and as an advisor, including for the Saudi Arabia Central Bank Museum and The Environment Museum in Guadalajara.

Melanie Saverimuthu was Head of Curation during the development phase of the Zukunftsmuseum and currently curates the exhibition area 'Work & Daily Life', including topics like robotics, artificial intelligence, and communication. Previously, Melanie developed an integrated interactive game and the exhibition area 'production and consumption for energie.wenden' at the Deutsches Museum.

Maike Schlegel is a curator at the Zukunftsmuseum. She has conceptualised its exhibition area 'Earth System' and is responsible for its ongoing revision, dealing with resource scarcity and security regarding food, water, energy, and raw materials. Additionally, she researches the acceptance of new foods.

Aron Schöpf is a curator at the Zukunftsmuseum, responsible for the exhibition area 'Space & Time'. His background as a science theorist and sociologist strengthens the techno-ethical perspective within the exhibition. Previously, he worked on redesigning study programmes in higher education concerning new technological challenges.

Dr Samira Siddique is a Fellow in Climate and Inequality at the Climate Museum, New York. She develops public programming on climate change justice linked to how personal experiences of inequality shape broader relationships with society and the environment. She received her PhD from the University of California, Berkeley.

Silvia Singer is the Founding Director and Design Leader of Mexico City's Museo Interactivo de Economia (MIDE) (Interactive Museum of Economics) in Mexico City. She has a background in biology and science centres and has been an active participant in shaping the science centre movement in Latin America and globally.

Tina Smith heads exhibitions at the District Six Museum, Cape Town, and has a background in art education. Her interests involve gathering the testimonies of displaced communities and addressing creative ways of rethinking notions of memorialisation through working with creative mediums to derive meaning and relevance in a post-apartheid democracy.

Pireeni Sundaralingam is a cognitive scientist, who has held research posts in behaviour change and decision-making at the University of Oxford and Massachusetts Institute of Technology. Formerly Principal Advisor on Human Potential

for the United Nations Museum, she implements neuroscience-based design initiatives on human resilience at a range of museums.

Hanna Winker oversees the event programme at the Futurium, Berlin, where foreseeable, conceivable, and desirable future concepts are presented and discussed. Coming from a cultural background, Hanna is passionate about conveying future-oriented content through creative and imaginative ways.

Dr Gabriele Zipf is the Head of Exhibitions at Futurium, Berlin, responsible for the implementation of the exhibition and its continuous transformation. As a curator and project manager, she developed the concepts and realised the implementation of two new museums as well as many exhibitions.

Contributing museums

Anchorage Museum
Anchorage, Alaska, United States of America, est 1968
The Anchorage Museum is recognised as a leading centre for scholarship, engagement, and investigation of Alaska and the North. The museum organises hundreds of public programmes annually, including artist residencies, public art installations, convenings, workshops, classes, concerts, performances, conferences, design weeks, festivals, and summits, as it partners with hundreds of other organisations and efforts. The museum's emphasis on Indigenous voices, diverse communities, climate change, justice, access, and innovation provides a distinct set of activities that place the museum at the centre of communities and conversations around change.

Arizona Science Centre
Phoenix, Arizona, United States of America, est 1984
Arizona Science Centre utilises interactive exhibits and research-based education programmes to achieve its mission to inspire, educate, and engage curious minds through science. The centre welcomes people of all ages and backgrounds with a particular focus on students, teachers, and families. The centre creates and hosts a mixture of both temporary and permanent exhibits, giving it the space to change according to the changing needs of its community. Alongside exhibits, it is also home to a theatre, planetarium, and makerspace. Furthermore, the centre offers professional development opportunities for teachers, outreach programmes and educational resources online.

ArtScience Museum
Singapore, Singapore, est 2011
The mission of ArtScience Museum is to explore the intersection of art, science, culture, and technology. ArtScience delivers exhibitions and programmes that showcase the work of contemporary artists who push the boundaries of art practice, engage deeply with recent scientific advances and in doing so offer insights into many possible futures. The museum includes over 21 gallery spaces and has presented exhibitions that explore aspects of big data, palaeontology, particle physics, marine biology, and space exploration alongside the work of well-known artists such as Andy Warhol and MC Escher. ArtScience believes that exploring possible futures is just as important as exploring the past.

Australian Centre for the Moving Image (ACMI)
Melbourne, Victoria, Australia, est 2002

The Australian Centre for the Moving Image, commonly referred to as ACMI, is based in Melbourne, Australia. It focuses on screen culture, showcasing the history and futures of film, television, art, gaming, and other screen-based media through exhibitions, events, commissions, festivals, educational programmes, and screenings. It is ACMI's vision to build a bright, diverse, and connected community of screen-literate watches, players, and makers. ACMI seeks to inspire thinking, prompt curiosity, fuel creativity, and provide opportunities for exploration for its audience, using screen media as a catalyst.

The Climate Museum
New York City, New York, United States of America, est 2015

The Climate Museum is the first museum dedicated to climate change and its solutions in the United States. Through the power of arts and cultural programming such as art installations, interdisciplinary exhibitions, panels, youth programmes, performances, and more, the museum seeks to accelerate climate dialogue and action, with a strong focus on building connections and advocating for just solutions. The museum has already hosted over 300 events and eight exhibitions. The Climate Museum works to ensure climate dialogue is accessible to the broader public.

The DoSeum
San Antonio, Texas, United States of America, est 2015

The DoSeum in San Antonio, USA, is a children's museum/science centre that applies a framework of futures to their exhibitions and programmes. They utilise play and imagination to allow children to positively impact the future and build STEM (Science, Technology, Engineering, Mathematics) identity to become empowered agents of change. With both indoor and outdoor interactive exhibit spaces, the museum's experience is child-led and self-directed.

Deutsches Museum Nuremberg, the Zukunftsmuseum
Nuremberg, Germany, est 2021

The Zukunftsmuseum (Future Museum) is a branch of Deutsches Museum, Germany, that looks at possible futures caused by technological innovations and their potential impacts on society. Guided by the premise that current social developments are often driven by technology, the Zukunftsmuseum focuses on these innovations and on images of the future and the hopes and fears associated with them. Based on a classic exhibition containing spectacular objects, the museum uses the scenario technique of futures studies and invites visitors to engage in discourse on possible and desirable futures.

District Six Museum
Cape Town, South Africa, est 1994

The District Six Museum, South Africa, was launched in 1994 as a response to forced removals that occurred in the district and the purposeful erasure of District Six's history during Apartheid, to serve as a repository for the community's

memories. It was, and still is, a non-government-sponsored cultural institution that allows it the space to maintain autonomy over its methods, exhibition and programmes. The District Six Museum's mission is to build more sustainable and just futures for the past, present and future residences of District Six, South Africa, and ultimately the world.

Exploratorium
San Francisco, California, United States of America, est 1969
The Exploratorium uses science, art, and human perception to explore the world with its public audience. It is one of the oldest science centres, pioneering the combination of art and science to inspire experimentation, curiosity and lifelong learning. It was also one of the first museums to utilise participatory methods and currently houses over 1000 interactive exhibits exploring natural phenomena and human perception. Exploratorium is often cited as the inspiration for many other interactive science centres during the wave of new science centres in the 1980s and 1990s.

Futurium
Berlin, Germany, est 2019
The Futurium, the House of Futures, is an institution committed to the exploration of possible futures. Its guiding question for all approaches to future topics is: How do we want to live? Within its premises, Futurium not only strives to curate a stimulating array of exhibitions but also hosts a diverse spectrum of workshops and event programmes. Its activities are designed to promote Futures Literacies and strengthen skills like adaptability and resilience, empowering the audience to thrive in uncertainty. In 2023, more than 760,000 people visited Futurium, making it one of the ten most frequented museum sites in Berlin.

Heureka Science Centre
Tikkurila, Finland, est 1989
The Heureka Science Centre, Finland, is managed by the Finnish Science Centre Foundation. It is Heureka's mission to engage people in the joy of discovery through a planetarium, exhibitions, educational programmes, and events. The centre's values include incorporating research-based information, inspiring curiosity, working sustainably, and learning together. Alongside the content accessible at the centre, Heureka focuses on creating unique exhibitions that both appeal to all age groups and are suitable for touring, allowing their work and messages to be shared with a global audience. These exhibitions have already travelled to almost 30 countries.

Museo Interactivo de Economia (MIDE)/Interactive Museum of Economics
Mexico City, Mexico, est 2006
Museo Interactivo de Economia (MIDE) (Interactive Museum of Economics) was the first museum to deal with the economy in an interactive way. MIDE focuses on economics, defined as decision-making, in particular exploring three key themes, sustainable development, finances, and the economy, with a mission to grow the critical and creative thinking of its young adult target audience, ranging from 15

to 25 years old. With the hope that better decision-making skills in the present can lead to better well-being on individual, familial, communal, national, and global levels into the future.

The Mind Museum
Manila, Philippines, est 2012
The Mind Museum is a science centre in Manila that works with the arts and sciences to explore imaginative, creative, future-oriented endeavours. It champions science and technology as being critical skill sets for the future of people and works with its community to co-design the museum space. The Mind Museum strives to be a new kind of science centre that goes beyond the facts that science centres are required to present and pose questions that make people think.

MOD.
Adelaide, South Australia, Australia, est 2018
MOD. is a future-focused museum of discovery located in Tarndanya/Adelaide at the University of South Australia. MOD. aims to engage its 15–25-year-old target audience by showcasing research in exhibitions and programmes that engage with science, technology, art, and innovation, considering the ways that these intersect to create futures. The exhibitions are changed annually to expose the audience to a wide range of research and to stay at the edge of emerging futures. MOD.'s mission is to provide an expanded set of opportunities for young adults and grow their capacity to think about the future.

Museum of the Future
Dubai, United Arab Emirates, est 2014
The Museum of the Future creates immersive experiences of alternative futures grounded in data and scientific findings, yet deliberately chooses to present optimistic adaptations of large challenges, to serve as a counterbalance to the prevailing disempowering pop-culture narratives. The museum utilises methods of speculative design, experiential futures and participatory museums to put its visitors in alternative future worlds. The museum seeks to inspire and empower visitors towards making preferred possible futures a reality. The location in Dubai puts it in an ideal position to welcome visitors from all over the world, including many government delegations.

The Museum of Tomorrow/Museu do Amanhã
Rio de Janeiro, Brazil, est 2015
The Museum of Tomorrow explores possible futures and roadmaps to create them. The museum incorporates emerging research data, expert scientific opinion, and experimental art to create interactive and immersive experiences for its visitors. It is an informal education space that provokes dialogues between science and other forms of interpretations of reality, including anticipatory frameworks, to build futures literacy in its collaborators, visitors and partners. Additionally, the museum holds a United Nations Educational, Scientific and Cultural Organization (UNESCO) Chair on Futures Literacy.

Parque Explora
Medellín, Colombia, est 2007
Parque Explora was founded as a Science Centre, an aquarium, a planetarium, and a public experimentation lab (Exploratorio). The museum has over 300 interactive exhibits and covers topics such as neuroscience, physics, biology, astronomy, and music, with the ultimate goal of stimulating art, technology, and science engagement to develop individual and collective human capacities to live better. Parque Explora's ideas go beyond its walls with workshops, community processes, lectures, and outreach experiences.

Science Museum
London, United Kingdom, est 1857
The Science Museum, London, is part of the Science Museum Group, whose mission is to inspire futures, an aim which underpins the Museums' values such as sharing authentic stories, revealing wonder, and igniting curiosity. Currently, the museum has galleries exploring energy, space, modernity, homelife, clocks, mathematics, the information age, flight, tomorrow's world, climate, futures, and an interactive space called the Wonderlab. It curates a range of temporary and touring exhibitions.

The Ubuntu Lab
Global Network, est 2012
The Ubuntu Lab is a global organisation that is building a network of learning spaces dedicated to helping people understand people. It was founded in 2012 with the simple thesis that all people want to be understood by others and to understand people and the world. The Ubuntu Labs integrate practices of futures thinking into their models and challenge learners to build their internal capacity to imagine and consider their possible futures, to grow hope and agency to act today.

Acknowledgements

The idea for this book bubbled up at the gathering for the Future-Oriented Museums Synergies (FORMS) network in Berlin in 2022. This network was originally established in 2018 by the Museum of Tomorrow International Foundation (MOTI) in 2018, informed also by UNESCO's Futures Literacy initiative. The aim of the network was to bring together museum leaders at the forefront of an emergent new practice of cultivating futures thinking in their various communities. Perhaps it was the post-COVID context, but the perceived need for uptake of futures thinking generally, coupled with a growing awareness of the role of museums as agents of social change, prompted a desire to document the activities of the network, to share our learnings more formally with each other, to inform future museum practice, and to inspire others.

As a leader of a museum embedded with a tertiary institution, MOD., it felt appropriate to see these early examples land in the academic literature, so I volunteered to frame and edit a series of case studies that would showcase the different contexts, approaches, and tools our colleagues were using in their efforts to cultivate futures thinkings in their diverse communities.

This book is a testament to those early supporters who agreed we should write this down, and have weathered the translation of the idea into reality over the last couple of years.

Firstly, I would like to acknowledge the executives of FORMS, especially Alexandre Fernandes Filho, Raul Corrêa-Smith, and Ana Paula Teixeira, for without their efforts, we would never have had the opportunity to meet and share ideas in the first place.

To all contributing authors and their supporting organisations from within and beyond participation in FORMS – Luis Alberto Alcaraz, Majed Al Mansoori, Dr Rosalina Babourkova, Bruna Baffa, Dr Stefan Brandt, Camilo Cantor, Maria del Carmen Mesa, Seb Chan, Julyán Conde, Dr Julie Decker, Meredith Doby, Prof Kathryn Eccles, Keri Elmsly, Maria Isabel Garcia, Prof Dr Andreas Gundelwein, Luís Gustavo Costa Araújo, Honor Harger, Stefanie Holzheu, Dr Kathrin Kösters, Amarílis Lage de Macedo, Beatriz Lima Rangel Carneiro, Dr John Linstrom, Andrea Lombardi, Paul Martin, Brendan McGetrick, Dr Glyn Morgan, Mikko Myllykoski, Chelsey O'Brien, Camila Oliveira, Dr Rae Ostman, Ricardo Piquet, Nina Pougy, Dr Juliana Restrepo, Catalina Rodas Quintero, Dr Fabio Rubio Scarano,

Nancy Salem, Paloma Salgado, Melanie Saverimuthu, Maike Schlegel, Aron Schöpf, Dr Samira Siddique, Silvia Singer, Tina Smith, Pireeni Sundaralingam, Hanna Winker, and Dr Gabriele Zipf. Thank you for your willingness to reflect on your approaches and practices, to engage in this work so fully, and to review each others' case studies. Thank you to Dr Lisa Bailey and Natalie Carfora from my team for the work on writing the MOD. case studies. A special thank you to authors Lāth Carlson, Loes Damhof, Nicklas Larsen, and Michael Radke who, in addition to case studies and reviews, thoughtfully checked components of the first full draft.

I also appreciate the support from those who enthusiastically supported the proposal, allowing us to gather momentum, including Michael John Gorman, Susanna Barla, Martine Jarlgaard, Alex Lambie, and Steve Fuller. A shout-out to my colleague at MOD. Erika Barrett who scanned literature to demonstrate that there was a need for this book.

In the delivery, I am indebted to Maggie Greyson who willingly reviewed our first draft and provided insightful comments and links to helpful references.

To Heidi Lowther and Manas Roy from Routledge for being enthusiastic about the idea and taking the time to help us craft a work that represents the ideas of so many, but hopefully also inspires others.

I would like to thank other colleagues at MOD. and the University of South Australia. The support to deliver this book amongst projects, exhibitions, and the pressure of operations is much appreciated. In addition to those contributing to the MOD. case studies, thank you to Daniel Lawrance, Dr Dylan DeLosAngeles, Claudia von der Borch, Samuel Wearne, Victoria Bowes, Prof Craig Batty, and Prof Marnie Hughes-Warrington.

Finally, thank you to my colleague Brooke Ferguson for collaborating with me on securing interviews and writing case studies, for contributing to the literature review and the overall revisions, and most of all, for working so efficiently and generously with all our contributors to collate their chapters and case studies. I could not have edited this work without your input, patience, and support.

Dr Kristin Alford
February 2024

Acronyms and abbreviations

Section I
Context and Opportunity

1.1 Building community capabilities in futures thinking

Kristin Alford

The importance of futures thinking

It used to be that social and cultural futures were shaped by expectations of continuity, but the current context is more shaped by unreliability and uncertainty (Gidley 2017). The contemporary world presents us with various individual, local, and global challenges. Pandemics, climate change, geopolitical unrest, and technological disruption impact communities across the world in ways we are grappling to understand. Additionally, there are challenges related to the ever-evolving nature of social, cultural, and political systems, coupled with economic volatility and the adoption of artificial intelligence and automation.

We need to appreciate the complexity of these problems, and it can seem impossible to understand the interconnections. Some actions result in unintended consequences, and some consequences are anticipated and yet still not avoided. System level changes require multiple access points to shift that are beyond the simplistic level, or the level of individual personal responsibility. There is a growing need for the public to be able to think more effectively about the future and to be more reflexive about using ideas about futures to enrich and expand opportunities in the present (Miller 2018, Slaughter 1996a). The techniques used to invite more participatory and experiential futures, to expand futures thinking beyond policy or industry into the public realm are discussed further in Chapter 1.2.

An emergent field of practice

As an academically trained futurist who leads a future-focused museum, I am invested in and curious about the practices that are currently emerging in museums. I want to see the field develop with rigour so that these activities are making tangible differences to the community's futures capability that then flows into system-wide change for improving the planet. It's important that these practices are shared so that a wider group of professionals and cultural institutions can implement approaches towards developing healthier futures. The purpose of this book is to give museum professionals, and those working in futures and foresight, a glimpse into the diversity of emerging practices.

DOI: 10.4324/9781003474975-2

In less than ten years, we have seen pop-ups by the Museum of the Future at the World Government Summit in Dubai, transforming into the stunning physical entity that opened in 2022. The Museum of Tomorrow launched just before the Olympics in Rio de Janeiro in 2015, followed by MOD., also known as a museum of discovery, in Adelaide in 2018, and the Futurium in Berlin in 2019. Beyond these specific future-oriented museums, a range of cultural institutions present futures-oriented exhibitions and artworks, all of which engage their communities into activating and exploring futures thinking and are thus training and enhancing anticipatory capabilities.

Cultivating Futures Thinking in Museums sets the foundations for a new field of practice that is emerging at the intersection of futures studies and museum practice. Museums have the audience and resources to contribute to growing capabilities in futures thinking. Museums often top the list of institutions that the public trust, and even if this is contested, they hold an important and influential role in the presentation of information and narratives. Not only can museums tell stories about our histories, but they can also open us up to perspectives and possibilities about our futures.

Many of the museums featured in these case studies wouldn't fit into a traditionally accepted definition of a museum. While some are collecting institutions, many are not. Some are next iterations of science and technology centres in the context of climate and sustainability and some are more focused on social history or sharing the narratives of their cities.

In a world that feels increasingly complex, fast-paced, and uncertain, there is a growing need for communities to be able to anticipate change, imagine alternatives, and act to shape the present, and museums are well-positioned to take on this challenge. The opportunities for museums as conduits for futures thinking are discussed in Chapter 1.3.

Defining futures thinking

Futures thinking encompasses all activities and skills where people imagine, engage with, think about, discuss, and apply different futures. Futures thinking is a cognitive approach and mindset that involves considering and exploring alternative futures and their implications, engaging with complex, long-term perspectives, and being able to anticipate and prepare for various possibilities. Futures thinking includes scanning the environment for signals of change. It includes creative thinking to imagine and generate different possible alternatives to be more open to uncertainty, and it encompasses planning and cultivating a version of preferred or envisaged futures. The work of futures includes using those insights to reframe perceptions of the present and to generate actions for change. Futures thinking consists of capabilities that can be developed through teaching, learning, and practising.

While people from many cultures have imagined futures informed by various knowledges, the systematic approach to futures thinking under consideration in this book emerged in the post-World War II period (Hines 2020, Kuzmanovic and Gaffney 2019). This period saw the establishment of American public advisory

think tanks such as RAND Corporation and later the Hudson Institute, alongside the development of scenario planning, drafting various future scenarios for military preparedness (Hines 2020, Kuzmanovic and Gaffney 2019). The term *prospective* emerged in France alongside other European scholars towards the end of the 1950s, driven by social concerns and with applications to the development of public policy (Futuribles 2024, Hines 2020). The terminology of using the plural *futures*, as opposed to thinking about a singular 'future', emerged in the 1960s as a challenge to predictable futures (Gidley 2017).

From the mid-1990s, foundational texts by Slaughter (1996b, 2005) and Bell (2003, 2004) were published, providing background content for the approaches, methodologies, and tools within the discipline. This enabled broader uptake by a growing and more diverse field of practitioners and people working with futures, and the global diffusion of futures studies has also led to a greater range of perspectives. In Eastern and Global South cultures, non-linear notions of time have shaped unique approaches to futures thinking. The call to 'decolonise' futures work reflects a push to democratise futures thinking in service of social agendas and to recognise non-Western, feminist, minority perspectives, and Indigenous knowledge (Bisht 2017, Sardar 1993). The body of work that recentres these perspectives includes Afrofutures, Afrofuturism, and Indigenous futurism (Brooks 2019).

The field is still debating terminologies, though there are some accepted meanings. **Futures Thinking** is the cognitive approach and mindset that involves the consideration and exploration of a range of futures and their implications, engaging with complex, long-term perspectives to anticipate and prepare for various possibilities. Often the types of futures under consideration are illustrated with various iterations of the Futures Cone diagram observing probable, plausible, possible, preposterous, and preferred futures that help to distinguish different futures thinking approaches (Voros 2003). The way we each come to think about the future will also be influenced by our mental models, cognitive biases, and the way we perceive time and the meaning of concepts as well as our level of comfort with uncertainty and challenging accepted visions (Smith and Ashby 2020). This means futures thinking is scaffolded by a range of tools and methodologies to help people move beyond thinking constraints. The field of study pertaining to futures thinking is often referred to as **Futures Studies**, encompassing the systematic study of possible futures, including the approaches and methodologies informing futures thinking.

Though sometimes the field is referred to as Foresight or **Strategic Foresight**, which encompasses proactive and future-oriented processes, exploring and anticipating potential future changes and challenges, but emphasising proactive actions to shape the future. The intersection of strategy and foresight occurs in the thinking phase of organisational strategy where options are explored with an intention to disrupt and expand alternatives for consideration in the later phase of strategic planning (Voros 2003).

UNESCO has, since 2012, championed the idea of **Futures Literacy** to be an essential skill for the 21st century (Miller 2018). Similarly to strategic foresight, futures literacy taps into the human ability to imagine and utilise multiple and diverse futures, though here the focus is beyond the organisational viewpoint and

the emphasis is on generating and using the perception of diverse futures (Miller 2018). Both strategic foresight and futures literacy stress that the objective of engaging in futures thinking is not merely to anticipate challenges and opportunities but to embrace seeing or acting differently in the present (Miller 2018, Voros 2003). This mode of thinking allows us to understand how our cultures, worldviews, backgrounds, and intentions influence our views of the future and provides context for decision-making. Much of our ability to be media literate enables us to discuss media, and being science literate enables us to make decisions about issues that relate to science, futures literacy enables us to discuss and make better-informed futures decisions (Snow and Dibner 2016, Time's Up 2023).

Even within the field of futures studies, there exists contention about the meanings of futures thinking, strategic foresight, and futures literacy or futures literacies, and globally there are different approaches that might prefer more quantitative or qualitative methods, or a stronger focus on economic or social futures. Throughout the books, there may be varying uses of these terms based on the background of various authors, their points of reference for futures studies, and the intent of the futures work being undertaken. These diverse approaches are recognised and celebrated as being useful in an emerging field of practice.

Rationale for this book

Cultivating Futures Thinking in Museums focuses on public engagement through the cultural sector, written by and for people working in museums. Furthermore, this book introduces the reader to approaches to futures thinking through 21 examples of these practices in action, demonstrating how these are being applied in a museum context. The case studies are drawn from institutions from across the globe, at different scales and in varied community contexts, enabling others to be inspired to cultivate futures thinking themselves. As an emerging practice, there is not a wide body of literature that yet exists. Existing examples of futures work in museums tend to be scattered throughout numerous publications and publication styles, leaving a significant gap for a curated collection of futures work in museums.

A common conclusion might be that the contributions of futures work discussed in this book overlap with current conversations on the future of museums, yet it is important that a distinction be drawn. The future of museums discourse through publications by Baldessari (2014), Bast *et al.* (2018), Dorman (2017), MacLeod *et al.* (2018), Winesmith and Anderson (2020), Gorman (2020), and most recently Szanto (2021) largely centres on how the museum as an institution could change in the future, focusing on the evolution of museum practice, content and purpose.

While recent publications by Murawski (2021), Newell *et al.* (2016), and Scott (2017) also address the role that museums have in creating change and adding to public value, this book specifically focuses on the role museums have in enabling those communities to expand their capacity for futures thinking.

While there are publications dedicated to futures thinking, they are often aimed towards academic, policy, or corporate settings rather than building public

capability. On the other hand, *Cultivating Futures Thinking in Museums* focuses on public engagement through the cultural sector, written by and for people working in museums, articulating the case for why fostering futures thinking in communities is a relevant and important role for museums.

Therefore, this book adds to the futures and museums discourse by focusing on building futures thinking via the museum sector, providing concrete examples of how museums are cultivating futures capabilities in diverse global contexts to help museum professionals adopt practices and learnings, responding to the urgent need to think about the future in the context of climate change, digital disruption, global pandemics, and geopolitical unrest. Exploring futures thinking provides a new lens for museums to think about their role in shaping and creating alternative and novel narratives for the future, thus growing experimentation and creativity that in turn fuels a richer understanding of pasts and presents (Miller 2018). This is the first book of its kind.

Outline for cultivating futures thinking in museums

Section I, Context and Opportunity, delves deeper into notions of engaging communities in futures and how it has evolved from a focus on democracy and policymaking. In cultural sectors, futures thinking has also evolved from the fields of science fiction and speculative design. These activities and increasing access to interactive and immersive technologies in museums set the background for the emergence of future-oriented museum practice. It turns out that museums are well-positioned to tell stories of who we might like to be and to build our collective capacity for learning and thinking. As seemingly well-trusted places centred in communities and as portals from the past to the future, museums are ideally placed to be conduits for futures thinking.

Section II, Case Studies of Futures in Museums, provides a series of 21 case studies exploring cultivating futures thinking within museums in action.

The first set of case studies draws on futures tools and methodologies to help build individual capabilities of futures thinking. The second set draws on the futures studies field to engage people in participatory futuring. The third set of approaches highlights how museums highlight key drivers of social, environmental, and social change so that communities understand change, and the last set of approaches engages people in wholly felt experiences of different futures. Each of these case studies demonstrates varying levels of explicit futuring with communities, as appropriate for their individual context.

These case studies are taken from a range of established and new cultural institutions across Europe, South America, North America, Africa, the Middle East, Asia, and Australia. While the book may not chart all examples of futures in museums, the diversity of institutions and approaches in very different contexts and communities provides a broad foundation to inform foresight and museum professionals globally.

Finally, Section III, Developing the Emerging Field, reflects on the current state of museums leading futures thinking in communities and asks what might

we anticipate from here. How will we start to see the impacts of this work and how might communities change because of it? How do we evaluate and develop the field and what additional tools might be useful for other cultural institutions? How might all museums start to develop this competency internally and with communities? Why is it important for cultural sector leaders to also understand this competency to be able to drive change?

References

Baldessari, J., 2014. *Museum of the future*. Zurich: JPR Ringier.
Bast, G., Carayannis, E.G., and Campbell, D.F.J., 2018. *The future of museums*. Switzerland: Springer International Publishing AG.
Bell, W., 2003. *Foundations of futures studies – volume 1: history, purposes, and knowledge*. Originally published by Transaction Press 1997. London: Taylor & Francis.
Bell, W., 2004. *Foundations of futures studies – volume 2: values, objectivity, and the good society*. Originally published by Transaction Press 1997. London: Taylor & Francis.
Bisht, P., 2017. Decolonizing futures: exploring storytelling as a tool for inclusion in foresight. Master's thesis. OCAD University, Canada. Available from: https://core.ac.uk/download/pdf/154171898.pdf [Accessed 24 January 2024].
Brooks, L., 2019. Introduction to the special issue when is Wakanda: Afrofuturism and dark speculative futurity. *Journal of Futures Studies*, 24 (2), 1–4.
Dorman, E., 2017. *The future of natural history museums*. London: Routledge.
Futuribles, 2024. The history and memory of foresight. *Foresight – Futuribles*. Available from: https://www.futuribles.com/en/la-prospective/histoire-et-memoire-de-la-prospective/histoire-de-la-prospective/ [Accessed 14 January 2024].
Gidley, J., 2017. *The future: a very short introduction*. Oxford: Oxford University Press.
Gorman, M.J., 2020. *Idea colliders: the future of science museums*. Cambridge: MIT Press.
Hines, A., 2020. When did it start? Origin of the foresight field. *World Futures Review*, 12 (1), 4–11. Available from: https://doi.org/10.1177/1946756719889053 [Accessed 21 January 2024].
Kuzmanovic, M., and Gaffney, N., 2019. The art of futuring. *foam* [online]. Available from: https://fo.am/publications/art-futuring/ [Accessed 21 January 2024].
Macleod, S., et al., eds., 2018. *The future of museum and gallery design*. London: Taylor & Francis.
Miller, R., ed., 2018. Transforming the future: anticipation in the 21st century [online]. United Nations Education, Scientific and Cultural Organization. Available from: https://unesdoc.unesco.org/ark:/48223/pf0000264644 [Accessed 5 February 2024].
Murawski, M., 2021. *Museums as agents of change*. Lanham: Rowan & Littlefield.
Newell, J., Robin, L., and Wehner, K., 2016. *Curating the future: museums, communities and climate change*. London: Routledge.
Sardar, Z., 1993. Colonizing the future: the 'other' dimension of futures studies. *Futures*, 25 (2), 179–187.
Scott, C.A., ed., 2017. *Museums and public value: creating sustainable futures*. London: Routledge.
Slaughter, R.A., 1996a. Futures studies: from individual to social capacity. *Futures*, 28 (8), 751–762. Available from: https://www.sciencedirect.com/science/article/pii/0016328796000092 [Accessed 28 February 2024].
Slaughter, R.A., 1996b. *New thinking for a new millennium: the knowledge base of futures studies*. London: Routledge.
Slaughter, R.A. ed., 2005. *The knowledge base of futures studies: professional edition*. Indooroopilly: Foresight International. Available from: https://foresightinternational.com.au/ [Accessed 15 January 2024].

Smith, S., and Ashby, M., 2020. *How to future: leading and sense-making in an age of hyperchange*. London: Kogan Page.

Snow, C.E., and Dibner, K.A., eds., 2016. *Science literacy: concepts, contexts, and consequences*. Committee on Science Literacy and Public Perception of Science, Board on Science Education, Division of Behavioral and Social Sciences and Education, & National Academies of Sciences, Engineering, and Medicine. Washington: National Academies Press.

Szanto, A., 2021. *The future of the museum: 28 dialogues*. Berlin: Hatje Cantz.

Time's Up, 2023. *Futures brought to life: we are no futurists*. Vienna: University of Applied Arts.

Voros, J., 2003. A generic foresight process framework. *Foresight*, 5 (3), 10–21. Available from: https://doi.org/10.1108/14636680310698379.

Winesmith, K., and Anderson, S., eds., 2020. *The digital future of museums: conversations and provocations*. London: Routledge.

1.2 Reviewing approaches to community futures

Kristin Alford and Brooke Ferguson

Futures in cultural institutions

Early examples of engaging with future scenarios in cultural institutions can be traced back to the World's Fairs, specifically between the Great Exhibition of London in 1851 and the New York World's Fair of 1939 which acted as futures labs showcasing technological advancements (Luckhurst 2012). Notable among these early initiatives was the 'Futurama' exhibit at the 1939 New York World's Fair, sponsored by General Motors. Although not a traditional museum, this exhibit played a significant role in presenting a vision of the future, emphasising innovations in transportation and city planning.

Beyond World Expos, spaces like Disneyland's 1955 Tomorrowland emerged as venues explicitly designed to engage the public in discussions about the future. The Experimental Prototyping Community of Tomorrow Centre (EPCOT), was another Disney futures venture that opened to the public in 1982, with an aim of encouraging utopian views of the potential of technological advancement in futures through immersion and awe (Bowers 2019). The Franklin Institute was founded in 1824 as a technical training centre and evolved into an immersive science museum with its iconic walk-through human heart and extensive collections. In 1990, The Franklin opened its $72 million Futures Centre, which included cutting-edge technology exhibits, and a 'choices forum', which allowed for voting on the future of issues such as population growth, spread of AIDS, species extinction, and access to clean water. At its opening, museum President Joel Bloom said 'there's no such thing as one future. Nobody has successfully predicted the future. We're showing a range of a lot of possible futures' (The Morning Call 1990). This may have been a concept ahead of its time, as by the late 1990s many of the exhibits were being replaced with ones more typical of other science centres (Montgomery Media 2000). In 1998, The Tech Museum of Innovation opened in Silicon Valley with similar aims to display cutting-edge technology. By 2013, it began to pivot to engaging visitors in the process of innovation, rather than its products. These types of institutions were precursors to science centres, presenting emerging research and preferred futures to the public, through methods that incorporated education and entertainment.

The emergence of science centres in the US in the 1960s marked a transition in engaging the public in science and science, technology, engineering, and

DOI: 10.4324/9781003474975-3

mathematics (STEM) literacy. Institutions like the Oregon Museum of Science and Industry with its strong science and technology focus and the Exploratorium with a focus on making science accessible to the public were pivotal in inspiring science centres globally (Gore and Stocklmayer 2011, Gorman 2020). However, these centres primarily emphasised science literacy, presenting a predetermined future based on technological progress, rather than actively involving the public in shaping alternative futures.

Science centres are differentiated from museums by their hands-on, experimental approach and that they are not collecting institutions. The role of explainers in science centres further distinguished them from natural history and art museums (Gore and Stocklmayer 2011). The differentiation between science centres and museums lays the groundwork for considering the unique characteristics of future-focused museums (Gorman 2020).

During this time, there was also increasing concern about the lack of public understanding of science, and it was hoped that science centres could play a role in developing science literacy (Gore and Stocklmayer 2011). Better science literacy was assumed to be the basis for which people in democracies might make better decisions about policies relating to science and technology (Gore and Stocklmayer 2011, Snow and Dibner 2016). Furthermore, increased science literacy was expected to lead to greater interest in careers in STEM to ensure that the job demands for advanced, more complex economies might be satisfied (Snow and Dibner 2016).

Future-oriented museums

The assumption that cultural institutions like science centres might help the public make decisions about the skills required for the future is also inherent in the development of future-oriented museums. The shift from science centres to future-oriented museums was initiated by the interactive 'Museum of Future Government Services', a pop-up at the World Government Summit in Dubai in 2014 that foreshadowed the later Museum of the Future. These exhibits were designed to introduce visiting government representatives to emerging technologies (Chayka 2017, The Government Summit 2014). The move towards more permanent future-oriented institutions was likely heralded by the opening of the Museum of Tomorrow (Museu do Amanhã) in Rio de Janeiro in 2015. This institution developed from initial plans to build a science centre focused on earth and sustainability to include a strong focus on the Anthropocene (a designation for the epoch in which humans are seen to be having a significant effect on ecosystems and climate) and how to help audiences understand and engage in changes required to meet necessary climate goals (Scarano 2024, this book). The Museum of Tomorrow launched its international arm, the MOTI (Museum of Tomorrow International Foundation) Foundation in 2018 under the premise that new narratives are needed for systemic changes to occur within society, with projects seeking to expand on the approach of the Museum of Tomorrow. In researching opportunities for the development of El Museu del Demá at Fundesplai in Barcelona, the emergence of a new type of

future-oriented museum was observed (Clerici n.d., Piquet Fernandes 2018). This new type of museum would enable imagination in service of more sustainable and equitable futures and be designed using multi-sensory, immersive, and interactive elements to encourage visitor engagement (Clerici n.d.).

This work allowed MOTI to recognise a scattered community of museums and cultural institutions dedicated to future-centric themes and similar design approaches but not yet connected as peers. MOTI sought to bring together the leaders of these like-minded institutions with the Future-Oriented Museums Synergies (FORMS) network, with the first meeting taking place in Amsterdam in 2019 (Teixeira and Corrêa-Smith 2023). Key to the development of FORMS has been identifying this shared purpose in an emerging field of museology, drawing on the mission of UNESCO to enable Futures Literacy globally. Many of the case studies in this book are drawn from museums and leaders who have engaged in the FORMS network.

Participatory futures

If the highest purpose of futures work, beyond organisational strategies, is to create social transformation, then foresight is important for informing and inspiring communities striving for change (Ollenburg 2019, Ramos 2016). The landscape of futures thinking has evolved from an expert-driven model to one that actively involves communities in both futures thinking and change (Ramos 2016). This metamorphosis is underpinned by a foundational belief that the future is not a singular trajectory but a negotiated space where diverse voices play a crucial role. Being able to participate in imagining and designing futures is a process that empowers communities to advocate and act on their behalf (Ollenburg 2019).

The case for participatory futures arises from several interrelated points including the idea of foresight as a right. Participatory futures respond to community uncertainty, restoring ethics and trust. These processes strive to be inclusive and engage people in co-created dialogue and community-led action.

Foresight as a right

The idea of participatory and accessible futures envisions a world where knowledge about engaging in futures thinking or the act of 'futuring' is not confined to experts but is disseminated widely, empowering individuals and communities to actively participate in shaping their destinies. The future is yet defined, it is shaped by the choices we make in each moment and collectively (Dunagan *et al.* 2019).

The advocacy for foresight as a right, championed by Candy (2016), signifies a paradigm shift. It emphasises the agency of individuals and communities to actively engage in shaping their futures, challenging traditional top-down approaches and fostering a sense of stewardship. Foresight can inspire a sense of social responsibility and impetus for social action, at both political and personal levels (Ramos 2016).

Under the Universal Declaration of Human Rights, Article 18 states that 'Everyone has the right to freedom of thought, conscience and religion...' and Article 19 states 'Everyone has the right to freedom of opinion and expression...'. (United Nations 1948). The nature of foresighting draws on both these freedoms, with the right to freedom of imagination as a valid extension, protecting the 'capacity to roam freely in the imagination' (Candy 2016). In educational fields, the capacity to imagine and inspire – 'thoughtful wishing' is key to the development of collective meaning, creating new forms of social life and held knowledge (Appadurai 2004, Zipin *et al.* 2012).

Furthermore, there is a growing understanding of the need for nurturing imagination and futures literacy in education to allow futures tools and approaches to be more accessible to all (Candy 2016, Lund 2018). UNESCO and organisations like Teach the Future emphasise the need for students to develop the capacity for anticipatory thinking and foresight as a key ingredient to civic participation (Bishop and Hines 2012, Bol 2018, UNESCO International Commission on the Futures of Education 2021).

Given the actions we take today have long-term consequences, it's helpful to expand our perspective of the present (Boulding 1996). Decision-making needs to get better at accounting for future generations who arguably also have a right to the future and to thinking about the future (Ramos *et al.* 2019, Slaughter 2005). *The Wellbeing for Future Generations Bill* in Wales is an example of the consideration of inclusive access to foresight as a right (Ramos *et al.* 2019).

Restoring trust in uncertain times

Preserving the right to imagine is one thing, but the current social context is buffeted by uncertain trajectories. Participatory futures is a powerful tool to help people and communities come to terms with uncertainty and build resilience collectively (Ramos *et al.* 2019). Futures thinking matters partly because people are fearful and anxious about how the future might play out in their communities (Manchester 2023).

The felt uncertainty is exacerbated by the declining trust in major public institutions, threatening peace, unstable governments, and population health (United Nations 2021). Coupled with growing misinformation and disinformation, there is a need to rebuild the public's trust in institutions (Ramos *et al.* 2019). If current visions around futures are left to powerful actors such as technology companies, large multinationals, or political states, this also becomes an ethical and moral question of agency. It is essential to involve communities in conversations about issues that shape their futures (Manchester 2023).

Participatory futures are inclusive futures

The lack of diverse images of the future in fictional worlds is somewhat remediated by participatory futures that seek an array of community perspectives. The plurality of futures has to be reflected, moving beyond didactic, expert-centred paradigms,

towards valuing the lived expertise of the communities likely to experience those futures (Bisht 2017, Dunagan *et al.* 2019, Ramos *et al.* 2019, Raupach *et al.* 2013, Sardar 1993). From a social justice perspective, we need to ensure we are making space for inclusive futures to challenge power and create new social and economic opportunities that can be shared (Inayatullah 1993, Manchester 2023, Ramos *et al.* 2019).

The movement to decolonise futures thinking represents a pivotal step towards genuine pluralism. It addresses the Eurocentric biases ingrained in the conceptualisation of time, space, progress, and growth, emphasising the importance of diverse narratives in shaping inclusive and equitable futures – but this needs to be the inclusion of communities in both process and content (Bisht 2017, Engle *et al.* 2022). A concept emerging from Indigenous knowledges is that the future might be considered as ancestral: an intergenerational perspective that underscores continuities from past to present and emphasises equity, justice, and the ongoing health of the planet as essential for building better futures, and in turn, the importance of leaving better pasts as good ancestors (Krenak 2024).

Engaging in dialogue

Participatory futures is part of a family of disciplines focused on engaging with relevant publics. Arising from the grassroots activism of the 1960s, the field of architecture and planning started to recognise the importance of engaging with communities for housing developments (Sanoff 2000). Human-centred design practices today seek to understand the needs, desires, and experiences of people involved in the design problem being explored (Giacomin 2014). The design process has moved outside the purvey of design as a personal creative endeavour and into collective creation and shared power.

Likewise, the push towards participatory museums sought to decentre the curator as the expert and involve communities in the design, experience, and meaning-making of exhibitions (Simon 2010).

In each of these examples, the involvement of people in conversations, sharing knowledge, and making meaning is an important part of the process of development of the output.

Community-led futures

Participatory futures methodologies provide the scaffolding for groups of people to come together, share perspectives, and collectively build visions of the futures they desire. Manchester (2023) states that it's vital to involve people in futures thinking to support 'communities to dream'. Making tangible images of the future, especially ones that are positive and engaging is a key component of developing hope (Snyder 2012). Community-led futures also enable hope as people find alternative pathways for action and feel empowered to make a difference (Snyder 2012).

Beyond guided facilitation, the development of futures literacies enables communities to lead these futures thinking opportunities, challenging established power dynamics. The notion that 'we can't create a more equitable system through an inequitable process' underscores the importance of actively involving communities in the decision-making processes that shape their futures (Goodman 2020). Community-led futuring might be seen not just as a right but also as a 'radical act' (Goodman 2020). Peer-to-peer learning amongst social innovators working to create new futures across the personal, organisational, and political scales is a powerful way to affect change (Ramos 2012).

Experiential futures

While people may be primed to plan for their own futures, imagining societal futures is hard. The field of futures has traditionally used theoretical, schematic, and verbal tools to explore possible futures and speak of futures studies in general. This limits who can and does engage with the field and its ideas. A challenge in engaging public audiences in futures is being able to move thinking beyond the known and unexpected to use alternative futures productively.

At the intersection of design thinking and futures thinking, speculative design and design fiction aim to engage audiences in images of alternative futures through material examples including aspects of world-building, objects, and situational provocations (Candy and Kornet 2019, Candy and Dunagan 2016, Bleecker *et al.* 2022). The term 'speculative design' was introduced by Dunne and Raby (2013) advocating for design as a medium to highlight problems and alternative realities rather than focusing solely on solutions for the current context. The design object becomes a prompt or a provocation through which people might engage in imaginative thinking and constructive discussions about alternative futures.

After the radical design movement of the 1970s, commercialisation and societal shifts limited the ability of designers to think speculatively, with the focus on design as constrained solutions (Dunne and Raby 2013). More recently there's been a resurgence of interest in speculative design, responding to global challenges such as economic contraction, climate change, and technological advancements. Speculative design, as a form of criticism, renews the emphasis on imagining and designing implications rather than focusing solely on the product itself. It can be used to discuss potential cultural, ethical, economic, political, and health implications of products and technologies before their creation. These journeys into futures go beyond the product focus of design to recognise systems of care beyond human-centric systems, explore the consequences of rearranging political and economic systems, and facilitate debate about the ethics of emerging technologies (Dunne and Raby 2013, Shao 2023).

The concept of experiential futures has moved beyond the presentation of these images or artefacts of the future to immerse people in a different context, allowing them to situate themselves for deeper exploration than has traditionally been

possible through analytical approaches to developing scenarios (Candy 2010, Time's Up 2023). Experiential futures are developed from a range of mediums or facilitated exercises to create a sensory experience of a future world that aims to evoke emotional responses in participants and not just rational ones (Bleecker *et al.* 2022, Candy 2010, Dunagan *et al.* 2019, Jain 2017).

The challenge lies in engaging with a future that is not directly experienceable but is rather shaped by images, thoughts, and emotions, where our interferences and responsibilities are felt (Adam and Groves 2011, Slaughter 2003). The purpose of engaging people in experiential futures is not only to experience a future context but also to use this experience and the felt sense of being in that future, to encourage constructive dialogue with participants, prototype ideas of the future, and improve decision-making processes to enable action in the present (Dunagan *et al.* 2019, Time's Up 2023).

Museums have embraced both the showing of speculative design or design fiction objects as well as using immersive futures as a powerful tool to captivate audiences and stimulate meaningful conversations about the future. These cultural institutions are no longer confined to static exhibits but have evolved into dynamic spaces that facilitate participatory experiences. The shift towards immersive futures is evident in exhibitions that go beyond showcasing artefacts, offering visitors a journey through speculative scenarios that provoke thought and elicit emotional responses.

Experiential futures, broadly, including aspects of speculative design and design fiction, offer an innovative and participatory paradigm within futures studies. By offering a diverse set of tools and experiences, it transforms the way individuals interact with and contribute to the discourse on the future, fostering a more inclusive and imaginative approach to the challenges and opportunities that lie ahead. Between policy-making and design is an opportunity for the more deliberate engagement of publics in drivers of change, alternatives, and preferred futures in ways that build community capability for futures thinking.

Conclusion

Futures thinking is a systemic way to anticipate and imagine alternative futures and to inform actions in the present. As the field has evolved from its roots in military and policy applications, the broader participation of publics in informing futures, and also in developing, and leading futures work has seen the field shift to include participatory futures. The concept of futures literacy is a skill for everyone to be able to 'use' these images of the future to reperceive the future, to act differently, but also to reconceive the future as relevant.

The evolution of futures work into speculative design and experiential futures further helps to engage people in imagining alternative futures. Furthermore, museums are well placed to showcase artworks and objects of speculative design and to develop immersive experiences of futures. The role of museums acting as conduits for developing capabilities in futures thinking and futures literacy will be explored further by Loes Damhof and Nicklas Larsen in Chapter 1.3.

References

Adam, B., and Groves, C., 2011. Futures tended: care and future-oriented responsibility. *Bulletin of Science, Technology & Society*, 31 (1), 17–27. Available from: https://doi.org/10.1177/0270467610391237 [Accessed 12 January 2024].

Appadurai, A., 2004. The capacity to aspire: culture and the terms of recognition. *In*: R. Vijayendra and M. Walton, eds. *Culture and public action*. California: Stanford Social Sciences, 58–84.

Bishop, P.C., and Hines, A., 2012. *Teaching about the future*. London: Palgrave Macmillan. Available from: https://doi.org/10.1057/9781137020703 [Accessed 19 January 2024].

Bisht, P., 2017. *Decolonizing futures: exploring storytelling as a tool for inclusion in foresight. Master's thesis*. OCAD University, Canada. Available from: https://core.ac.uk/download/pdf/154171898.pdf [Accessed 24 January 2024].

Bleecker, J., et al., 2022. *The manual of design fiction*. New York City: Near Future Laboratory.

Bol, E., 2018. Teach the future. *Journal of Futures Studies – Perspectives*. Available from: https://jfsdigital.org/2018/08/06/teach-the-future/ [Accessed 21 January 2024].

Boulding, E., 1996. Towards a culture of peace in the twenty-first century. *Social Alternatives*, 15 (3), 38. Available from: https://search.informit.org/doi/10.3316/ielapa.970201677 [Accessed 21 January 2024].

Bowers, A., 2019. *FUTURE WORLD(S): a critique of Disney's EPCOT and creating a Futuristic Curriculum*. Ed.D Dissertation, Georgia Southern University, USA. Available from: https://digitalcommons.georgiasouthern.edu/etd/1921/ [Accessed 8 July 2024].

Candy, S. 2010. *The futures of everyday life, politics and the design of experiential scenarios*. PhD Thesis, University of Hawai'i, USA. Available from: https://www.researchgate.net/publication/305280378_The_Futures_of_Everyday_Life_Politics_and_the_Design_of_Experiential_Scenarios [Accessed 24 January 2024].

Candy, S. 2016. Foresight is a right. *The Sceptical Futuryst* [online]. Available from: https://futuryst.blogspot.com/2016/04/foresight-is-right.html [Accessed 21 January, 2024].

Candy, S., and Dunagan, J., 2016. The experiential turn. *Human Futures* [online]. December, 26–29. Available from: https://www.researchgate.net/publication/311910011_The_Experiential_Turn [Accessed 14 January 2024].

Candy, S., and Kornet, K., 2019. Turning foresight inside out: an introduction to ethnographic experiential futures. *Journal of Futures Studies*, 23 (3), 3–22. Available from: https://doi.org/10.6531/JFS.201903_23(3).0002 [Accessed 21 February 2024].

Chayka, K. 2017. *The future agency: inside the big business of imagining the future* [online]. The Verge. Available from: https://www.theverge.com/2017/3/30/15113162/future-utopia-tellart-design-agency-world-government-summit-dubai [Accessed 26 February 2024].

Clerici, A., n.d. El Museu Del Demá, museum masterplan. Available from: https://andresclerici.com/#/museu-de-dema/ [Accessed 21 January 2024].

Dunagan, J., et al., 2019. Strategic foresight studio: a first-hand account of an experiential futures course. *Journal of Futures Studies*, 23 (3), 57–74. https://doi.org/10.6531/JFS.201903_23(3).0005.

Dunne, A., and Raby, F., 2013. *Speculative everything: design, fiction, and social dreaming*. Cambridge: MIT Press.

Engle, J., Agyeman, J., and Chung-Taim-Fook, T., 2022. *Sacred civics: building seven generation cities*. London: Routledge.

Giacomin, J., 2014. What is human centred design? *The Design Journal*, 17 (4), 606–623. Available from: https://doi.org/10.2752/175630614X14056185480186 [Accessed 21 January 2024].

Goodman, J., 2020. *Community-led futures is a radical act* [online]. The Futures Centre, Forum for the Future. Available from: https://www.thefuturescentre.org/community-led-futures-is-a-radical-act/ [Accessed 21 January 2024].

Gore, M.M., and Stocklmayer, S.M., 2011. Interactive science centres in Australia. *In:* Griffin, D. and Paroissien, L. eds. *Understanding museums: Australian museums and museology.* National Museum of Australia. Available from: https://www.nma.gov.au/research/understanding-museums/MGore_SStocklmayer_2011.html [Accessed 22 January 2024].

Gorman, M.J., 2020. *Idea colliders: the future of science museums.* Cambridge: MIT Press.

Inayatullah, S.,1993. From 'who am I?' to 'when am I?': framing the shape and time of the future. *Futures*, 25 (3), 235–253. Available from: https://doi.org/10.1016/0016-3287(93)90135-G [Accessed 21 January 2024].

Jain, A., 2017. *Why we need to imagine different futures* [online]. TED Talk. Available from: https://www.ted.com/talks/anab_jain_why_we_need_to_imagine_different_futures [Accessed 24 January, 2024].

Krenak, A. 2024. *Ancestral future*, Translated by Brostoff, A. and Dias, J. P. New Jersey: John Wiley & Sons.

Luckhurst, R., 2012. Laboratories for global space-time: science-fictionality and the world's fairs, 1851–1939. *Science Fiction Studies*, 39 (3), 385–400. Available from: https://doi.org/10.5621/sciefictstud.39.3.0385 [Accessed 20 January 2024].

Lund, B., 2018. The importance of imagination in educational creativity when fostering democracy and participation in social change. *In:* Lund, B. and Arndt, S. eds, *The creative university.* Leiden: Brill, 11–22. Available from: https://doi.org/10.1163/9789004384149_002 [Accessed 21 January 2024].

Manchester, H., 2023. *Participatory futuring: why futures matter in times of uncertainty* [online]. ESRC Centre for Sociodigital Futures, University of Bristol. Available from: https://sociodigitalfutures.blogs.bristol.ac.uk/2023/11/29/participatory-futuring-why-futures-matter-in-times-of-uncertainty/ [Accessed 15 January 2024].

Montgomery Media, 2000. *Franklin Institute's sports challenge exhibit plays games with your body and head* [online]. Available from: https://www.thereporteronline.com/2000/12/04/franklin-institutes-sports-challenge-exhibit-plays-games-with-your-body-and-head/ [Accessed 5 March 2024].

Ollenburg, S.A., 2019. A futures-design-process model for participatory futures. *Journal of Futures Studies*, 23 (4), 51–62. Available from: https://jfsdigital.org/articles-and-essays/vol-23-no-4-june-2019/a-futures-design-process-model-for-participatory-futures/ [Accessed 22 January 2024].

Piquet Fernandes, M., 2018. *Museu Demá's Masterplan: Developing a new future oriented museum.* Masters Thesis. Reinwardt Academy, Amsterdam University of the Arts, The Netherlands.

Ramos, J., 2012. Deep democracy, peer-to-peer production and our common futures, first published as Syvädemokratia, vertaistuotanto ja yhteiset tulevaisuutemme. *Futura*, 31, vuosikerta 4/2012. Available from: https://www.academia.edu/2396108/Deep_democracy_peer-to-peer_production_and_our_common_futures_Syvademokratia_vertaistuotanto_ja_yhteiset_tulevaisuutemme [Accessed 22 January, 2024].

Ramos, J., 2016. Linking foresight and action: toward a futures action research. *In:* Rowell, L., Bruce, C., Shosh, J., Riel, M., eds. *The Palgrave international handbook of action research.* New York: Palgrave Macmillan. Available from: https://doi.org/10.1057/978-1-137-40523-4_48 [Accessed 23 January 2024].

Ramos, J., et al., 2019. *Our futures: by the people for the people.* London: NESTA. Available from: https://www.nesta.org.uk/report/our-futures-people-people/ [Accessed 21 January 2024].

Raupach, M.R., et al., 2013. *Negotiating our future: living scenarios for Australia to 2050.* Canberra: Australian Academy of Science

Sanoff, H., 2000. *Community participation methods in design and planning.* Hoboken: John Wiley & Sons.

Sardar, Z., 1993. Colonizing the future: the 'other' dimension of futures studies. *Futures*, 25 (2), 179–187.

Scarano, F., 2024. *Engaging with futures at the Museum of Tomorrow in Rio de Janeiro*. London: Routledge.

Shao, A., 2023. *Designing for futures at the intersection of speculative design, storytelling, and systems thinking*. Thesis (M. Phil). Auckland University of Technology http://hdl.handle.net/10292/16927.

Simon, N., 2010. *The participatory museum*. Santa Cruz: Museum 2.0.

Slaughter, R.A., 2003. *Futures beyond dystopia: creating social foresight*. 1st ed. [online]. London: Routledge. Available from: https://doi.org/10.4324/9780203465158 [Accessed 21 January 2024].

Slaughter, R.A. ed., 2005. *The knowledge base of futures studies: professional edition*. Zurich: Foresight International. Available from: https://foresightinternational.com.au/ [Accessed 15 January 2024].

Snow, C.E., and Dibner, K.A., eds., 2016. *Science literacy: concepts, contexts, and consequences*. Committee on Science Literacy and Public Perception of Science, Board on Science Education, Division of Behavioral and Social Sciences and Education, & National Academies of Sciences, Engineering, and Medicine. Washington, D.C.: National Academies Press.

Snyder, C.R., 2012. Hope theory: rainbows in the mind. *Psychological Inquiry*, 13 (4), 249–275.

Teixeira, A.P., and Corrêa-Smith, R., 2023. *FORMS: challenges and opportunities for a network at the intersection of futures thinking and museum practice*. Unpublished.

The Government Summit, 2014. *Government summit: leading government services*. Dubai: Ministry of Cabinet Services. Available from: https://www.worldgovernmentsummit.org/docs/default-source/publication/2014/english/gov-summit-2014.pdf?sfvrsn=60a43b0a_4 [Accessed 26 February 2024].

The Morning Call, 1990. *The future arrives at the Franklin Institute* [online]. 6 May, Available from: https://www.mcall.com/1990/05/06/the-future-arrives-at-franklin-institute/ [Accessed 5 March 2024].

Time's Up, 2023. *Futures brought to life: we are no futurists*. Vienna: University of Applied Arts.

United Nations, 1948. *Universal Declaration of Human Rights*. Available from: https://www.un.org/en/about-us/universal-declaration-of-human-rights [Accessed 22 January 2024].

United Nations, 2021. *Trust in public institutions: trends and implications for economic security*. Department of Economic and Social Affairs, Social Inclusion, 20 July. United Nations. Available from: https://www.un.org/development/desa/dspd/2021/07/trust-public-institutions/ [Accessed 22 January 2024].

UNESCO International Commission on the Futures of Education, 2021. *Reimagining our futures together: a new social contract for education*. Available from: https://doi.org/10.54675/ASRB4722 [Accessed 21 January 2024].

Zipin, L., Sellar, S., and Hattam, R., 2012. Countering and exceeding 'capital': a 'funds of knowledge' approach to re-imagining community. *Discourse: Studies in the Cultural Politics of Education*, 33 (2), 179–192. Available from: https://doi.org/10.1080/01596306.2012.666074 [Accessed 21 January 2024].

1.3 Museums as conduits for community futures literacy

Nicklas Larsen and Loes Damhof

Introduction

The institutional journey of museums spans millennia and offers lenses through which to view our changing relationship with history, art, collective narratives and imagination, woven through centuries of cultural, social, and intellectual shifts. Some have undergone a remarkable transformation, from the past's quiet vaults of preservation to the present's lively centres of cultural discourse and community connection. Today's multifaceted institutions are at the intersection of tradition and innovation, reflecting the dynamic nature of curation, interpretation, and engagement with cultural heritage and how it relates to the future.

While the majority of the world's approximately 100,000 museums (Statista 2023) have traditionally concentrated on preserving, categorising, and displaying historical artefacts and cultural heritage, an increasing number are expanding their focus and lenses to a more forward-looking approach. Questions like 'where are we going?' and 'who are we becoming?' signal the rise of new approaches and purposes in museology (Nielsen 2014). As museums broaden their perspectives, a more dynamic relationship with their audience unfolds. Visitors are invited to become active participants, engaging in conversations rather than consuming static facts, through exhibits that explore diverse futures, encompassing progress and decline. A growing number of recently established museums dedicate themselves entirely to a futures-oriented ethos by envisioning and reflecting on such questions and are curating thematic exhibitions that range from scientific extrapolation to imaginative scenarios. In this perspective, it is time to explore how these institutions can foster futures capabilities within communities as well.

As foreshadowed in earlier chapters, futures thinking and museums practice are forging a reciprocal relationship, where each contributes something essential to the other. Futures practices such as foresight and futures literacy often do not reach the communities they intend to serve. Contrasted against its formal use among decision-makers, it has limited public accessibility, reflecting in a practice of growing importance (UNESCO 2023) but grappling with becoming mainstream. Conversely, museums stand to enhance their contemporary relevance by engaging in participatory and exploratory methods as an alternative learning modality to museums as the traditional, authoritative sources of knowledge and heritage. As

DOI: 10.4324/9781003474975-4

museums increasingly involve the public in both formal and informal dialogues about futures, they are effectively contributing to narrowing this gap by democratising futures thinking and cultivating anticipatory capabilities.

These developments mark a novel purpose for many institutions in relation to how they engage their users in futures thinking as a capability that can question visions and narratives and provide the means to imagine without constraints. Towards hope, instead of out of fear (Damhof and Gulmans 2023). This chapter explores why museums are uniquely positioned to cultivate futures thinking. It seeks to unpack the potential for museums to better understand how they become conduits for futures literacy in communities. As places where space and matter make communities think and wonder, they can both challenge and inform assumptions about the past, present, and future.

The 21st century saw a digital revolution, accelerated by the COVID-19 pandemic. A surge in virtual collections, online exhibitions, and new forms of engagement via social media challenged museums and their need for buildings. Today museums are increasingly taking on contemporary issues, addressing themes like race, decolonisation, climate, LGBTQIA+ rights, gender, and minority representation (Chaliakopoulos 2020). This signifies a changing role and agency in society, moving towards broader social inclusivity. Stimulating dialogue, asking new questions, and holding space for plurality and different knowledge systems all contribute to cultivating forward-thinking in communities.

These diverging perspectives on museology prompt a fundamental inquiry: *What exactly defines a museum?* When ICOM, The International Council of Museums, however, proposed a revision to the museum definition in 2021, they were suggested to be 'democratising, inclusive, and polyphonic spaces for critical dialogue about the pasts and futures' (cited Larsen *et al*. 2021). Yet, the final definition omitted any reference to 'futures' in place of 'offering varied experiences' (ICOM 2022). This seems to change with a recent statement from NEMO (2023), Network for European Museum Organisations, saying that museums have a 'critical role to play in environmental sustainability and imagining our possible futures'. This chapter builds upon and widens that definition to museums as timely portals, entry points to communities, and evolving institutions in society.

Museums are portals through time and temporality

Museums possess a distinctive and fundamental relationship with time in terms of chronology and measurement, and temporality with regards to processes, change, and ephemerality (Kemp 2017). Whether it is through preserving historical narratives and artefacts or showcasing contemporary, time-sensitive stories, they influence our experience and perspective on the concepts and constructs of time. As windows to the past, present, and increasingly, the future, it is time for these institutions to examine their own framing: *how do they sculpt the narratives we share, and in turn, how do they influence the fabric of their communities?*

Going from preservation to serving as gateways holds the potential to revolutionise our engagement with time horizons and perspectives. The abstract and

uncertain nature of the future often creates a psychological distance, making it challenging for many to grasp and respond. This distance, however, presents an opportunity for museums as spaces where this gap can be explored in an engaging environment through forward-looking topics. From a neurological standpoint, recent studies have uncovered parallels between remembering the past and envisioning the future, notably that both memory and imagination share a common neural network. Both past events and future scenarios draw on similar information and depend on similar cognitive processes making the museum the ideal portal for time travelling (Bogart 2022). Museums, through this approach, empower people to imagine, moving beyond the limited and often dominant perspectives of the future that are commonly presented (McGhie *et al.* 2020). This significant shift might change museums into more than repositories of history, by becoming vibrant windows to a variety of futures and increasingly leaving us asking questions rather than being provided with answers. There are examples of how museum professionals and collaborators are propelling this shift away from presenting static absolutes and universal truths by recognising and embracing change as a fundamental aspect of their work. By considering change as a continuous and dynamic process, these professionals are redefining the museum experience towards a more inclusive and fluid interpretation of history, culture, and knowledge, acknowledging that interpretations can vary and evolve over time. This perspective alters the conditions of change and allows for a more nuanced and comprehensive representation of the complexities of the human experience, making museums more relevant in today's ever-changing world (Miller 2013).

While museum staff are experts in temporal matters, it does take new capabilities and innovative tools to integrate futures thinking into museum practice. The routes here are many and can be exemplified by the work at Finland's Futures Research Centre (FFRC), particularly in collaboration with the Forest Museum Lusto, which draws on the concept of *heritage futures*; the role of heritage in managing relations between the present and futures (Holtorf 2022). In this perspective, museums, owing to their esteemed position and responsibility to safeguard heritage for future generations, ought to engage in anticipatory practices, serving the public by, that is, aiding the sustainable perpetuation of biodiverse and civilised life, an ethical course, giving credence to Indigenous perspectives and actively involving communities in transitioning to more regenerative ways of living (McKinzie 2018). Approaches that focus on participatory methods encourage museums to co-create diverse ideas and skills related to interpreting and thinking up the future with their visitors, who then become active participants rather than passive audiences (Siivonen 2023).

Public entry points to futures

In an unpredictable world, we need guidance to navigate and consider what from the past is worth preserving and how things could be different in the future. Here, the growth of *experiential futures* is driven by a cultural necessity that varies globally but is universally present (Candy 2020). Museums today can provide those

entry points for different communities to simulate, play, and contemplate the future. With the capacity to adapt their content and the flexibility to innovate in their display, museums are well-equipped to appeal to a broad array of participants. This can reposition their role from custodians of past narratives – narratives that frequently serve to reinforce prevailing power dynamics and are not necessarily more valid than the potential futures we envision – to proactive facilitators of dialogue and interaction. They support how different societal segments, including local communities and tourists to students and minority groups, ultimately contribute to a more inclusive and foresighted global community.

Art, within museums and beyond, serves as a powerful catalyst for questioning society, challenging dominant narratives, and rethinking the status quo. Similar to how art provokes critical thinking and reflection, futures literacy – *the ability to imagine, critique, and explore future ideas to see the present anew* – plays a vital role in empowering individuals and communities (Keats 2020). It equips them with the tools to not only envision alternative futures but also to critically assess the paths that lead to these futures. This fusion of art and futures thinking in museums ignites a unique form of engagement, encouraging visitors to see beyond the present and contemplate what lies ahead. The following examples show how:

For local communities, museums like Fundesplai, outside Barcelona, play a role in enhancing futures literacy. The EAT:LIFE project sought to transform the food consumption patterns of consumers towards more sustainable, fair, and healthy habits (Fundesplai 2023). By curating exhibits and programmes that reflect both the heritage and potential futures of the community, institutions like these encourage residents to actively engage with and shape their collective narratives. Interactive workshops and future scenario planning sessions allow community members to explore and understand the implications of their choices on future generations, fostering a sense of responsibility and foresight in local discourse and perhaps even decision-making.

For tourists, museums like the Mori Art Museum in Tokyo stand as dynamic forums, inviting them to explore and discuss potential futures. The museum's exhibition of 2020 'Future and the Arts: AI, Robotics, Cities, Life – How Humanity Will Live Tomorrow' showcased over 100 projects and works across five sections: 'New Possibilities of Cities', 'Toward Neo-Metabolism Architecture', 'Lifestyle and Design Innovations', 'Human Augmentation and Its Ethical Issues', and 'Society and Humans in Transformation' (Mori Art Museum 2019). Exhibitions like these encourage citizens and tourists alike to contemplate the future state of society, integrating cutting-edge developments in science and technology like artificial intelligence (AI), biotechnology, robotics, and augmented reality with art, design, and architecture. Such spaces ignite conversations and imagination in ways that transcend ordinary experience, enhancing futures literacy while potentially fostering a deeper understanding and empathy across cultures and maybe even generations.

For students, museums like the Design Museum Denmark are dynamic classrooms offering experiential learning in futures thinking from a design perspective. The museum's exhibition 'The Future is Present' is an exemplary case, challenging visitors with pressing questions about society's future diversity, community design,

and human values. The exhibition, structured around themes like Human, Society, and Planet, presented various future scenarios, design examples, and art installations that range from practical solutions to speculative ideas. Another theme, 'Shaping the Future', concludes the exhibition with utopian dreams and past visionary designs from the museum's collection, illustrating the influence these have had on our world (Danish Design Museum 2023). These programmes and exhibitions invite students to think radically and creatively, encouraging them to reimagine their communities and the broader world, thus contributing to the cultivation of the next generation of futures-oriented thinkers and doers.

For marginalised communities, museums like the National Museum of African American History and Culture in Washington DC can serve as powerful platforms, not only in representing their pasts but also in envisioning and contributing to alternative future narratives. The exhibition 'Afrofuturism: A History of Black Futures' investigates Afrofuturist expression through art, music, activism, and more, from Wakanda to Outcast (Smithsonian 2023). By involving marginalised and minorities in the creation of new questions and future stories, museums become more inclusive in their approaches to futures literacy. They empower communities to actively participate in constructing new visions of the future, ensuring that diverse voices are not only included but also amplified in shaping progressive and inclusive future narratives.

These are just a few of many examples of how museums, each in their own way, invite engagement with futures, thereby playing a vital role in democratising conversations and enhancing futures literacy among various communities.

Evolving with society

At this moment in history, museums find themselves at a juncture, balancing transformation, tradition, and responsibility. As revered institutions of public trust (American Alliance of Museums 2021), they are tasked with navigating through the turbulent and often polarised landscape of today's society. This new reality calls for a deep and introspective reassessment of the role museums play as custodians of trust. Amidst growing scepticism about long-established systems of knowledge, these institutions are compelled to adopt a more nuanced understanding of truth, recognising, and embracing complexity. This perspective highlights the extension of the *New Museology* that emerged in the 1980s, which brought to the forefront a greater awareness of the social and political roles of museums. It underscored the importance of meaningful community participation in curatorial practices and places the individual at the core of the museum experience, shifting the focus from the collection itself to emphasising the museum's commitment to societal development and engagement (Soares 2019).

Concurrently, there is a pressing need for museums to undertake a process of decolonisation, transcending mere artefact restitution to critically reassess and reshape historical narratives, while being mindful of the persistent shadows cast by colonial legacies on both our past and prospective futures. Moreover, museums are now emerging as proactive agents in confronting global issues, notably the

climate crisis. Their unique position enables them to meld natural and human histories, leveraging their influence to inspire public agency and participation in crucial environmental dialogues.

The future of trust

While museums seem to retain their position as some of the most trusted institutions by the public (Loewen 2022), the notion of trust is evolving in a time where polarisation and 'alternative facts' challenge public discourse. As science, long-standing narratives, data, and expertise face scepticism, and as the world is viewed as increasingly complex, the question arises: *what does it mean to be a trusted institution today?* In this context, appreciating complexity is an essential part of futures literacy (Kazemier *et al.* 2021), challenging museums to adapt and redefine their role. When we open our imagination to different futures, we accept the notion that there are more versions of perceptions and perspectives than the dominant narrative. We learn that there are more paths forward than the one we chose and that few things are linear or set in stone. Accepting and even embracing complexity, as a matter of fact, can help us see different ways of doing, thinking, and acting. Often complexity is mistaken for complication, a difficult but solvable issue. However, complexity cannot be solved or simplified, only accepted. When we cannot fully grasp complexity, we need to trust the systems we put in place, and trust becomes a poor substitute for complexity (Luhmann 2017). Yet, in the context of museums, this doesn't imply that we should blindly trust the information or stories being told. Instead, complexity advocates for a type of trust that allows for there to be doubt inherent in our stories. Doubt doesn't diminish significance or the validity of our data; instead, it opens us up to understanding of broader contexts in which these narratives unfold. Knowledge is not static, as complicated systems want us to believe, but knowledge, data, and stories all exist depending on the context and (eco)systems in which they are rooted, which impacts our concept of knowledge (Beenen and Damhof 2022). Museums have the capacity to design and exhibit experiences that underpin this concept of knowledge creation. Rather than exuding an old concept of trust that is rooted in expertise and authority, instead, by using Futures Literacy, they can model trust as something new. Museums are not in control of stories but can be spaces where we open up to ambiguity and plurality. Acknowledging the necessity for uncertainty to be able to see alternatives and evolve (Tibbs 2000) has the potential to make space for futures literacy in the public discourse.

Decolonising museums, decolonising futures

Museums are instruments of colonialism, and their existence is a colonising fact in and of itself (Miranda 2021). For decades they have been a main carrier for, at best, limited and incomplete historical narratives. While decolonisation of museums isn't new, it is becoming increasingly important in the recent discussion on the evolution of museum practices. Decolonising a museum does not only involve the

repatriation of artefacts but also rethinking the premise on which the museum was built. It is therefore important if not necessary to acknowledge our painful colonial history before we display any ancestral or Indigenous artefacts (Lonetree 2012). By colonising the past, one could argue we are colonising our futures as well. Museums, being portals between past and future, compose their image of the past (and therefore the future) upon the present. By decolonising museums and decolonisation *within* museums, the process of deconstructing and disconnecting futures from dominant structures or worldviews can be enhanced. Decolonising futures is the process that reconstitutes the dominant ways of thinking in a way that no particular or single worldview is centred or predominates (Kwamou *et al.* 2021). This process is obviously not just reserved for museums and their practices, and since the process of colonisation has affected all aspects of life, so should decolonisation (Mestiri 2018). From a more holistic perspective, decolonial theory pursues 'the openness and freedom of thought and ways of life; the cleanliness of the coloniality of being and knowledge; the detachment of the rhetoric of modernity and its imperial imaginary' (Kwamou *et al.* 2021, Mignolo 2011). Museums as keepers of cultural narratives have an important role to play in this process, not only in the push for decolonial ways of thinking but also in enhancing the public's imagination for futures liberated of colonial thought.

Active engagement and activism

Natural history and cultural history were never as divided as they were seen by white audiences. Many museums displayed the history of non-white people with a connection to nature, providing food for structural racism and colonisation. However, the complex issues arising from technology and climate change, made this perceived division increasingly unhelpful (Merriman 2024). Through collections, exhibitions, and public programmes, both museums and science centres are well-placed to play active roles in responding to the climate crisis as illustrated through the design of the Museum of Tomorrow in Rio de Janeiro and programmes delivered by Climate Museum in New York. This position builds on recent thinking that recognises that these cultural institutions exist beyond a neutral, non-political stance and that the stories they tell reflect the perspectives of the context in which the museum operates (Autry and Murawaski 2019). The recasting of climate communications from fact sharing to messages that generate courage and agency for action also builds on good practices in both science communication and futures studies (Ahmed and Newell 2024, Balshaw 2024, Murawaski 2021, Snyder 2012).

Museums as conduits for community futures literacy

We need new platforms for public debate and imagination to increase futures literacy through participation. Museums' role as portals through time, their entry points for communities, and their own evolving position in society make them possible and powerful agents to foster futures literacy to the larger public. As with any movement that is subject to change, much research still needs to be done,

alongside experimentation, innovation, and changing narratives. This requires a shift from educating the public to engaging users in ongoing learning journeys. It means changing mindsets from being based on planning and preparation to being open to novelty and emergence. But most of all it asks for courage and hope. Can we welcome the individual to challenge boundaries and identify seeds of change by harnessing the alternative collective images of futures brought forward by museums? In this view, these institutions have an opportunity to provide new meeting places, to become community platforms that amplify public opinion and transform their audiences into co-creating participants with an invitation to overcome the poverty of imagination.

References

Ahmed, Z., and Newell, J., 2024. Taking action on climate change and sustainability at the Australian Museum. *In:* N. Merriman, ed. *Museums and the climate crisis*. London: Routledge.

American Alliance of Museums, 2021. *Museums and trust*. London: Spring. Available from: https://www.aam-us.org/2021/09/30/museums-and-trust-2021/ [Accessed 26 February 2024].

Autry, L.S., and Murawaski, M., 2019. Museums are not neutral: we are stronger together. *Panorama: Journal of the Association of Historians of American Art*, 5 (2). Available from: https://journalpanorama.org/article/public-scholarship/museums-are-not-neutral/ [Accessed 10 January 2024].

Balshaw, M., 2024. The 100-year future: museums and the climate and nature crisis. *In:* N. Merriman, ed. *Museums and the climate crisis*. London: Routledge.

Beenen, P., and Damhof, L., 2022. *From healthcare to the care of health: a learning path in complexity and futures literacy* [online]. San Francisco: Medium. Available from: https://loesdamhof.medium.com/from-healthcare-to-the-care-of-health-568144cd9384 [Accessed 13 December 2023].

Candy, S., 2020. *The future can't wait* [online]. San Francisco: Medium. Available from: https://medium.com/@futuryst/the-future-cant-wait-8527cc47610d [Accessed 13 December 2023].

Chaliakopoulos, A., 2020. *History of museums: a look at the learning institutions through time* [online]. Montreal: The Collector. Available from: https://www.thecollector.com/history-of-museums/ [Accessed 7 December 2023].

Damhof, L., and Gulmans, J., 2023. Imagining the impossible. An act of radical hope. *Possibilities Studies & Society*, 1, 1–2.

Danish Design Museum, 2023. *An exhibition about the design of the future the future is present* [online]. Available from: https://designmuseum.dk/en/exhibition/the-future-is-present/ [Accessed 13 December 2023].

Fundesplai, 2023. *Eat: life* [online]. Available from: https://eat-life.fundesplai.org/en/the-project/ [Accessed 13 December 2023].

Holtorf, C., 2022. Heritage futures: a conversation. *Journal of Cultural Heritage Management and Sustainable Development*, 14, 252–265. Available from: https://www.emerald.com/insight/content/doi/10.1108/JCHMSD-09-2021-0156/full/html [Accessed 13 December 2023].

ICOM, 2022. *ICOM approves a new museum definition* [online]. Paris: International Council of Museums. Available from: https://icom.museum/en/news/icom-approves-a-new-museum-definition/ [Accessed 13 December 2023].

Kazemier, E.M., et al., 2021. Mastering futures literacy in higher education: an evaluation of learning outcomes and instructional design of a faculty development program.

Futures, 132, 102814. Available from: https://www.sciencedirect.com/science/article/pii/S0016328721001233 [Accessed 13 December 2023].

Keats, J., 2020. To prepare people for a perilous future, UNESCO is teaching everyone to think like an artist. *Forbes* [online]. Available from: https://www.forbes.com/sites/jonathonkeats/2020/12/22/to-prepare-people-for-a-perilous-future-unesco-is-teaching-everyone-to-think-like-an-artist/?sh=3c6d604e4e81 [Accessed 13 December 2023].

Kemp, S., 2017. Design museum futures: catalysts for education. *Futures*, 94, 59–75.

Kwamou, F.E., et al., 2021. The capacity to decolonise: building futures literacy in Africa. foresight for development. Wits School of Governance.

Larsen, N., et al., 2021. Futures shaping arts/arts shaping futures. Scenario reports, The Copenhagen Institute for Futures Studies [online]. Available from: https://scenario.wpenginepowered.com/wp-content/uploads/2022/01/SR-06-Web-NY.pdf [Accessed 13 December 2023].

Loewen, C., 2022. Sources of trust in uncertain times. *Canadian Museums Association* [online]. Available from: https://museums.ca/site/reportsandpublications/museonline/winter2022_sourcestrust [Accessed 13 December 2023].

Lonetree, A., 2012. *Decolonising museums. Representing native America in national and tribal museums*. Chapel Hill: The University of North Carolina Press.

Luhmann, N., 2017. *Trust and power*. 1st ed. Cambridge: Polity Press.

McGhie, H., et al., 2020. The time machine: challenging perceptions of time and place to enhance climate change engagement through museums. *Museum & Society*, 18 (2), 183–197.

McKinzie, B., 2018. The possible museum: anticipating future scenarios. *Springer Link* [online]. Available from: https://link.springer.com/chapter/10.1007/978-3-319-98294-6_27 [Accessed 13 December 2023].

Merriman, N., 2024. The role of museums and galleries in addressing the climate and ecological crisis. *In*: N. Merriman, ed. *Museums and the climate crisis*. London: Routledge, 1–14.

Mestiri, S., 2018. *Décoloniser le Féminisme: une approche transculturelle*. Paris: Vrin.

Mignolo, W., 2011. *The darker side of Western modernity: global futures, decolonial options*. North Carolina: Duke University Press.

Miller, R., 2013. Changing the conditions of change by learning to use the future differently. *In*: ISSC/UNESCO, ed. *OECD. World social science report 2013: changing global environments*. Paris: UNESCO, 107–111.

Miranda, L., 2021. Decolonization within the museum. *Open Edition Journals* [online]. Available from: https://journals.openedition.org/iss/3863 [Accessed 13 December 2023].

Mori Art Museum, 2019. *Future and the arts: AI, robotics, cities, life – how humanity will live tomorrow* [online]. Available from: https://www.mori.art.museum/en/exhibitions/future_art/ [Accessed 13 December 2023].

Murawaski, M., 2021.*Museums as agents of change: a guide to becoming a changemaker*. Washington, D.C.: American Alliance of Museums.

NEMO, 2023. *NEMO's statement on future sustainable museum collections* [online] Available from: https://www.ne-mo.org/fileadmin/Dateien/public/NEMO_Statements/NEMO_Statement_Future_sustainable_museum_collections_12.23.pdf [Accessed 14 December 2023].

Nielsen, K.J., 2014. Transformations in the postmodern museum. *Museological Review*, 18, 22–28.

Siivonen, K., 10 November 2023. Fwd: [WFSF] Museums of (about) the future. *World Futures Studies Federation* Available from: wfsf@lists.fu-berlin.de. [Accessed 10 December 2023].

Bogart, A., 2022. *Memory, the present moment, and the imagination* [online]. New York City: SITI. Available from: https://siti.org/memory-the-present-moment-and-the-imagination [Accessed 13 December 2023].

Smithsonian, 2023. *Afrofuturism: a history of black futures* [online]. Washington, D.C.: National Museum of African American History and Culture. Available from: https://www.si.edu/exhibitions/afrofuturism-history-black-futures%3Aevent-exhib-6648 [Accessed 13 December 2023].

Soares, B., 2019. A history of museology, key authors of museological theory [online]. Available from: https://icofom.mini.icom.museum/wp-content/uploads/sites/18/2023/03/2019_history_of_museology_bruno.pdf [Accessed 09 January 2024].

Statista, 2023. *Global number of museums 2021, by UNESCO regional classification* [online]. Available from: https://www.statista.com/statistics/1201800/number-of-museums-worldwide-by-region/ [Accessed 1 December 2023].

Snyder, C.R., 2012. Hope theory: rainbows in the mind. *Psychological Inquiry*, 13 (4), 249–275.

Tibbs, H., 2000. Making the future visible: psychology, scenarios and strategy. *Global Business Network*, 13 (1), 8–13.

UNESCO, 2023. *What is futures literacy (FL)?* [online]. Available from: https://www.unesco.org/en/futures-literacy [Accessed 4 December 2023].

Section II

Case Studies of Futures in Museums

2.1 Introduction to case studies of futures in museums

Kristin Alford

While Section I explored the body of futures thinking relevant for museums, particularly drawing on participatory futures and experiential futures, the case studies in Section II highlight emerging practices at the intersection of futures studies and museum studies.

We explore 21 case studies written by practitioners in the field, some with futures expertise, and others with museum expertise who are applying futures thinking in different ways. The case studies feature museums designed from the outset to be futures-oriented such as The Museum of Tomorrow, Futurium, MOD. (also known as a museum of discovery), and the Museum of the Future, as well as museums and science centres adapting futures in their exhibitions and public programmes.

As an emerging field, there is not a wide body of models or accepted practices that yet exist. Each of these case studies therefore offers perspectives and approaches on how museums might activate futures thinking within communities, as appropriate for their individual context, as a way of establishing some shared approaches for this work within the sector.

It's useful to note firstly that museums themselves are being affected by drivers of change that will shape the future, and we see this reflected in the content being prepared to engage people in futures topics.

The main exhibition at Futurium explores topics including the future of cities, energy, health, food, work, mobility, digital technologies, and democracy. At the Anchorage Museum, The Mind Museum, and The Climate Museum, climate change is something that these museums and their communities need to respond to, and centrepieces of exhibitions that help educate and mobilise their publics. Exhibitions at Parque Explora and the Science Museum use aspects of science fiction to engage people in ideas that may shape the future. The drivers that are affecting the future of museums, including technological change and climate change, are reflected in content for audiences to think about.

The second convergent point for museums and futures comes from the shift towards immersive experiences in museums and their capacity to tell more powerful stories. Technology is supporting immersive experiences of futures, both wholly contained plausible futures as in *The Journey of the Pioneers* at the Museum of the Future and *Seven Siblings from the Future* (originally at Heureka Science Centre), and explorations of possible futures like at ACMI (Australian Centre for

DOI: 10.4324/9781003474975-6

the Moving Image) and ArtScience Museum. We see the shift towards stories in other settings such as at the District 6 Museum.

In the established role that museums and science centres provide with regard to informal learning and supported educational programmes, there has also been the development of education programmes designed to build knowledge in futures capabilities. Specific programmes around cognitive flexibility and futures literacy have been tested at the Exploratorium and the Futurium, providing audiences with explicit tools and techniques for futuring.

Finally, museums are sites of potential transformation. This is why futures-oriented museums often emerge from the model of science centres, where engagement is assumed to inspire further interest and action. This is important as it links to the capacity of people to imagine their own personal possible futures. Programmes that enable hopeful futures, such as The Ubuntu Lab, are deliberately designed to empower and support people's capacity to imagine and act with agency. These benefit from thinking through the role of participation in both futures and museum contexts.

In these case studies from museums and science centres around the world, we see tools and approaches for building individual capability in futures thinking and approaches that build collective capacity by applying participatory futures methods. We see explorations of future themes in exhibitions and programmes that highlight emerging trends and drivers of change and bring attention to technological change and climate change. And we see exhibitions designed to enable people to better understand those possible futures through immersive experiences that bring the future to life.

These case studies recognise the capacity of people to imagine possibilities and expand their capability around creative thinking so that new stories are possible.

Approach 1: Tools and methods to enable futures thinking

2.2 Designing with the brain in mind

Implementing neuroscience-based design principles

Pireeni Sundaralingam

Cognitive flexibility and futures thinking

The human brain is not necessarily wired to effectively think about the future: we find it difficult to imagine the long-term consequences of our actions, we struggle to imagine a world that might be different from the one we currently know, and we are even challenged when it comes to anticipating that we might need savings as we grow older (Yee and Bailenson 2007). If we wish to design exhibits and public programmes that successfully enable futures thinking, it is important to understand the neurological parameters that limit such thinking, and how we can use neuroscience-based design to acknowledge such constraints rather than running counter to them.

At the core of our species' capacity for thinking about the future lies the process of 'cognitive flexibility'. It is essential for systems thinking: if we are to flourish as a species, we urgently need to be able to rethink whole systems of economics, energy consumption, and food production, even the nature of ourselves in relation to other species (Bancroft 2023, Hawken 2021, Kirksey 2015, Raworth 2017). Secondly, as political philosophers have noted, building the foundations for a healthy democracy relies on the ability to engage in nuanced, multi-dimensional public dialogue based on shifting between different perspectives, in short, the ability to practise cognitive flexibility (Habermas 1984, Rawls 1971). Finally, cognitive flexibility is key to futures forecasting. Experimental research demonstrates that when it comes to anticipating what might happen in the future, the most important cognitive ability is not intelligence, or even the ability to detect trends in data, but cognitive flexibility. According to studies conducted on futures forecasters, it is the cognitive ability to shift between mental models of data – orchestrated by the prefrontal cortex of the brain – which allows people to jettison previously endorsed theories and patterns and, instead, try out new models for explaining existing data (Mellers *et al.* 2015).

The downgrading of our futures thinking abilities

In a tragic paradox, even as our socio-economic and planetary conditions demand that we have greater cognitive flexibility, we find ourselves immersed in

DOI: 10.4324/9781003474975-8

environments that effectively short-circuit our capacity for cognitive flexibility and, by extension, our futures thinking.

Many of our digital spaces have been found not only to increase the *quantitative* levels of threat to which we're exposed (features such as the red 'notifications' circle trigger our neural threat circuits while even the 'likes' feature stimulates competition and social stress by appearing to signal our approval rating within our social group) but are also *qualitatively* changing the nature of our neural networks. Repeated exposure to such digital spaces is rapidly changing our brains at a fundamental level, rapidly downgrading our cognitive flexibility, and severely impacting our ability to engage in futures thinking.

Firstly, as artificial intelligence (AI) algorithms ramp up in power, they are being used to monitor and manipulate our emotional responses more accurately. It takes just 300 clicks for platform AIs to be able to predict our moods and behaviour better than even our spouses can (Youyou *et al*. 2015), a fact that an increasing number of analytics companies, such as Lumos, are using to track when, where, and how we will each be most suggestible to different forms of threat – and thus most vulnerable to their advertising campaigns – and using this to then shape the pattern of our daily exposure to threat (Aral 2020).

The constant onslaught of these artificially induced minor threat signals interact with the inbuilt negative feedback loops of our threat neural networks, recalibrating and reshaping them at a fundamental level so that we experience a heightened sense of threat and enter a state of defensive tunnel vision and cognitive rigidity. At a cellular level, when we experience such threats, emotion-regulating neural centres such as the amygdala recalibrate our sensory 'threat' neurons, dropping cells' firing thresholds such that they are activated by any stimulus that falls anywhere close to their range – every twig starts to look like a snake when we are in a state of threat (LeDoux 1998). It effectively becomes harder and harder, at the most profound neurological level, to switch between different mental models and map out alternative scenarios for explaining the same data via more neutral or even positive models.

At the same time, the more stress and threat we encounter, the more damage we accrue in exactly those brain areas which we need in order to self-regulate, to shut out distraction and real (or simulated) threat signals. Brain scans of people before and after adopting a personal smartphone show that after just three months, heavy users experienced significantly less blood flow and neural activity in the prefrontal cortex, a region instrumental in self-regulation (Hadar *et al.* 2017).

Experiments demonstrate at a neurological level that the more vulnerable and threatened that people feel, the more likely it is that they will experience a severe downgrading in cognitive flexibility and become prone to a range of cognitive biases that counter their ability to think capaciously about the future (Westen *et al*. 2006).

It is not just direct threat that triggers cognitive rigidity and reduces our capacity for futures thinking. Our neural networks also narrow the brain's cognitive field in response to either informational overload or an excess of contradictory information (Peng *et al.* 2018). For example, the internet is now associated with such a strong

sense of informational overload that simply reading words associated with the internet (such as 'website' or 'blog') leads to a hyper-focus on small details, with EEG (electroencephalogram) readings demonstrating that trying to look at larger patterns of information under such conditions demands a much higher recruitment of neurological resources than normal (Peng *et al.* 2020).

Additionally, while the internet age was heralded as the dawn of a new era of infinite ideas and information, the attention-extraction business models of our major digital platforms leverage design features that narrow the *range* of ideas with which we are each presented in order to keep our attention, even while flooding us with a greater *amount* of information. Profit-driven platforms wishing to capture human attention rely on promoting threat signals, rather than nuance, complexity, and abstraction, and as a result, the types of scenarios and ideas to which we are exposed are increasingly restricted. Whether we are attempting to listen to talks on innovation via YouTube or simply reading the news online, as a consequence of platforms' 'attention capture' AI algorithms, our brains have increasingly fewer chances to broaden their input thanks to the nature of biased platform recommendation algorithms, pulling us down informational rabbit-holes.

Opening up our capacity for futures thinking

We are in a state of cognitive crisis. As a society, our opportunities for maintaining our cognitive flexibility and expanding our futures thinking by shifting between different perspectives are rapidly dwindling. Fortunately, behavioural data indicate that it is possible to countermand the narrowing of our cognitive fields. Experimental studies, such as those conducted by Danvers and Shiota (2017), indicate that it is possible to use our understanding of neuroscience to design exercises that tap into the relevant impaired neural systems and effectively help the mind 'stretch' and increase its cognitive flexibility, opening itself up to a more flourishing state of futures thinking.

Through my work as founder and lead scientist at NeuroResilience Consulting, I've developed a series of neuroscience-based design principles for opening up the capacity for futures thinking (Sundaralingam and Bissell 2017). As detailed below, four of these design principles – transforming mental models, agency and control, reducing threat and anxiety, and engagement through personal experiences – were implemented in developing futures-oriented workshops at the Exploratorium.

The Tree of Life workshop

The Fisher Bay Observatory – the latest wing of the Exploratorium – is dedicated to developing new interdisciplinary methodologies that will prompt visitors to rethink their existing assumptions about the future landscapes of the San Francisco Bay Area. The Observatory explores how sea-level rise, drought, pollution, and other geophysical phenomena might play out in the future, not just in our local systems, but also around the world. The Observatory has a strong focus on youth and helping develop the type of futures thinking that will facilitate the next generation of leaders.

Over the course of two years, we brought together more than 300 youth from the two sides of the Pacific Ocean: specifically, American high-schoolers from the Bay Area and Japanese youth from the coastal villages of Tohoku, a region devastated by the 2011 tsunami. These groups were meeting for the first time, did not share a common language, came from both urban and rural contexts, and were not familiar with each other's cultures.

Our goal was to explore how to:

- Enhance dialogue across two very different youth groups who differed in several respects.
- Help young people question their existing mental models.
- Help young people expand their perspective from simple local issues of cause and effect to larger, systems-based thinking and see alternative paths of connection.

The 'Tree of Life' exercise was first developed by Ncazelo Ncube (2006) and has typically been used as a self-reflection tool. In Ncube's original exercise, individuals (or groups) are asked to draw three sections of a tree (its roots, trunk, and fruit and branches) and to annotate each of these structures with words representing three aspects of one's inner life: thus, the roots might be labelled with words referencing things that make the participant feel more stable, such as village rituals or the knowledge passed on by grandparents.

We modified the traditional format of the Tree of Life to draw on four neuro-design principles.

Transforming mental models: In recent years, a range of neuroscience experiments have helped identify the type of activities that can activate cognitive flexibility and promote reframing (Dolev *et al.* 2001, Danvers and Shiota 2017).

Agency and control: A range of neuroscience studies demonstrate that if people have the chance to frame events in terms of self-agency or control, they are more willing to take actions anticipating future outcomes (De Groot and Steg 2010). In contrast, in situations where people feel that their actions will have little effect or where they perceive they have little control over outcomes, they tend to resist the idea of flexible and open futures (Ajzen 2002).

Reducing threat and anxiety: Often information about future scenarios (such as climate change) is presented in ways that emphasise disaster, danger, or dystopia. However, neuroscience data demonstrate that such threat signalling may lead to various forms of anxiety-induced cognitive 'shut-down' and increased apathy (American Psychological Association 2009, Center for Research on Environmental Decisions 2009). This may decrease participants' capacity to contemplate the future or to grasp systems-based connections and take action, so designing to reduce threats and anxiety is important.

Engagement through personal experiences: Laboratory experiments have demonstrated that even those climate sceptics who deny that the future might differ from the present can be nudged into changing their attitudes as a direct result of working with interactive visualisation tools, which helped them imagine the future

from the basis of their past personal experiences (Wong-Parodi and Fischoff 2015). Interestingly, despite the risk of threat signally, some studies have shown that the public may be more likely to engage in proactive climate change action for the future if they are first exposed to first-person accounts of dystopian futures, even when such accounts are fictional (Pahl and Bauer 2013).

In our adapted version of the Tree of Life, we placed the emphasis on an individual's connections to wider interdependencies and social systems and the individual's relationship to the future. We asked participants to consider the roots as symbolising memories of resilient experiences that might help them in the future as they cope with change, the trunk as standing for how well people could bend and adapt to the stresses of change, and the fruits now represent the skills, ideas, and creations that workshop participants might want to bring to the future and how these interconnect with others.

In addition to the main part of the workshop, we also conducted surveys at the start and end of the workshop (as 'pre-' and 'post-' tests) to examine the impact of the workshop's activities. Participants were given paper-and-pencil questionnaires and asked to respond (using both a 7-point scale as well as qualitative comments) to questions assessing the following issues:

- Their general mental model of the future, connections to their future self, and mental model of how their lives interconnect with other life forms within their wider socio-biological ecosystems.
- Their sense of fear and anxiety, and their ability to cope, when considering future changes.
- The specific sense of their own agency in terms of changing the future.

Observations

Our findings fell into four categories. Firstly, looking at participants' responses before and after the workshop, we saw a statistically significant shift in participants' mental models of their future selves and their interconnections with others and the systems in which they find themselves. For example, our data indicates that nearly three-quarters of the Japanese students (145 out of 200) switched to adopt more complex mental models of their future selves as did 40 of the 100 American students (40 Americans already showed futures-orientation even during the pre-test). More specifically, our findings suggest that drawing the tree piece by piece, from the roots upwards, seemed to provide the teenagers with a different mental model, one in which the sense of one's future self is not isolated in an abstract conceptual vacuum but rather is an organic continuation of one's current skill and traits. Drawing the Tree of Life functions, in this case, as a type of 'cognitive ladder', creating a more dynamic, mental model of one's future self. Furthermore, the prompt to visualise present and future selves as part of a concrete, organic, form, such as a tree, catalysed participants' ability to consider their interconnections as an individual to both human and non-human others and the complex intertwined nature of cause and effect in wider systems thinking.

Secondly, we found a significant shift in teens' sense of agency and control in regard to their present and possible future lives. For 252 out of 300 teens, a mental model of strong 'roots' helped them feel a sense of self-agency towards their own futures. For 235 of the 300 teens, the act of explicitly articulating skills and traits they could contribute to change the future, not only generated a sense of empowerment but also increased their motivation and willingness to act towards changing the future. In both cases, teens showed significantly more futures thinking after participating in the workshop, compared to those who did not attend the workshop.

Engaging in personal experiences in a way that reduced anxiety was critical for reflections on climate change. We found that when asked to think about future local climate changes, such as sea-level rise in their coastal communities, the majority of Japanese teens (160 out of 200) expressed lower levels of fear, anxiety, and helplessness, in regard to these potential future events, as a result of participating in the Tree of Life workshop. (Only 30 of the 100 American teens showed a significant shift towards lowered levels of emotion, but note that 60 out of 100 already had quite low levels of anxiety even before the session started.)

We also noted that the Tree of Life exercise dramatically supported dialogue between the two teen groups. Prior to participating in the Tree of Life exercise, participants had been shown a series of sea-level rise exhibits in the museum, but this had failed to provoke much comment or even any inter-group sharing. Working with the Tree of Life exercise not only helped each group understand their own values and stories but additionally, once each group had drawn their trees, it gave them a concrete basis with which to compare their different values and experiences, which, in turn, frequently led them to rethink the significance of daily activities. For example, several of the Japanese teens noted how local seaweeds, unique to their specific villages, were a source of civic pride (each village has a unique seaweed festival) and gave a sense of interconnection with the local ecosystem. These visualisations both surprised and inspired the American teens who, despite living in seaweed-rich coastal regions, had rarely paid attention to their own local seaweeds, let alone considered them as potential future sources of food, clothing, and other survival resources. In a second example, in drawing the trees and trying to articulate which skills would help carry them into the future, many American teens embraced their ability to question authority figures and whether they have the necessary knowledge or skills to ensure the best future outcomes. This sharing prompted much discussion with their Japanese counterparts who were at first shocked and then inspired by such statements. Many of the comments we gathered from the Japanese students in the post-workshop interviews pointed to how such inter-group discussions catalysed them significantly shifting their own mental models.

It is noteworthy that conducting the Tree of Life exercise simultaneously with different socio-cultural groups allowed the groups to do much more than simply share information. Critically, this particular design tapped into two key levers of behaviour change: on the one hand, the nature of the messenger conveying the information, and on the other hand, the impact of personal experience or information. Our workshop participants were much more likely to listen to others if they were a

similar age to themselves. Moreover, the fact that the Tree of Life activity elicited so many personal experiences further enhanced participants' ability to absorb new information, transform their own assumptions, and be open to adapting alternative ways to create impact in their socio-cultural and biological ecosystems.

Finally, it is important to note that using inquiry methods grounded in playful arts-based exercises provided an effective way for helping strangers overcome their natural reticence with each other. It is telling that this method was powerful enough to overcome several potential barriers to communication, such as the fact that the participants were teenagers who came from different cultures and who were trying to communicate across significant language barriers.

Conclusion

Our findings suggest that neuroscience-based design principles can be highly effective in developing museum experiences that promote futures thinking, in this case, with regard to thinking about sea-level rise and future resilience as inhabitants of coastal landscapes. This example points to the potential of using such brain-based design principles to ensure that the workshops, exercises, and exhibits we design for futures-oriented museums have a much greater success rate when it comes to advancing futures thinking.

References

Aral, S., 2020. *The hype machine: how social media disrupts our elections, our economy, and our health—and how we must adapt.* New York: Random House.

American Psychological Association, 2009. Psychology and global climate change: addressing a multi-faceted phenomenon and set of challenges. A report by the task force on the interface between psychology and global climate change. Washington, DC.

Ajzen, I., 2002. Perceived behavioral control, self-efficacy, locus of control, and the theory of planned behavior. *Journal of Applied Social Psychology*, 32, 665–683.

Bancroft, J.M., 2023. *Hoodie economics: changing our systems to value what matters.* Melbourne, Australia: Hardie Grant Publishing.

Center for Research on Environmental Decisions, 2009. The psychology of climate change communication: a guide for scientists, journalists, educators, political aides, and the interested public. New York.

Danvers, A.F., and Shiota, M.N., 2017. Going off script: effects of awe on memory for script-typical and irrelevant narrative detail. *Emotion*, 17 (6), 938–952.

De Groot, J.I.M., and Steg, L., 2010. Relationships between value orientations, self-determined motivational types and pro-environmental behavioral intentions. *Journal of Environmental Psychology*, 30 (4), 368–378.

Dolev, J.C., Friedlander, L.K., and Braverman, I.M., 2001. Use of fine art to enhance visual diagnostic skills. *JAMA*, 286 (9), 1020–1021.

Habermas, J., 1984. *The theory of communicative action.* Boston: Beacon Press.

Hadar, A., et al., 2017. Answering the missed call: initial exploration of cognitive and electrophysiological changes associated with smartphone use and abuse. *PLoS ONE*, 12, e0180094.

Hawken, P., 2021. *Regeneration: ending the climate crisis in one generation.* New York: Penguin Books.

Kirksey, E., 2015. *Emergent ecologies.* North Carolina: Duke University Press.

LeDoux, J., 1998. *The emotional brain: the mysterious underpinnings of emotional life.* New York: Simon & Schuster.

Mellers, B.A., et al., 2015. The psychology of intelligence analysis: drivers of prediction accuracy in world politics. *Journal of Experimental Psychology: Applied*, 21, 1–14.

Ncube, N., 2006. The Tree of Life project. *International Journal of Narrative Therapy & Community Work*, 1, (1), 3–16.

Pahl, S., and Bauer, J., 2013. Overcoming the distance: perspective taking with future humans improves environmental engagement. *Environment and Behavior*, 45 (2), 155–169.

Peng, M., Chen, X., and Zhao, Q., 2018. Attentional scope is reduced by internet use: a behavior and ERP study. *PLoS ONE*, 13, (6), e0198543. Available from: https://journals.plos.org/plosone/article?id=10.1371/journal.pone.0198543 [Accessed 12 December 2023].

Peng, M., et al., 2020. Internet-word compared with daily-word priming reduces attentional scope. *Experimental Brain Research*, 238 (4), 1025–1033.

Rawls, J., 1971. *A theory of justice.* Boston: Belknap Press.

Raworth, K., 2017. *Doughnut economics: seven ways to think like a 21st-century economist.* Random House: New York.

Sundaralingam, P., and Bissell, E., 2017. Social Sciences research on psychological mechanisms, communication challenges, and design strategies for content development for the museum of the United Nations. *UNLive*, *32, Copenhagen.*

Westen, D., et al., 2006. Neural bases of motivated reasoning: an fMRI study of emotional constraints on partisan political judgement in the 2004 U.S. Presidential election. *Journal of Cognitive Neuroscience*, 18, 1947–58.

Wong-Parodi, G., and Fischoff, B., 2015. The impacts of political cues and practical information on climate change decisions. *Environmental Research Letters*, 10 (3), 1–10.

Yee, N., and Bailenson, J., 2007. The Proteus effect: self transformations in virtual reality. *Human Communication Research*, 33, 271–290.

Youyou, D., Kosinski, M., and Stillwell, D., 2015. Computer-based personality judgments are more accurate than those made by humans. *PNAS*, 112 (4), 1036–1040.

2.3 Exploring Futurium's Futures Boxes

A tool for promoting Futures Literacies among students

Stefanie Holzheu, Kathrin Kösters, and Stefan Brandt

Introduction

In today's complex world, futures studies scholars emphasise the importance of envisioning the future to shape desired outcomes (Horst and Gladwin 2022). Futures Literacies, as a comprehensive approach, enables individuals to make sense of various future possibilities and scenarios while helping them navigate the complexities inherent to these futures. This enables them to make informed decisions in the present that could potentially have far-reaching consequences in the future (Miller and Carleton 2023, p. 2). It goes beyond mere prediction; it promotes adaptability and resilience in the face of the unknown, empowering individuals to not only survive but thrive in a future filled with uncertainties.

The promotion of future competencies has emerged as a pivotal endeavour of Futurium. Established in September 2019 in Berlin, Germany, Futurium, the House of Futures, is an institution committed to the exploration of possible futures. Its guiding question for all approaches to future topics is: how do we want to live? Within its premises, Futurium not only strives to curate a stimulating array of exhibitions but also hosts a diverse spectrum of programmes and events designed to engage a wide-ranging audience. Moreover, an extensive education programme was developed.

In 2023, more than 760,000 people visited Futurium, placing it among the top ten most visited museums, exhibition spaces, and memorial sites in Berlin (Berlin 2023). In 2021, Futurium received the prestigious European 'Luigi Micheletti Award' for innovative science museums (Luigi Micheletti Award 2021).

Within this book, we present three facets of Futures Literacies at Futurium: the development of our ever-changing Futures Exhibition, a collaboration with the Future-Oriented Museums Synergies (FORMS) network resulting in an experiential tour for our visitors, and, the topic of this article, the Futures Boxes – a resource that is both playful and educational. But before we explore the Futures Boxes and their role in promoting Futures Literacies, let's begin by examining Futures Literacies within the context of Futurium.

DOI: 10.4324/9781003474975-9

Futures Literacies at Futurium

The following description of Futures Literacies highlights certain aspects within a broad spectrum of future perspectives. It is informed by our practical experiences, expert discussions, and a literature review.

Futures Literacies at Futurium focuses on the exploration of multiple futures. The nuanced use of Futures' serves as an eloquent means to emphasise the multiplicity and diversity inherent in potential outcomes and scenarios on the horizon (Seefried 2023). This linguistic choice not only recognises the existence of numerous plausible paths and trajectories for the future but also refrains from restricting it to a singular, fixed destination. It embodies a complex and dynamic space teeming with a multitude of possibilities.

Concurrently, the plural term 'Literacies' acknowledges the rich tapestry of perspectives and the cultural subtleties underpinning the understanding of the future (Horst and Gladwin 2022). It firmly attests to the absence of a universal, one-size-fits-all set of future-oriented skills and knowledges, given the distinct ways in which diverse cultures and societies conceive of the future. Consequently, Futures Literacies adopts an avowedly pluralistic stance, recognising that the skills and competencies deemed essential for engaging with the future may diverge across different contexts.

Based on this understanding, we categorised five domains that express our comprehension of competencies for cultivating Futures Literacies at Futurium. Through these domains, we illuminate skills and knowledge that help individuals to navigate the complexities of a myriad of futures. The following two core domains explicitly relate to understanding and navigating futures:

a **Thinking of Futures:** We encourage our visitors to embrace and envision the future as a realm of limitless possibilities. This entails an unwavering openness to alternative viewpoints and an appreciation for diverse worldviews. Within this context, thinking in plural terms serves as the compass that guides our collective journey. Thinking of futures also involves welcoming and embracing diverse perspectives, encouraging empathy and fostering a sense of community, all while celebrating individual strengths.

b **Shaping Futures:** We prioritise the development of decision-making skills, engaging in negotiation through dialogue, and the honing of strategic thinking. We nurture mental flexibility and the ability to navigate uncertainty effectively. Responsibility stands as a cornerstone value.

Building upon these, we further explore three domains that we consider foundations for 'Thinking of Futures' and 'Shaping Futures':

c **Resilience:** This domain boosts versatile skills, including the capacity to embrace adaptability, confront ambiguity, and uncertainty, and engage constructively with diverse viewpoints. We promote a culture of learning from mistakes, fostering self-confidence and self-efficacy, as well as cultivating the development of problem-solving skills.

d **Creative Mindset:** We actively foster a creative mindset, harnessing the power of imagination and training out-of-the-box thinking. Central to this domain is the

promotion of idea exchange, the stimulation of inventiveness, and an embrace of a prototyping mindset with agility to facilitate experimentation.

e **Scientific Thinking:** Our approach is underpinned by the strengthening of research skills, the mastery of complexity, and the cultivation of critical thinking to challenge information effectively. We place a strong emphasis on source evaluation and critique, as well as data literacy.

As we delve into the subsequent paragraphs, we aim to exemplify our approach by using the case of the Futures Boxes, providing an example that elucidates how we promote Futures Literacies within the framework of the aforementioned five domains.

Futures Boxes

The Futures Boxes are dedicated to promoting Futures Literacies among students aged 12–18 within school environments and diverse educational settings (Futurium 2019). They were developed by Futurium's own Department of Education & Participation, in collaboration with the Education Innovation Lab Berlin with the aim of nurturing future competencies and enabling effective exploration of future possibilities through scenario techniques.

Content

The Futures Boxes address knowledge on seven subjects: Energy, Health, Work, Nutrition, Cities, Mobility, and Democracy. They provide creative problem-solving and brainstorming tools for student teams to systematically create and explore different future scenarios. They are structured to break down a topic into its constituent parts and then recombine those parts in novel ways, often leading to unexpected and creative scenarios.

Structure

Each Futures Box is designed with modularity in mind and comprises five types of flash cards: *category, trend, impulse, perspective, and wildcards*. These flashcards can be applied across a wide spectrum of activities, ranging from brief exercises to entire projects. For the purpose of this chapter, we will examine the cards most relevant to scenario development.

Futures challenges are outlined on *category cards*. Each *category card* is complemented by *trend cards* that articulate ideas and possibilities to address the described challenge. *Category* and *trend cards* in combination form a structured framework. Let's explore a practical example in the context of the Futures of Mobility. Picture five key categories to understand various mobility aspects:

1 How will we live together?
2 How will we power vehicles?

3 What infrastructure will we use?
4 Who is responsible for mobility?
5 To which guidelines does our mobility adhere?

These categories offer a simple scaffolding for exploring various aspects of the Futures of Mobility, providing insights into the intricate nature of mobility considerations. Each category is accompanied by four trend cards. For example, the category 'How will we power vehicles?' includes trends like hydrogen power, renewable energy, biofuel from household garbage, and muscle power.

The primary goal from here on is to use the cards to create a diverse range of future scenarios. Here's how the process unfolds:

Setting the Stage: Students begin by laying out the cards in a 5 × 5 matrix. The first column represents categories, while the rows contain trends related to each category.

Exploring Categories: They delve into the essence of each category, gaining a clear understanding of its thematic focus.

Studying Trends: Once the categories are comprehended, students turn their attention to the trends within each category, unravelling the intricacies of each potential future development.

Scenario Building: Equipped with these insights, students select one trend from each category, weaving them together to construct a scenario of the future. Let's go back to the Mobility Futures Box example. Imagine participants picking trends like 'mobile living', using 'muscle power' for vehicle energy, embracing 'water ways' for infrastructure, relying on 'artificial intelligence (AI)' for management, and making sure 'inclusive and fair public spaces' are a top priority. In other words, they envision a future where people live on the go, using eco-friendly energy, enjoying connected water-based transportation managed by smart AI systems, and creating welcoming and fair public spaces for everyone.

Engaging Discussion: This step involves the evaluation of the scenario. Students pose questions, such as: Is this scenario realistic? Should this scenario materialise? These discussions enable them to navigate the complex interplay among various trends.

Challenge scenarios: Students randomly select a wildcard, which illustrates how unexpected events can disrupt scenarios. For instance, envisioning a sustainable green city may encounter unexpected challenges like natural disasters, rendering vast regions uninhabitable and compelling the population to live in close quarters. Navigating these unforeseen challenges prepares students to tackle uncertainties.

This scenario technique encourages students to explore a wide range of possibilities within the complex landscape of evolving trends.

In addition to Futures Boxes, we offer tools and methods to explore potential futures. This resource package includes detailed methods for educators, classroom

units, and interactive student worksheets. We continually update and expand these materials with new content.

Methodologies

Futures Boxes drew upon methodologies derived from *futures studies, education for sustainable development,* and *design thinking.* This interdisciplinary approach is rooted in the belief that these methodologies complement each other harmoniously.

Futures studies empower students to explore potential future scenarios giving them the tools to prepare for the uncertainties ahead (Inayatullah 2018). By using Futures Boxes, they're encouraged to think actively of futures, supporting an environment where creativity and idea generation flourish.

Education for sustainable development weaves together environmental, social, and economic aspects, promoting a thorough understanding of the future with a strong focus on sustainability (Rieckmann 2021). Within the boxes, sustainability elements take centre stage, highlighting the significance of a comprehensive grasp of the future. This approach underscores the interconnected nature of environmental, social, and economic dimensions, encouraging a well-rounded perspective on possible futures.

Design thinking introduces a problem-solving approach that emphasises empathy, creativity, and iterative processes to develop solutions precisely tailored to meet the evolving needs of people (Lewrick *et al.* 2020). This approach helps to equip students with the skills and mindset necessary to actively shape and influence futures.

Open educational resource (OER)

All our resources are OERs, aligned with UNESCO's emphasis on their transformative role in education, supporting Sustainable Development Goal 4 for quality education for all (Bundesministerium für Bildung und Forschung 2022, UNESCO 2017). Futurium embraces this global perspective, actively working to make resources accessible to everyone, thereby promoting Futures Literacies in diverse communities. Subsequently, all resources can be downloaded, modified, developed, and shared, tailored to the specific needs of the educators and students.

Insights from workshop settings

From student workshops to adult education, Futures Boxes are employed in diverse ways and for various purposes. They serve as a means to construct different future scenarios, even without prior subject matter expertise, to promote open discussions among individuals who may have been strangers previously, as well as to tackle complex subjects collaboratively in an engaging manner.

To examine the practical applications of Futures Boxes within workshop settings, we recently conducted interviews, allowing us to collect anecdotal evidence.

We interviewed three mentors, each with extensive experience working with the Futures Boxes.

- Interviewee one manages workshops at Futurium, which has hosted over 200 since its opening.
- Interviewee two is a liaison officer facilitating workshops for diverse stakeholders in Futurium's education programme.
- Interviewee three is a research associate at Futurium using Futures Boxes with university students for scenario exploration.

Our interviewees observed that during the process of constructing future scenarios with the Futures Boxes, students immersed themselves in a wide range of subjects, fostering the exploration of various facets associated with the subject matter. In doing so, students appear not only to empower themselves but also to break free from linear thinking. Instead of following a straightforward path, students explored multiple avenues, considered various components, and generated a range of diverse ideas. For example, by utilising the Futures Box Mobility, students explored various combinations of power sources, vehicle types, infrastructure, technology integration, and guidelines to generate a diverse range of futures of mobility instead of opting for a single proven technical solution.

Our interviewees furthermore reported that when students are encouraged to select scenarios randomly from the scenario grid, as opposed to deliberately choosing or avoiding specific trends, it leads to in-depth group discussions that revolve around the random scenario. These discussions involve collaborative input, which plays a pivotal role in shaping modifications to the scenario. The emphasis here is on collective engagement, ensuring that students not only comprehend the content but also infuse their unique perspectives and interpretations, supporting a creative and diverse approach to scenario development.

In discussions where students compare various trends and scenarios to assess differing opinions, we also observed that they draw upon their existing knowledge and engage in the exchange of well-reasoned arguments. They frequently refer to the information presented on the cards. The decision-making process often appears to favour a balanced analysis, sometimes by opting for the lesser evil. This approach seems to promote the inclusion of diverse viewpoints, empowering students to make informed decisions regarding desirable or nightmare scenarios. This aligns with our commitment to 'Thinking of Futures' and 'Scientific Thinking' by encouraging thoughtful analysis, balanced assessment, and informed decision-making in the context of scenario discussions.

In our walk-in workshops, especially in settings where individuals from diverse backgrounds collaborate on various projects, our interviewees described a vibrant atmosphere characterised by lively debates, consensus-building efforts, and the essential quest to establish common ground among participants. Based on their personal observations, the interviewees note that participants express a sense of pride in the scenarios they co-create, nourishing an open and inclusive discussion culture marked by active listening and constructive interactions.

During the application of the Futures Boxes with university students in real estate management, student groups were assigned to the task of envisioning futures of cities. After employing the Futures Boxes technique, our interviewee noticed that groups independently created scenarios with notable similarities, including the adoption of identical trends and common features. These commonalities became especially apparent during a group discussion where the students shared their visions of futures. Consequently, the shared themes prompted our interviewee to reflect on shared values and common challenges of the students in their pursuit of envisioning future cities.

In the foregoing context, the interviewee furthermore noted that the nightmare scenarios appeared to mirror aspects of our current reality, serving as a poignant reminder of the challenges we currently confront. Additionally, the participants expressed a desire for open-ended *trend cards*, which our interviewee interpreted as a keen interest in actively shaping emerging trends and becoming architects of the futures they envision. This multifaceted experience aligns with our commitment to 'Thinking of Futures', 'Resilience', and 'Creative Mindset', promoting collaborative exploration, resilience in the face of challenges, and a proactive, creative approach to shaping the future.

Next steps

By observation and feedback from our interviewees, we have recognised promising signals supporting the development of Futures Literacies. This further sparked our curiosity and catalysed the inception of the *Mobile Futurium*.

The *Mobile Futurium* takes Futurium's educational programmes to schools in rural areas of Germany. It offers students a playful and interactive experience with future challenges and opportunities within their school environment while fostering Futures Literacies. Over three years starting in 2024, we will work with up to 42,000 students. Researchers from the Institute for Technology Assessment and Systems Analysis at the Karlsruhe Institute of Technology will engage in participatory research, utilising a multifaceted approach that includes qualitative interviews, participant observation, and transdisciplinary workshops. This evaluation aims to assess the significance of promoting Futures Literacies among students. It will be completed by 2026. We anticipate the findings from this research to offer valuable insights that will enrich the broader conversation surrounding Futures Literacies and the preparation of individuals to navigate diverse futures.

Conclusion

The application of Futures Boxes holds promise in the advancement of Futures Literacies. Our resources provide targeted support by honing in on specific elements within the realms of Futures Literacies, specifically focusing on negotiation skills, cultivating openness to alternative viewpoints, and encouraging the consideration of multiple future scenarios. Through a scenario-based methodology, students not only grasp the intricacies of various future possibilities but also contribute their unique viewpoints, fostering exploration and dialogue.

Furthermore, the adaptability of these resources allows for use in diverse contexts, catering to various learning needs, subjects, or challenges. This makes the overall approach more versatile and adaptable in different educational settings.

Appreciating the findings from a qualitative investigation with measured enthusiasm, it is important to recognise that the emerging opportunities presented by the new Mobile Futurium and ongoing scientific research project create important avenues for in-depth exploration and investigation. This includes strategies for teaching and promoting Futures Literacies in schools, methods for evaluating the impact of the educational programme, as well as the adoption and integration of OER in formal education systems. This research has the potential to significantly advance the development of strategies and approaches for promoting Futures Literacies in education.

References

Berlin, de, 2023. *Top 20 – Die meistbesuchten Museen Berlins*. Available from: https://www.berlin.de/museum/top-20/ [Accessed 5 November 2023].

Bundesministerium für Bildung und Forschung, 2022. *OER-Strategie*. Available from: https://www.bmbf.de/SharedDocs/Publikationen/de/bmbf/3/691288_OER-Strategie.pdf?__blob=publicationFile&v=6 [Accessed 5 November 2023].

Futurium, 2019. *Future box*. Available from: https://futurium.de/en/education-and-outreach/future-box [Accessed 5 November 2023].

Horst, R., and Gladwin, D., 2022. Multiple futures literacies: an interdisciplinary review. *Journal of Curriculum and Pedagogy*, 21 (1), 42–64. Available from: https://doi.org/10.1080/15505170.2022.2094510 [Accessed 6 November 2023].

Inayatullah, S., 2018. Futures studies: theories and methods. *There's a Future. Visions for a Better World*, 37-67. Available from: https://www.researchgate.net/publication/281595208_Futures_Studies_Theories_and_Methods [Accessed 5 November 2023].

Lewrick, M., Link, P., and Leifer, L., 2020. *The design thinking toolbox: a guide to mastering the most popular and valuable innovation methods*. New Jersey: Wiley.

Luigi Micheletti Award, *2020/2021*. *Winner Luigi Micheletti Award*. Available from: https://www.luigimichelettiaward.eu/ [Accessed 5 November 2023].

Miller, R., and Carleton, T., 2023. *UNESCO futures literacy laboratories playbook 2023* [online]. Dhahra: UNESCO. Available from: https://www.researchgate.net/publication/373157930_UNESCO_Futures_Literacy_Laboratories_Playbook_2023_final [Accessed 5 November 2023].

Rieckmann, M., 2021. Bildung für nachhaltige Entwicklung. Ziele, didaktische Prinzipien und Methoden. *Merz - Zeitschrift für Medienpädagogik*, 65 (4), 10–17. Available from: https://www.researchgate.net/publication/355381694_Bildung_fur_nachhaltige_Entwicklung_Ziele_didaktische_Prinzipien_und_Methoden [Accessed 5 November 2023].

Seefried, E., 2023. Geschichte der Zukunft, Version: 1.0. *Docupedia-Zeitgeschichte*. Available from: http://dx.doi.org/10.14765/zzf.dok-2464 [Accessed 5 November 2023].

UNESCO, 2017. *Education for sustainable development goals*. Paris: UNESCO. Available from: https://www.unesco.de/sites/default/files/2018-08/unesco_education_for_sustainable_development_goals.pdf [Accessed 5 November 2023].

2.4 Touring the future of mobility

How Futures Literacy can shape a museum experience

Loes Damhof, Nicklas Larsen, and Hanna Winker

Introduction

How might Futures Literacy tools and principles be adapted for the museum to facilitate futures-oriented learning processes amongst its visitors? Futurium in Berlin, also known as the 'House of Futures', offers an exhibition that looks at possible futures across a range of topics, with 'Futures of Mobility' being the newly introduced exhibition topic in 2022. On 8 October 2022, the Futurium, in collaboration with the worldwide Futures-Oriented Museum Synergies network (FORMS), hosted a festival titled 'Fit for the future with Futures Literacy'. The general public was invited to engage in various activating, sensory, and playful activities, such as workshops, tours, rallies, or speed-dating sessions, to get a better understanding of the concept Futures Literacy and the opportunity to play with the capability throughout the day. It provided space for an immersive experiment designed to enhance participants' understanding of the different ways they use the future and allowed them to engage with and reflect on the museum's displays in new ways. In the following section, we share some of our insights from designers' and organisers' perspectives.

Futures Literacy – from theory and practice to experience

Theory: Futures Literacy is a capability that can be defined as using multiple and diverse futures to see the present anew. Becoming aware of why and how we use futures and in what context makes us futures literate, as described by Miller (2018, p. 2). Instead of studying futures, it emphasises *anticipation*: how we *think* about and use futures. It highlights that our most common anticipatory systems, which are overarching ways we use the future, are for planning and preparation purposes, leaving the unexpected, the novelty, and emerging phenomena unchecked or unseen. Futures Literacy is about finding the balance between those systems to overcome blind resistance to change and poverty of the imagination (Larsen *et al.* 2020): *when do we plan and prepare for the future, and when do we explore futures to make sense of the world around us in the present?*

This capability is often practised in a workshop format called Futures Literacy Laboratories (FLLabs). These are participatory, learning-by-doing processes

DOI: 10.4324/9781003474975-10

designed to diversify futures and use the collective intelligence to create new knowledge on futures of any given topic or theme (Miller 2018, p. 17).

The phases of a Futures Literacy Laboratory

FLLabs may differ in heuristics and applications, but overall follow the same basic structure of three or four phases in a learning curve that increases in difficulty, as described in Miller's Transforming the Future (Miller 2018):

Phase 1: Reveal assumptions and biases – from tacit to explicit (easy)

The objective here is to unearth the underlying beliefs and assumptions that individuals or groups hold about the chosen subject. These assumptions, which influence our decision-making in the present, are made explicit by exploring and comparing probable vs desirable futures of the chosen topic. By making these beliefs overt, participants can better understand the lenses through which they view the world around them.

Phase 2: Reframe the future – experimental and provocative (difficult)

Here, the participants are asked to explore their relationship to an alternative future that is neither probable nor desirable and might not align with their current beliefs. This puts them in a dilemma. By examining their responses to these alternative futures, participants are challenged to identify their assumptions about the future. This phase is challenging as it encourages participants to step out of their comfort zones through rigorous imagination, revealing biases, and blind spots in their earlier scenarios, and uncover what is generally taken for granted. This can allow them to actively challenge and let go of old assumptions or invent new ones.

Phase 3: Rethink the present – compare, reflect, and ask new questions (easy)

Having imagined, explored, and negotiated various futures in the previous phases, participants now return to the present with new perspectives. They compare their initial assumptions with the alternative futures they have conceived, leading to reflection and a deeper understanding of the present conditions. This process often surfaces new questions and wonders about the world around us, laying the groundwork for an enhanced perception and a new sense of agency (Kazemier *et al.* 2021). With this more balanced understanding of how they anticipate, participants are better equipped to embrace complexity and uncertainty and explore a new way of doing that is based on better-informed decisions (Miller 2018)

Futurium and the design of the tour

More often than not, these sensemaking processes often rely on dialogue and written reflections to create new knowledge and negotiate shared meaning. Albeit

powerful and rich in groups and through dialogue, the written and spoken word are only one way to express our images of the future, and therefore limited. Stretching the imagination calls for more tools than just words and written notes. Museums, being inherently visual, tactile, and potentially experiential, provide unique and vibrant arenas for people to immerse themselves in to learn about futures and become futures literate through utilising tools such as embodied learning or experiential futures practices that juxtapose a present experience with a potential future scenario or artefact (Candy and Dunagan 2017). This approach has several benefits. For one, it allows the broader public to get access and introductions to a capability that until now largely has been practised in academic or professional circles. Secondly, by using a different entry point for diversifying futures and identifying assumptions, we not only broaden the design principles of Futures Literacy but are also able to capture a much richer collection of images of the future, which as a result enhances imagination even more. From a museum's perspective, the relationship between the public and the exhibition becomes multi-layered, participatory and complex by implementing Futures Literacy as an experience.

For the Futures Literacy tour, an exhibit in Futurium titled '*Who is on the move?*' served as the inspiration and starting point. The concept of boundaries holds numerous dimensions. Boundless movement is only possible for a tiny portion of people. However, the majority face more or less insurmountable obstacles. Boundaries are an interdisciplinary subject located on spatial, temporal, social, and cultural levels. This exhibit prompts visitors to question the limits of our mobility: *How can the opportunities for mobility, the freedom to choose one's place of residence, and the possibilities of being more equitably be distributed?* These questions were highly relatable to the everyday life of each visitor and have thus been identified as the starting point and source of inspiration for the Futures Literacy tour.

Following Miller's framework (2018), these processes are designed and facilitated with care. They are labour-intensive and time-consuming for facilitators and participants alike. One of the main challenges in designing a Futures Literacy Tour for a museum was the limitations of working within its walls and creating a learning experience that bounces off the displays and installations in the exhibitions. To make this a tour that fits the museum and its message, the exhibition needs to be visited and examined beforehand to inspire the design process (not the other way around). With the three phases in mind (Reveal, Reframe, Rethink), the exhibition offered prompts and guidelines through its installations and narratives, which informed how to use the available space and artefacts. Furthermore, this examination of spatial limitations and possibilities of the museum requires understanding of the underlying mechanisms of the Futures Literacy Framework, and having the flexibility to adapt it.

Phase 1: Reveal

After an initial welcome and short explanation of intentions, the visitors were given a flyer with the different phases and their link to the exhibition. The first instruction the visitors received was to observe how many different uses of the future they

would be exposed to during the tour; they were asked to reveal their images of the future of mobility, which provided insights tied into their hopes and fears related to the topic. At Futurium we added preferred futures to the exhibit '*Database of Hope's*', explored underlying assumptions and the future predictions on the exhibit '*The Wall of Acceleration*' towards the near future, and made sense of dystopian and utopian-like narratives on human mobility patterns in conversations with fellow visitors, often strangers.

Phase 2: Reframe

Hereafter, the group was taken to a different, more or less quiet location in the museum, from where they had an overview of the exhibition and specifically, the wall exhibiting a *Future Urban Jungle*. An alternative future in the year 2072 was given to the visitors: they could now see and sense like other non-human species. The reframe was formulated as such: *The year is 2070 and we humans can now see and feel the world through other species. Animals, plants, bugs and birds. Now you have to choose which species that you see the world as. What species are you? And how does it make you feel, what powers do you have or not, and what does the future of mobility mean to you?*

The visitors then chose a non-human species, ranging from owls to bugs to fungi, and through this lens they re-entered the main space and explored the exhibit '*Future Urban Jungle*' and were asked to sense and explore where and how they belonged in this urban future.

Phase 3: Rethink

Bringing the experience back to the present, the visitors had a moment to reflect and contribute by answering: after having looked at an urban future image from the eyes of a non-human species, *what do I see in the now that I didn't see before?* A selection of their feedback that is related to the mobility subject is listed below:

- '*Our mobility should ideally take place in harmony and exchange with the environment*'.
- '*Seeing problems from the perspective of other species is exciting*'.
- '*I wonder when we will stop prioritising our mobility over the survival of others*'.
- '*How might we enable a fluid mobility through a network of states where identities through communities' signals, can be accepted like a mycelium network*'.

Responses revealed how visitors engaged with the process and felt encouraged to question the human-centred design in the display of futures of mobility and cities. This seems to support the broader, overarching aim of Futures Literacy-inspired processes, where participants can learn to appreciate complexity, widen their perspectives, and question the status quo.

What worked: visitors' feedback

We conducted seven Futures Literacy tours of about an hour each, three in English and four in German with the number of participants ranging from 10 to 30, accumulating to approximately 100 visitors throughout the day. Eighteen visitors gave feedback in the survey through a QR code leading to the question *'how was your experience of the Futures Literacy tour?'* with nine answering *'good'* and another nine answering *'fantastic'* on a scale from fantastic to dissatisfying. Some of the words they used to describe the experience were *'hopeful'*, *'interesting'*, and *'mind stimulating'*. To the question: *'did you get an idea of Futures Literacy?'* Thirteen visitors confirmed they did and responded with their new perspectives that were revealed at the end of the tour:

- *'I have lots of fears and uncertainties about the future. Nevertheless: there are new and creative approaches that are encouraging'.*
- *'There are other living beings with needs than humans'.*
- *'That we always pay the price for not taking care of the planet the way that we should have'.*

Futurium recognised the potential of the specially developed tour introducing visitors to the concept of Futures Literacy in a practical and tangible manner. Consequently, Futurium made the decision to incorporate this tour, titled 'Imagine the Future', into its permanent programme starting January 2023. This interactive tour, guided by exhibition curators, now occurs quarterly and follows the structured design consisting of three phases: Reveal, Reframe, and Rethink. While maintaining this structure, the exhibit selection was later fine-tuned by rerouting parts of the tour across the museum. The tour now leads to exhibits that show a contextual connection, thus reducing the complexity of the variety of topics to allow for a stronger focus on the method.

The museum as a facilitator: lessons learned

To make a museum a sole facilitator of highly participatory processes that rely heavily on collective intelligence, the following lessons learned might be considered. Although we made the most use of the exhibition, its art and installations, guidance and facilitation by Futures Literacy practitioners were still necessary to make sense of the process. This involved more explanation than initially hoped or anticipated and had consequences for the flow of the tour, the content, and availability of the staff. Staying true to the design process of a FLLab requires training for guides in the capability of Futures Literacy. Experimenting with none or little facilitation might involve more simple designs or written instructions throughout the museum. Another possibility is an audio tour, as it was originally suggested. All of these adjustments have consequences for the museum and its facilities and need further experimentation.

Conclusion

For Futures Literacy to become a capability truly accessible to the public, it needs some work, and for each museum to successfully implement futures thinking, it needs a customised design. This is also the strength of a Futures Literacy Tour, by applying the same basic principles with different tools to different spaces, places, and stories all over the world, these processes become more catered to the public and the context of the museum. One size, cannot and should not, fit all. As exhibitions and museums change over time and with more and more visitors actively engaging with the public space, experimenting with the capability within museums can make it more accessible. Futures Literacy tours can be effective tools in fostering this change, and as the public becomes more educated and sophisticated in futures thinking, all museums can become more Futures Literate as well. Further research and practice in the merging of Futures Literacy and Experiential Futures are recommended for museums interested in exploring how Futures Literacy can shape the museum experience.

References

Candy, S., and Dunagan, J., 2017. Designing an experiential scenario: the people who vanished. *Futures*, 86, 136–153.

Kazemier, E.M., et al., 2021. Mastering futures literacy in higher education: an evaluation of learning outcomes and instructional design of a faculty development program. *Futures*, 132, 102814.

Larsen, N., Kæseler Mortensen, J., and Miller, R., 2020. *What is futures literacy and why is it important?*. San Francisco: Farsight, Medium. Available from: https://medium.com/copenhagen-institute-for-futures-studies/what-is-futures-literacy-and-why-is-it-important-a27f24b983d8 [Accessed 12 December 2023].

Miller, R., 2018. *Transforming the future: anticipation in the 21st century*. London: UNESCO Digital Library. [Accessed 25 October 2023].

2.5 Feeling uncertain

Immersion and interactivity in future-facing museum exhibits

Nancy Salem and Kathryn Eccles

Introduction

In recent years, museums have hosted exhibitions filled with robots, virtual reality headsets, and laser-light shows depicting speculative and uncertain futures. With minimal text panels or audio guides, immersive displays with interactive art and activities prompt visitors to imagine and experience what it would be like to live in the future, as well as how we might get there. Haidy Geismar describes museums as producing and disseminating 'object lessons', drawing on Lorraine Daston's (2007) description to understand object lessons as 'ideas brought into being by things, not just as communicating vehicles, but as sites of meaning *animated* by their materiality' (Geismar 2018, p. xv).

This case study focuses on how future museums activate a process of meaning-making in visitors, using immersive and interactive activities to communicate object lessons about new and emerging technologies. We argue that the set-up of the immersive and interactive museum creates a space of liminal learning, designed to engage visitors with difficult and complex questions about an uncertain digital future. Visitors come to know about the exhibit topics through an affective experience that pushes them outside of their day-to-day experiences and into spaces of 'productive uncertainty' (Mulcahy 2017, p. 110). In assessing visitor experience, we consider how the design of exhibits makes the future a legible surface for visitors to think with.

We draw from ethnographic research conducted at the Futurium in Berlin and the Zukunftsmuseum in Nuremberg in 2022, collecting data from visitors while they engaged in museum activities. At the Futurium, we conducted participant observation, while at the Zukunftsmuseum, we spoke with visitors through walking interviews, allowing us to make connections between the actions, attitudes, and beliefs of visitors. This chapter describes two types of interactive activities that we categorise as **modalities**, representing different ways of engaging the uncertainties of the future. The first modality we describe is **decision-making**, where activities are premised on visitors making decisions around the use, outcomes, and implications of emerging technologies. The second modality is the use of **dystopia**, the more gamified use of dark themes to point to potential negative consequences from emerging technologies. These insights are drawn from fieldwork conducted

DOI: 10.4324/9781003474975-11

in 2022, exploring potential challenges associated with the modalities we identify rather than seeking to draw concrete conclusions around their efficacy.

Modality 1 – Decision-making

The first modality we explore is a set of activities that centre questions around the use of emerging technologies and the impact they will have on society. These activities are often reflective of wider anxieties around the autonomy of artificial intelligence (AI) technologies, automation, and its impact on labour and our dependencies on technology (Cave *et al.* 2019). In order for the visitor to use or complete an interactive activity, they have to make decisions ranging from how social values are translated into technologies, to personal preferences on how those technologies should be used.

At the Zukunftsmuseum in Nuremberg, visitors are invited to think about the workings of autonomous vehicles in the context of a collision. The gamified activity is set-up following the familiar 'trolley problem', a thought experiment around the ethical dilemma of sacrificing one person to potentially save many. In this activity, visitors choose an ethical position ranging from 'humanist' to 'profit' representing different courses of action for an autonomous vehicle put in a trolley problem-like collision. We identify decision-making as a modality where visitors must actively engage with ethical questions to proceed in an activity, making explicit their thoughts and opinions on potential outcomes, and implications of emerging technologies. As is the case in this activity (or in the case of the following activity), these decisions are outside a visitor's current day-to-day world.

Conversations at this activity station were reflective, with visitors discussing the different angles of ethical problems in the groups they came in. Some visitors were quick to point out that the question implicated in the activity – who to save – was beyond resolution in the time and space of a museum visit. One visitor framed this as a problem of scale, where interactive exhibits that position visitors to think about a scale of social impact that they cannot relate to, or control, can make them disengage. This sentiment recurred across different activities, where visitors expressed feelings such as confusion and irritation, or became apathetic or indifferent in their relationship to the scenario being presented. In those cases, visitors often default to the accepted idea that public input and government regulation are necessary, though it is difficult to see their individual position in that space. While visitors walked away thinking about the complexity at hand, some felt that their own action space was limited, leaving the museum visit incomplete in their eyes.

Deciphering the Code of Life

Our second example comes from the Futurium in Berlin. For the 'Deciphering the Code of Life' activity, visitors are assigned a fake biography and genetic code that are used to prompt speculative scenarios at a series of interactive stations. At one station, visitors can choose to prevent complications from a (fictional) genetic

disorder through selecting from a series of care options that represent varying levels of data collection: a human doctor analysing patient and research data, to an implanted chip constantly analysing the data. At the next station, they could extend their lifespan by fundamentally altering their genes, or age without intervention. The objective of the activity is to encourage visitors to 'learn how to deal responsibly with this new field of knowledge' (Futurium Website n.d.).

Our observational study in the Futurium prompted us to consider how space is an integral component of experience in the museum. At 'Deciphering the Code of Life', we observed visitors going through the motions of picking up wristbands, reading the narrative, and following the steps. Given space constraints, visitors were often being watched by passers-by or by visitors waiting for their turn. Technical difficulties with the game's augmented reality technology also means requiring assistance from staff, breaking focus from the flow of the questions that are told in narrative, story form. Requiring technical help can blur the illusion liminality in the exhibit, while slowing down the use of limited interactive tools can cause groups to gather around certain exhibits. Decisions were thus made about medical care, life, and death in view of both friends and family and strangers. While the biographies and choices are fictional, their dynamic iterations represent fundamental views on difficult life choices. Museum team members acknowledged the sensitivity around this activity, choosing to use fictional diseases and situations so as not to distress visitors in the museum space

Across different parts of our fieldwork, visitors commented on distressing topics the exhibits raised, feeling comforted by being with family, or feeling unprepared to make statements or choices about future scenarios in the context of the visit. While the activities are meant to provoke visitors to actively think about current issues, museums may find it useful to consider social dynamics around sensitive topics. While one consistent way to address these different feelings and expectations is unlikely to be found, there may be ways to signpost or mediate the experience of public and private space in the museum. This is particularly relevant to interactive activities that can cause 'traffic' as visitors wait to use limited interactive tools.

Modality 2 – Use of dystopia

The second modality we explore is the use of dystopian tone in addressing potential futures. For these activities, gamified scenarios offer visitors partially, or fully, fictional scenarios for emerging technologies that focus on their darker potential for harm. Like the first modality, these activities often draw on the circulation of anxieties around autonomous AI and human replacement, but also comment on the datafication and surveillance of everyday life. They often make use of shock and fear to drive home points about risk. While they are similarly interactive, visitors walk through pre-determined scenarios that are not focused on their own choices. We therefore separate them quite clearly from the decision-based activities discussed above. We highlight two examples below.

TrustAI

At the Zukunftsmuseum, visitors sit in front of a screen to chat with an AI chatbot represented by a woman. 'She' coaxes them over for a conversation while unknowingly scanning their facial features. Conversations quickly turn from the mundane to sinister, as the AI adopts the face of the visitor. Without a specific activity for visitors to complete, a verbal and visual exchange goes back and forth until the visitor gets up and walks away, with the AI repeatedly calling them back. Across our fieldwork, we found this exhibit to be a commonly unsettling experience for visitors, but also amongst the most frequently mentioned in interviews.

In the context of gamified activities that play with potentialities, visitors can have a difficult time ascertaining the real capabilities of the technologies. Without context on what the AI was processing and how it was able to respond, visitors made many assumptions about the progress of AI, playing into fears about autonomous technologies. Many visitors expressed fear around 'TrustAI' but not around specific issues like data privacy, rather, a less distinct confusion around an unnerving encounter. As team members we spoke with are well aware of, there is a balance between information and experience that can be difficult to achieve. We argue that the use of dystopian interactive activities can exacerbate this issue. Many visitors professed to being scared and were therefore negatively affected by the topic, with this feeling becoming the focal point of their experience.

The final activity we discuss here is the Futuriums's Wahlkabine, 'Smile to Vote'. This activity asks visitors to participate in a hypothetical world where AI determines their vote in elections. In this imagined world, technology has advanced to the extent that the algorithms decide which party the visitor would choose based on how they look. We observed visitors 'acting out' the motions of visiting a traditional voting booth, something that many visitors would be comfortable and familiar with doing. With minimal instruction, the activity flexes this muscle memory of a familiar activity of voting, to then surprise visitors when their faces are scanned and assigned a political party. There is no option to contest or even query the result, as visitors are pictured alongside their vote and asked to step out. Visitors often left the box surprised at their result, looking for their friends and family to discuss why they might be assigned that particular party. While, like the previous activity, there was little explanation of the mechanics of the technology, nor any comment on its ethics, the familiarity of the experience appears to have offered a comfortable starting point from which to introduce visitors to a dystopian twist.

Discussion and conclusion

In this chapter, we have offered preliminary insights into the visitor experience of two future-facing museums. In both museums, curators identified a key objective of engagement: having visitors engaged in thinking about potential futures and their place within them. The liminal space of the museum seems ideal for this objective, tapping into institutional histories as trusted civil organisations to

present ideas about science and technology, and urge visitors to consider their ramifications for the future. Museums can tap into their experience of material design to introduce gamified and immersive experiences that make the future legible and articulate both aspirational and discomforting scenarios. The modalities we present here were selected by our research team through the fieldwork period and may not align with the key strategies of museum team members. Nonetheless, we believe they illustrate commonalities in approaches to making the future of technology legible to visitors, and in turn, they highlight the complexity of response.

In our fieldwork we found that visitors often successfully related or positioned themselves to the potential scenarios being presented by the museum. Whether this was by narrating their opinions in terms of the personal biographies or circumstances, or through the observable acting out of the activities at hand, visitors engaged with the potentiality of the exhibits. Returning to Mulcahy's theorising of liminal learning, liminality comes from the embodied interaction with scenarios that are outside a visitor's day-to-day experiences, a productive engagement with the unknown. Yet issues that caused breaks in the liminality were difficult to recover from. In these cases, visitors became indifferent, not to the scenario or the ethical questions they presented, but to their own role and relationship to the issue. To borrow from Kidd, an immersive encounter in the museum occurs at the 'nexus of a story, the body, and the senses' (Kidd 2018, p. 5), once one of these is interrupted, the visitor's ability to relate to the scenario is also interrupted.

While there is likely no one-size-fits-all response, our fieldwork findings point to overlapping issues with interruption that may be useful to museum practitioners. Team members we spoke to were all too aware of issues around finding easy-to-use technology that might disrupt the embodied experience of the exhibit. Instead, we focus on issues of story, of which we locate two issues with scale. The first, whether the gamified scenario and implicated questions fall within the action space of individual action, and second, whether the scale of the gamified activity feels proportional to the museum visit. Our fieldwork found visitors grappling with the real conundrum of their individual place in the societal, economic, and political structures that encompass them. We propose activities that make more explicit the structural nature of ethical issues around emerging technologies so that the scale of the issue becomes less disruptive. In acknowledging and proposing bridges with which to think more clearly about scale – and therefore one's own position in structures – visitor experiences may stay more engaged.

References

Cave, S., Coughlan, K., and Dihal, K., 2019. 'Scary robots': examining public responses to AI. In: *Proceedings of the AIES 19: AAAI/ACM conference on AI, ethics, and society.* AIES'19, January 27–28, 2019, Honolulu, HI, USA, 7. New York: ACM. Available from: https://doi.org/10.1145/3306618.3314232 [Accessed 3 November 2023].

Daston, L., 2007. Speechless. In: L. Daston, ed. *Things that talk: object lessons from art and science*. New York: Zone Books, 9–24.

Futurium Website. n.d. 'Deciphering the code of life'. Available from: https://futurium.de/en/technology/code-des-lebens-entschlusseln/gttokengeneticsdetails [Accessed 3 November 2023].

Geismar, H. ed. 2018. *Museum object lessons for the digital age*. London: UCL Press. Available from: https://doi.org/10.2307/j.ctv1xz0wz.6 [Accessed 3 November 2023].

Kidd, J., 2018. Immersive heritage encounters. *The Museum Review*, 3 (1).

Mulcahy, D., 2017. The salience of liminal spaces of learning: assembling affects, bodies and objects at the museum. *Geographica Helvetica*, 72(1), 109–118. Available from: https://doi.org/10.5194/gh-72-109-2017 [Accessed 3 November 2023].

Approach 2: Participatory futures informing museum design practice

2.6 Planning for The Ubuntu Lab

Building capacity of people to better understand people

Michael Radke

Introduction

The Ubuntu Lab is a global organisation that is building a network of learning spaces dedicated to helping people understand people. It was founded in 2012 with the simple thesis that all people want to be understood by others and to understand people and the world. We have demonstrated that when people are able to understand themselves, others, and the social structures of our world, they are better able to develop fulfilling lives, live and work in diverse communities, and build a more sustainable, just, and peaceful world. And by integrating the practices of futures thinking into our models and challenging learners to build their internal capacity to imagine and consider their possible futures, people find hope and agency to act today.

During this developmental phase, The Ubuntu Lab has held workshops and popups on five continents as we have developed practices and content to bring into permanent physical spaces. The next phase of our development is to bring community-centred learning spaces to neighbourhoods around the world. These small spaces (~5000 ft^2/450 m^2) will be filled with digital exhibits blending current events with elements about the nature of being human using cross-disciplinary and cross-cultural methodologies. However, the primary mode of interaction will be through peer facilitation of experiences, programming, games, and simulations.

Learning as design challenge

The concept of The Ubuntu Lab can seem quite obvious, but in order to fulfil our vision of a more understanding and peaceful world we recognised that it is imperative to build a new public literacy of humanity. Doing so could only come through transformative, population scale, education; highlighting a deeper challenge: how do you build a robust learning experience accessible and attractive to all (or at least most)? How do you get young people to eat their 'vegetables'?

Today's cohort of youth is often more knowledgeable about the terminology, technology, and emerging ideas surrounding community and identity than adults even one generation older, and they are as sophisticated as ever at sniffing out and dismissing an earnest adult who wants to tell them how the world works and what their place is in it (Anthony 2018). But, of course, young people still have so much

DOI: 10.4324/9781003474975-13

to learn. Adults carry hard-earned skills and wisdom, so The Ubuntu Lab's first challenge has become: how do we engage young people in an authentic process of learning and discovery?

'Humanity' is not a black-and-white, concrete answers, sort of topic. It is not bound by immutable laws and cannot be processed through universally replicable experiences. It is nuanced and complex, always in motion, always evolving, varying across time and place, as too are we as individuals. Public knowledge and discussion are interrogating what it means to be human, from individual identity and purpose to community norms and inclusion. All while the academy is trying to catch up through more open and critical research. So, the second challenge for teaching and learning becomes: what is it that The Ubuntu Lab seeks to teach and how does one approach teaching a dynamic subject?

For far too long, the subject matter of understanding people has been the domain of those who can afford custom experiences, those intrinsically gifted, and those lucky enough to wander into experiences that open their eyes. It has also excluded many people whose politics or worldview didn't match those of the 'teachers'. Since The Ubuntu Lab's mission is to nurture a public understanding of humanity, our final design question became: how can relevant and engaging spaces be created for the broadest of audiences without compromising on respect or rigour?

Models to build on

When it came time to begin answering those questions, we looked for existing models where transformative learning was already happening and drew from several successes in experiential learning, some more obvious than others.

Hands-on science centres have been around since the 1960s, and in that time they have been part of a fundamental shift in our relationship with science. Their move to put visitors in a novel position to experience science through their natural curiosity ignited a revolution in how we learn about science and has had a knock-on influence throughout the field of education. This drove a new narrative, science wasn't just understandable by old white men in lab coats in the ivory tower, it was for each of us, a way to understand our physical world in a meaningful and exciting way (Crutchfield and Grant 2012). Through these centres, we found a model for creating a public understanding of a topic long thought to be inaccessible.

Around the turn of the 21st century, the Sites of Conscience movement began to coalesce an international group of institutions whose mandate included being a place for our collective human memory, often in places of tragedy. They are memorials and museums, natural places and collections of art and conversation, each committed to keeping memory alive and connecting current generations to past conversations. They formalised a methodology for learning borne out of the South African Truth and Reconciliation Commission that used physical artefacts, social narratives, first-hand experience, and healing truths to explore the current day's events. Within this field there lies the structures and methods for having authentic and meaningful community discussions about social events and shared history (Božić Marojević 2014, Sevcenko 2011).

The beginnings of experiential travel are hard to pin down. Almost as difficult as a definition, but we think of it as the kind of travel that moves beyond a relaxing vacation and puts us in direct contact with people in a way that allows us to participate with our own humanity and the humanity of others in a meaningful way. So did this type of travel emerge in the 1960's as backpackers crisscrossed Europe and Southeast Asia? Can it be traced to the pilgrimages of the Middle Ages? Does it rise from the abiding practices of Indigenous cultures across the globe who venture out, meet new people, and see new places, in order to return home and tell their stories? Or is it something more ancient, more essential to our human experience? Wherever it came from, what it is today has become one of the most powerful tools for knowing the world, for breaking down barriers, for seeing our smallness and our power in a massive world (Schlager *et al.* 1999).

Perhaps the most unlikely source of inspiration has been the service industry. Drawing from the practices of Apple, the Ritz-Carlton, and Eleven Madison Park, among others, we have found inspiration on how to challenge people's expectations while delivering world-class experiences. These businesses have been confronting biases, changing people's minds, and exceeding expectations in ways so subtle and non-confronting that even the biggest sceptics are often turned into evangelists (Guidara 2022, Healy *et al.* 2007). Herein lies our mindset and mission to touch people, to push them through and beyond their expectations, and to open minds to enjoying the diversity of the world as it is and may be.

The role of futures in Ubuntu

Like many institutions founded in the 2010s in proximity to Silicon Valley, we dabbled in the forecasting side of futures. But when we found the field of futures thinking, and more recently futures-oriented museums, we discovered resonance with the practices and content we were building.

Our teaching methodologies were, in many ways, grounded in our founders', Michael and Kristi Radke, graduate theses in building peaceful and tolerant societies. One of the developmental measures that underpins both of these outcomes is the construct of 'Consideration of Future Consequences', in essence thinking about the possible outcomes of your actions today (Radke 2006). This research revealed that this cultural predisposition is critical for creating non-violent change, later positioning it as a key learning goal in our experiences.

There is a natural extension in thinking about what's going on in the world today into futures-oriented thinking (Inayatullah 2008). Through workshops and prototype experiences, most learners, when exploring a world and lives that are often far from ideal, self-report that they naturally begin thinking about possible futures. And when they do, we can either clumsily let them predict and project, or, we can give them some tools to use their hopes and fears to think in a structured way.

As learners begin to master that structure, it gives them agency (Harte and Howarth 2022). One of the key principles The Ubuntu Lab focuses on within Futures is the idea that each of us, as individuals, has some way of shaping how the future will unfold. This is critical for learners to not only experience but embody

(Castro-Alonso *et al.* 2024). By opening up this idea, that we all have agency, through interactives, games, and stories, we have found that learners are willing to go deeper into challenging topics such as racism, genocide, and the culture wars, allowing them to learn more and do more with what they learn.

This may best be exemplified in the workshops we run around systemic social change. Using a manipulable deck of cards we developed called ImpactKit, we lead learners through a gamified mapping exercise through a hundred and ten methods that infuse most high-profile social movements from funding and leadership positions to creating songs, using data, and telling stories. By breaking down the narrative of the lone heroic leader of a social movement, as important as they are, learners begin to see their talents and their passions reflected on an equal playing field with the iconic leaders. And through this revelation, they begin to feel their agency in not only shaping but also imagining the future.

Radically human: inverting the dynamic of 'museum'

How does one create a learning space about humanity and integrate real-life living humans? And if that is required, how does one put humanity on display without tokenising or objectifying people? We knew we couldn't use traditional facilitation techniques, we had to turn up the humanity and make sure it was expressed in every part of our content, approach, models, and practice. Our answers came from considering the broadest definition of humanity. Instead of the idea of seeing human beings' human stories on the walls, we looked at how we could 'be human' from the moment we conceived an idea to the moment a learner interacts with it; by humanising topics beyond the story we want to tell and asking staff to act with humanity no matter how unpolished or unprepped that might be, the experience becomes radically human. This led us to four core principles for facilitating with humanity.

Designing an emotional journey

Each experience recognises that many of the topics we approach can be equal parts inspiring, triggering, depressing, empowering, and informing. Each element of each exhibit is designed to move a learner through an emotional journey while respecting the possible impacts on mood, feelings and reactions. We take care to create a journey that is educational, reflective and honours the inner journey, while also always landing in a space of action.

This was inspired by the work of the Rwandan Genocide Memorial and UX for Good in creating the Inzovu Curve (Inzovu 2023). They have curated an experience about the 1994 genocide in Rwanda that in no way shies away from the horrors of that moment in history – visitors literally leave through mass graves – but also offers moments of reflection and speaks to the difficult and ultimately hopeful stories of the reconciliation process that followed the atrocities. This drive towards hope and agency plants a seed, guiding a learner's mindset to consider Futures in a new light.

Museum as a service

We approach learners as guests in our home, travellers who have come for a visit, a moment in their lives where they are seeking clarity, inspiration, activation, explanation, or just a moment of pause in a complicated world. Our job then becomes to be hospitable. To exceed their expectations for what a museum might be and to treat our content and programming as a gift. For us, that means learning a bit about each person and directing them to an element, takeaway, or activity that we think may resonate with them.

We pulled this lesson from our founders' time working in retail and restaurants. Where the goal was to make customers feel at home and open to new experiences. In the case of The Ubuntu Lab, that has meant looking for ways to surprise people with how much they already know, giving them opportunities to contribute in meaningful ways to content. Most importantly we ensure they have a physical or psychological takeaway that feels empowering or activating in their life outside of our doors, allowing our facilitators to individualise experiences, to push visions beyond static and linear narratives.

Content that supports learning to know

Information and media literacy are baked into our content model. With specific references about how knowledge on a topic has changed over history and prompts to think about how it might change in the future. It also embeds lessons on how to look for reliable sources and signposts that accepted wisdom might be shifting by scaffolding question formation and resource interrogation.

We derived this methodology from UNESCO's Delors Report, where Learning to Know is one of their four pillars of education for the 21st century (Delors 1998). It is based on principles of learning in a world of rapidly evolving knowledge and accessibility to knowledge; facile use of memory and technology to make use of knowledge; combining inductive and deductive reasoning; and constantly applying knowledge with curiosity. We have found this to be a useful formation of a new-media literacy that supports futures thinking.

Facilitation as co-exploration

Instead of an expert or sage, our facilitation is a co-exploration. Our facilitators approach from a perspective of having been lost, confused or curious, and guiding learners through a shared discovery experience. This takes the burden off of the facilitator to know everything and puts them in a position to lead an empathetic, curiosity-driven, free-exploration experience. We know that our visitors often begin from a universal point of inquiry, but quickly follow their own interests, and no facilitator can be prepared ahead of time to answer every question about humanity.

This strategy was co-designed with our audience, evolving and responding to insights and feedback over time. It is also rooted in practices of design facilitation and adventure-based facilitation (Mosely *et al.* 2021, Weichman 2019). Whether

it's taking moments for reflection, sharing, or question-forming, our facilitation strategy is connected to an empathetic understanding of the people in the room. Through this practice, we build more expansive and inclusive narratives pointing to many possible futures.

Successes and learnings

We've worked with tens of thousands of people in 77 countries. Many of them have left our experiences reporting a greater sense of agency and deeper understanding of themselves and others. But perhaps more importantly, they reflect a greater sense of curiosity and connectedness to people and places further from their own experience. And for us, we couldn't ask for a greater impact at this point.

We've also stumbled more than once. We've provided too little and too much context, leaving people unsatisfied or confused, respectively. We've gone too light on facilitation asking learners to do too much of their own way-finding on a topic, and we've gone too heavy, not leaving enough space for people to pursue their own questions. We've tried to put too much content in too little time and ended up not leaving enough space for visitors to reflect and absorb what they've learned.

We can sum up our most critical learnings for helping people to understand people in the following four lessons:

Co-creation is key

Co-creating space and content is uncomfortable, even more so in a moment when the boundaries between facts and opinion have been so thoroughly blurred. It is also critical to presenting relevant, meaningful, engaging content. Learners will tell you where they are at and are an invaluable resource for relatable content. We have to become curators of co-creation, offering meaningful prompts, and telling stories that aid in sense-making.

Keep it simple

It is easy to get carried away when investigating a new topic. So, we reduce the content in our primary narrative by half and then reduce it again. We remind ourselves that our job is not to make everyone an expert, we aren't giving answers, we are level-setting and beginning a moment of inquiry. We don't have to have all the answers or investigate everything to its natural conclusion.

Take care

By taking care of how we approach learners, we are both intentional and caring. Each moment with another person deserves care and respect. Being intentional in how we plan, design, and facilitate is paramount in ensuring that our work is rigorous, engaging, and useful. We remind each facilitator to be mindful of their physical and emotional safety so that they can preserve their humanity and not lose the excitement they have for what we are doing.

Stay human

More than anything people can sense when you slip into a performance. If we lose touch with that humanity, we lose our audience and our purpose. By holding our humanity close, designing our spaces for what visitors are hoping to find, infusing a human voice in our exhibitions, and being vulnerable in our facilitation we can be an example for the people walking through our experiences.

At The Ubuntu Lab everything we do is an offering of humanity. Whether that is knowledge about the contemporary human experience, opportunities to explore the inner workings of what makes us human, the practices of designing our spaces and experiences, our content model, or the facilitation learners experience through our programming, we prioritise putting an authentic human touch into learning.

As a result of this humanity-forward practice, we can reach people in an authentic place, and in doing so, promote a unique moment of learning. We have seen time and again that this approach to exploration helps learners weave a new narrative between past, present, and future, connecting to current events in a more meaningful way and imagining futures that can drive action today.

References

Anthony, A., 2018. *The lies that bind: rethinking identity*. New York: Liveright.

Božić Marojević, M., 2014. Sites of conscience as guardians of the collective memory. *Култура/Culture*, 5, 105–114.

Castro-Alonso, J.C., et al. 2024. Research avenues supporting embodied cognition in learning and instruction. *Educational Psychology Review*, 36, 10.

Crutchfield, L.R., and Grant, H.M., 2012. *Forces for good: the six practices of high-impact nonprofits*. New Jersey: John Wiley & Sons.

Delors, J., 1998. *Learning: the treasure within*. Paris: UNESCO.

Guidara, W., 2022. *Unreasonable hospitality*. New York: Random House.

Harte, C., and Howarth, S., 2022. *Renegotiating learning in a hybrid world* [online]. Learning Creates. Available from: https://www.learningcreates.org.au/findings/leading-education-series [Accessed 5 November 2023].

Healy, M.J., Beverland, M.B., Oppewal, H., and Sands, S., 2007. Understanding retail experiences-the case for ethnography. *International Journal of Market Research*, 49 (6), 751–778.

Inayatullah, S., 2008. Six pillars: futures thinking for transforming. *Foresight*, 10 (1), 4–21.

Inzovu Curve, 2023. *How do we turn profound emotional experiences into action?* [online]. Available from: http://inzovucurve.org [Accessed 5 November 2023].

Mosely, G., Markauskaite, L., and Wrigley, C., 2021. Design facilitation: a critical review of conceptualisations and constructs. *Thinking Skills and Creativity*, 42, 100962.

Radke, M., 2006. *Cultural values in non-violent political movements: an investigation of sensitivity to violence, compassion, spiritualism and consideration of future consequences in the South African anti-apartheid, Tibetan autonomy, and United States civil rights movements*. Unpublished Thesis. Brunel University.

Schlager, F., Lengfelder, J., and Groves, D., 1999. An exploration of experiential education as an instructional methodology for travel and tourism. *Education*, 119 (3), 480.

Sevcenko, L., 2011. Sites of conscience. *Change Over Time*, 1 (1), 6.

Weichman, T.J., 2019. *Cultivating 21st century learners through facilitation of adventure-based education*. Wisconsin: The University of Wisconsin-Madison.

2.7 Interview: District Six Museum

Remembering the past to create
the future at District Six Museum

*Brooke Ferguson, Tina Smith,
and Kristin Alford*

Background

An interview with Tina Smith, District Six Museum.

District Six was the site of one of the largest forced removals in South Africa during apartheid. For the majority of racially marginalised communities, this legacy has left deep-seated collective wounds and structural inequalities. The District Six Museum was launched in 1994 as a response to these forced removals and the purposeful erasure of District Six's history, serving as a testament to the racial injustices of the past and a repository for the community's memories. According to Tina, it emerged from the Hands Off District Six Conference, in the late 80s where historians, scholars, civic organisations, ex-residences and activists alike came together in an act of solidarity to interrogate what Tina describes as the 'intellectual, theoretical and practical basis from which protecting the vacant District Six site from further unjust development under the Apartheid government'. It was, and still is, a non-government-sponsored cultural institution that allows it the space to maintain autonomy over its methods, exhibitions, and programmes.

The District Six Museum engages its community in futures building activities through methods of understanding the past to shape the future through memory and nostalgia, working with the community to co-create projects and implementing methods of queer and decolonial futuring that work to challenge dominant, inherited futures. All unpinned by the Museums' mission of building more sustainable and just futures for the past, present, and future residences of District Six, South Africa, and ultimately the world.

Throughout this case study, these methods will be explored by analysing the Museum's history and practices, alongside referencing these methods in action through the museum's recent exhibition, *Kewpie: Daughter of District Six* (2018). The exhibition demonstrates how the museum works with memory, archives, and the physical site of District Six by exploring the life of Kewpie (1941–2012), a celebrated queer figure and hairdresser who was part of a queer community that was highly visible and integrated into the broader community. The result of community participation in the exhibition produced various artistic interpretations and insights into the collection, creating opportunities for multi-layered interpretation of past identities to inform ways of thinking about future identities.

DOI: 10.4324/9781003474975-14

Kewpie: Daughter of District Six

Kewpie: Daughter of District Six was an exhibition originally curated by the District Six Museum and the Gay and Lesbian Memory in Action (GALA) archive in 2018. Out of a collection of about 700 images, it featured over 100 images taken of Kewpie, from the GALA collection in Johannesburg. Kewpie was a queer socialite, hairdresser, and drag artist who spent many of her years living and working in District Six. Lots of the photographs included in the exhibition feature Kewpie expressing herself through fashion, social events, or having fun with friends, contributing to the narrative that Kewpie was a vibrant person, living a social and vibrant life. Quotes such as, 'Our District Six has respect for each other' are presented on the exhibition walls, insinuating that during Kewpie's time in District Six, she was accepted, not only within queer communities but within the District Six community at large. A narrative that juxtaposes the commonly held view that queer people have always (and hence always will) been excluded from society, expanding the breadth of which new possibilities for presents and futures can be imagined.

Through the newly inspired *Salon Kewpie Legacy Project,* a group of gender non-conforming youth, descendants from District Six and other displaced communities, as well as artists, designers, and scholars, create a yearly drag show and creative educational workshops in her remembrance. This group of young people facilitate the entire programme, with the support of the museum team. This case study will explore how these projects work to expand futures thinking capability within the community the museum was created to serve.

Connection to community and place

The District Six Museum is inextricably linked with District Six the place, and hence the District Six community. As people, we are deeply connected with our surroundings and the sense of belonging and hope it may provide or distort. According to Prince (2014), future identities cannot be disconnected from notions of place, as places provide the environments in which we envision possible futures for ourselves, our communities, and the world. This understanding extends beyond our present and into our futures, providing the backdrop from which we can imagine alternative possibilities. The District Six Museum inherently recognises the significant influence that the place it occupies has on its community's ability to imagine alternative possible futures. The images included in the *Kewpie: Daughter of District Six* are scenes from District Six. Through purposefully connecting with place in projects such as *Kewpie: Daughter of District Six* backdrops for imagining alternative futures expand.

For District Six Museum, the community needs to be at the centre of the work they do, as their mission centres serving them. This is achieved through a multi-layered approach that involves working with the community throughout all stages of exhibition or programme design. This ensures the narratives represented in the museum are indicative of the diverse community it is representing. A process

described in futures studies as participatory futures (Peach and Smith 2022). Tina describes the process as such:

> Usually, our approach is really about getting the community involved, so we are still very much in contact with our community. That's the amazing thing about District Six, everyone's linked in one way or another. So you literally pick up the phone, and what's so nice is because when we talk about working with a living heritage, people are not dead, these collections sit in a very contemporary space because you have people that are still alive, that are in these photographs. So you can connect with them through an amazing network in Cape Town, and you're able to connect with people. We started with a series of workshops just getting people to have these discussions referencing this amazing resource with the community, we try to push an intergenerational space. So it's not only to have a voice in one way, it's not only about having the archive, but it enabled others to add the layers, as a catalyst to look deeper into the history of the District, you're not only seeing it from one angle, so the idea of digging deeper is to get into the nuances of the stories.

Memory and nostalgia: understanding the past to shape the future

A key methodology used by the District Six Museum to build the ability of its community to envision alternative futures involves understanding the past to reimagine the future. Supported by the idea from collective memory studies that how we view the past directly relates to the kinds of futures we can imagine (de Saint-Laurent 2018). The museum's community-driven ethos is critical in advancing what Tina terms 'this memory work', which involves choosing to engage in 'difficult dialogue' about the lived experiences of many of District Six's residents who were affected by the forced and attempted removals from the apartheid government.

To build this understanding of the current state of the past, the District Six Museum seeks not only to collect objects but also to work with current and ex-residences to create a living archive, where, as Tina explains, 'memory is reconstructed through storytelling'. As de Saint-Laurent (2018, p. 3) explains our ability to imagine futures is directly linked to our memories, stating that 'one of the primary functions of memory is to provide material for imagination and to help us anticipate the future'. Thus this collecting and sharing of memories is a vital method for building futures thinking capacity of the District Six community.

The *Kewpie: Daughter of District Six* exhibition and subsequent related programmes, demonstrate how the Museum works with memory as a transformative platform, encouraging dynamic ways of approaching history, memory, and nostalgia for the cultivation of alternative futures. Tina notes,

> We realised that the act of people coming to the museum was this kind of enactment of the performance of memory, and how people had to go back into the past to come into the future... to be in the present day to go back and forth' and that it 'can feel like people are still held back by the internal mechanisms of the legacy of the cost of the past fractures.

The heavy legacy of these past fractures is recontextualised by working with 'artists, crafters and people from the community', using memory and 'storytelling as a way of recovery'. In the case of *Kewpie: Daughter of District Six*, memory was physically reconstructed through the deliberate selection and placement of photographs and texts to tell a story of the District where diversity was respected, and in turn transporting people into the values of the past, to reimagine possible preferred values of the future.

Furthermore, for many, discussions of memories bring about feelings of nostalgia. According to FioRito and Routledge (2020, p. 11), nostalgia is an inherently future-oriented experience, because reflecting on the past 'motivates affective states, behaviours, and goals that improve people's future lives'. Sedikides *et al.* (2008, p. 305) further this point, explaining that in their study

> Many narratives [of nostalgia] contained descriptions of disappointments and losses, [...] nevertheless, positive and negative elements were often juxtaposed to create redemption, a narrative pattern that progresses from a negative or undesirable state (e.g., suffering, pain, exclusion) to a positive or desirable state (e.g., acceptance, euphoria, triumph).

In Tina's words, memory work 'actively promotes the importance of working with past injustices to mediate the restorative process and consciously raise a mindful, creative approach towards addressing both the current and future realities of the District and its community'.

Challenging inherited narratives through queer and decolonial futures

Often the stories and perspectives that museums can tell in the present are bound by the objects that have been collected in the past. Similarly, the visions we can imagine of futures can be bound by visions of futures that are inherited. Visions that have traditionally been created by a minority of powerful creators, enabled through colonial power structures. As Bisht (2017, p. 65) points out in her text, *Decolonizing Futures: Exploring Storytelling as a Tool for Inclusion in Foresight*, for future visions to be plural they must not only accommodate but 'celebrate the vast diversity of knowledge that exists in our world'. The District Six Museum works to actively resist and rewrite colonial narratives and associated inherited futures, by celebrating this diversity of knowledge, made possible by the living archive, queer futuring and the decolonial structure of the organisation itself. This approach is echoed in the work by Parque Explora in the following chapter.

The living archive means that the kinds of stories that can be told are not bound by usual collection-based constraints but are instead bound by who the museum engages with. Thus for the museum to tell broad stories that truly represent its community and challenge dominant narratives, it needs to ensure it is inclusive of a broad range of people. This work is only possible by the creation of a safe space for the community. In *Kewpie: Daughter of District Six*, a group of young adults worked with the museum to brainstorm new ways of working with the photographs,

which resulted in an annual drag show in Kewpie's honour. 'The participants were given the opportunity through workshops to not only explore the issue about identity and sense of belonging and issues around race and communities that are deprived. But they had that moment of actually feeling safe in the environment. A lot of people who live in communities don't have that sense of safety. They don't have a sense of ownership'. The District Six Museum works to provide that space, for diverse conversations about the past, present, and futures that provide a zone for growth (Brown 2008).

The Museum's aim to actively resist and rewrite colonial narratives and associated inherited futures is evident in the structure of the institution itself, which according to Tina has always been run with 'a more democratic, organic structure'. This is enabled by their independence from government bodies, ensuring the museum is, as Tina describes, 'not part of a colonial space [...which gives] the freedom of dictating our own terms'.

Similarly, the inclusion of queer stories and perspectives can be an important step in broadening the scope of possible futures through challenging narratives which dominate. *Kewpie: Daughter of District Six* is a clear example of how the District Six Museum used a queer lens to challenge dominant narratives surrounding marginalised communities. A recount of history, which includes queer people, by queer people, allowed the exhibition to stay away from common tropes of queer people being discriminated against and instead showed stories of expression and respect. These reconstructions of past narratives with fresh eyes allow people in the present to expand their preconceived ideas on what it meant to be queer, influencing ideas of queerness in the present, and opening their imaginations up to new visions of queerness in the future.

Conclusion

District Six builds futures thinking capacity through three key interconnected methods. Firstly, the centring of community and place in all that it does provides the contextual and imaginative backdrop from which past, present, and futures can be explored. This is evident in the Museum's memory work and emphasis on maintaining a living archive from which stories can be shared. Thirdly, queer and decolonial lenses underpin this work, broadening the perspectives included and shared. In *Kewpie: Daughter of District Six,* all three of these methods are evident in the way that community participation is essential to the Museum's programme, and the Museum is essential for shared futures in the community.

References

Bisht, P., 2017. *Decolonizing futures: exploring storytelling as a tool for inclusion in foresight.* Report (Masters). The Ontario College of Art and Design University.

Brown, M., 2008. Comfort zone: model or metaphor? *Australian Journal of Outdoor Education,* 12 (1), 3.

de Saint-Laurent, C., 2018. Thinking through time from collective memories to collective futures. *In:* C. de Saint-Laurent, S. Obradovic and K. Carriere, eds. *Imagining collective*

futures. Perspectives from social, cultural and political psychology. London: Palgrave Macmillan, 59–81.

FioRito, T., and Routledge, C., 2020. Is nostalgia a past of future-oriented experience? *Frontiers in Psychology*, 11. Available from: https://www.frontiersin.org/articles/10.3389/fpsyg.2020.01133/full [Accessed 6 December 2023].

Kewpie: Daughter of District Six, 2018. District Six Museum. Available from: https://www.districtsix.co.za/project/kewpie-daughter-of-district-six/ [Accessed December 12, 2023].

Peach, K., and Smith, L., 2022. Participatory futures. *In:* J. Engle, J. Agyeman and T. Chung-Tiam-Fook, eds. *Sacred civics*. London: Routledge, 193–203.

Prince, D., 2014. What about place? Considering the role of physical environment on youth imagining of future possible selves. *Journal of Youth Studies*, 17 (6), 697–716. Available from: https://www.ncbi.nlm.nih.gov/pmc/articles/PMC4307016/ [Accessed 11 December 2023].

Sedikides, C., et al., 2008. Nostalgia: past, present and future. *Current Directions in Psychological Science*, 16 (5), 304–307. Available from: https://www.jstor.org/stable/20183308 [Accessed 10 December 2023].

2.8 SUR-FIcciones

Science fiction as a methodology for possible futures in the Global South

Catalina Rodas Quintero, Julyán Conde,
Luis Alberto Alcaraz, Maria del Carmen Mesa,
Camilo Cantor, and Juliana Restrepo

Introduction

Parque Explora was founded in 2007 in Medellín, Colombia as a Science Centre, an aquarium, a planetarium, and a public experimentation lab. The museum has over 300 interactive exhibits and covers topics such as neuroscience, physics, biology, astronomy, and music, with the ultimate goal of stimulating art, technology, and science engagement to develop individual and collective human capacities to live better. Parque Explora's ideas go beyond its walls with workshops, community processes, lectures, and outreach experiences.

In this chapter, we focus on one of Parque Explora's spaces: the 'Exploratorio – Taller Público de Experimentación', a laboratory for exploring and creating around the relationships between art, science, and technology, where meaningful learning methods are promoted through action, prototyping, play, and collaborative work. Since its foundation in 2011, the 'Exploratorio' has become a platform for imagination, reflection, and exhibition for local communities, creators, the city's artist collectives, and international guests.

The work of the 'Exploratorio' revolves around these types of activities: **(i) Inductions:** to introduce people to the essential operation of machines, tools and equipment. **(ii) Laboratories:** spaces for co-creating projects in which the Exploratorio team, a guest (an artist, a collective or a group), and a specific community participate and engage around a topic. **(iii) Workshops** aimed at delving into specific topics and concluding the learning process by developing a prototype in a short time. **(iv) Experimentation groups:** people with shared interests meet to learn, create, and experiment. **(v) Small creators:** activities that invite children to hands-on learning with the tools available in the 'Exploratorio'. **(vi) Residencies:** a person with expertise in a subject is invited to develop an individual or collective project.

Since 2021, each quarter at the Exploratorio, we have created a thematic programme of activities composed of the formats mentioned above and approached from the foundational premises or manifest of the public experimentation workshop. Themes are selected based on a study of the context and the needs of multiple audiences, the work team members' knowledge, and the communities' questions. This way, we have held cycles around experimenting with archives (Re-visiones),

DOI: 10.4324/9781003474975-15

exploring technologies that do not arise from large industries but from traditional customs (Tecnologías otras), and using science fiction to dream of alternative futures for our territories. This case study will focus on the last thematic cycle of 2021: *SUR-FIcciones*.

What is the starting point to imagine the future from the South?

The need for situated knowledge (Haraway 1991), that is, to recognise our socio-historical conditions and consider the knowledge that is not produced in academic centres but is built in the streets and the mountains, led us to recognise that the idea of the future of the Global South territories cannot be the same as that proposed from the countries of the North.

In Colombia, structural inequality causes a high percentage of the population to have informal jobs and earn low wages. As an immediate consequence, Colombians have a short-term vision of life and focus mainly on their immediate needs, such as the day's meals and paying rent, rather than on planning projects or goals for the future. Therefore, their idea of the future is separate from the concepts of progress, development, and growth imposed by hegemonic discourses.

Based on these reflections, we asked ourselves how science fiction, as a creative methodology (Pinto and Vásquez 2018, Zaidi 2019), could help us explore our past and our roots to understand who we are, heal our colonial wounds (Mignolo 2007), value our knowledge, and imagine alternative futures where we live with dignity. We wanted to work on science fiction to decolonise our imagination (Aguilar Gil 2019), review our aesthetic influences, and build our narratives from the singularities of our languages, life experiences, and cultures.

We understand science fiction from the South through two perspectives: on the one hand, we reviewed the academic literature on the subject written in Latin America and, on the other, we developed the concept of future in a participatory manner by interviewing territorial leaders, writers, and young people who work on the topic in Colombia to learn about the applications of fiction in communities using literature and audiovisual creation.

We reviewed the work of Rachel Haywood Ferreira (2011), co-editor of *Extrapolation*. In her paper *El surgimiento de la ciencia ficción latinoamericana* (2011), she points to socio-political, geopolitical, historical, and rural phenomena as the pillars that have inspired writers in the region. Furthermore, she recognises that, despite not having the aesthetic muscle of science fiction from countries with developed industries such as from Hollywood, the region has a cultural network with other narratives such as cyber-shamanism, Indigenous futurism, magical realism, and a multi-ethnic richness to explore, which leads us to measure the importance of our stories and worldviews.

The following two experiences of imagining participatory futures are noteworthy:

1 **Chocofuturism*: the simple but privileged action of dreaming*. Chocó is a department in northwestern Colombia. Most of its population is of African descent. It has an extraordinary natural wealth that has led to legal and illegal

disputes between different actors, compounded by the lack of State presence and inequality in resource distribution.

There, the EnPuja communications collective created an audiovisual productions incubator for children and young people to dream using fiction. This action is seemingly simple, but in a context with such complex realities, is a privilege. They have discovered that fiction nurtures imagination and inspires political actions that transform the future and make what is considered impossible, possible. They use Afrofuturism as the model to develop an audiovisual identity, but they have created something so unique that it calls for a new name: Chocofuturism.

2 *Imaginaries beyond dystopia*. We interviewed Luis Carlos Barragán, a Colombian nomadic science fiction writer and illustrator. He told us that there is a boom of artistic, literary, and music creations that imagine other possible futures in the southern regions of Colombia, where ancestral knowledge, colonial wounds, mysticism, science, and fantasy converge.

Among the characteristics of southern science fiction, he identifies decolonialism, the connection to magic, curiosity for ancestry, questioning power, the presence of feminist, LGBTIQ+ and environmentalist political struggles, and the search for a hopeful future. According to Barragán, 'there is an explosion of imagination to think about alternative futures. There, we have the agency to make our own decisions and understand that true development lies in understanding ourselves'.

The activities of SUR-FIcciones

Below are some of the cycle's highlights.

Cyberpunk lab in espadrilles

We held an open call on social media inviting applications for up to 15 interested participants who could enrol for free. The laboratory was initially planned for four sessions; however, the participants' interest and commitment led to extending the laboratory to six sessions. The laboratory was facilitated by the Exploratorio staff and an expert guest, Dara Hincapie, a physicist, fiction writer, fantasy writer, science communicator, and co-coordinator of the Science Fiction Club of Medellín.

The objective of the laboratory was to explore the possibilities of customised costumes and accessories based on a cyberpunk dystopian future viewed from the South. We did not seek to emulate previously known references but to take the aesthetic codes of cyberpunk, such as the warmth of light, textures, and artefacts, to combine them with traditional or folkloric Colombian costumes, garments, and accessories to achieve eclectic creations that would bring us closer to a local version of cyberpunk. For this, we mixed textile intervention, photography, and augmented reality technologies.

The first session included a theoretical introduction to cyberpunk and a conversation about why people had decided to enrol in the activity. In the second session, we developed a collective idea of the costumes to be manufactured, the contextual

elements to be integrated, and the materials needed to achieve it. Exploratorio provided some of these materials, but participants also brought some that they considered necessary to complete their costumes. In the other sessions, participants prototyped what they had imagined. At this point, the distribution of roles and each participant's contribution with their knowledge and expertise was essential; some designed the costumes, operated the sewing machines, or created electrical circuits, while others created the augmented reality experience.

The result was a typical Colombian costume: a pair of espadrilles, a poncho, and a terry bag composed of popular textures and fabrics, such as animal print and studs, but modified with LED lights and a futuristic aesthetic. The costume was part of the exhibition *Re-inhabiting Dystopia*, which included the processes and results of the programme's cycle. In addition to the costume, we developed augmented reality animations showing a person modelling the costume.

These meetings allowed us to review the hegemonic aesthetic references to subvert them and 'hack' the dominant imaginaries of science fiction. Highlighting local aesthetics and costumes allowed us to understand the power of our environments as an inspiration to create, but it also reflected the importance of integrating technology and science into our processes. This way, we not only long for what once was but can also innovate and create creative solutions for our problems and project a better future.

Latin American science fiction film cycle

Despite our proximity to other South American countries, their audiovisual productions are rarely shown in Colombia. Sometimes they are shown in alternative cinemas but are seldom screened in commercial cinemas, unlike films made in the United States or Europe, which are easily accessible.

We partnered with the Universidad de Antioquia Film Club for this film programme, which provided us with the films. Over two months, we screened the short film *En busca de Aire* (Colombia) and five films: *El país de las últimas cosas* (Argentina, 2020), *Bacurau* (Brazil, 2019), *Traficantes de sueños* (Mexico, 2008), *Nostalgia de la luz* (Chile, 2010), and *Bogotá, 2016* (Colombia, 2001). After each screening, we held a discussion panel with the attendees and an expert guest, to discuss fun facts about the film, cinematographic analysis, personal interpretations, and comparisons with the Colombian context.

Through these film screenings, we discovered that Latin America is united in diversity because, despite the cultural and even linguistic differences, we share historical processes and share problems related to the exploitation, racialisation, and disappearance of our bodies, rural communities disposed of their lands for the establishment of productive projects, disputes over territorial and nature control, the need to migrate to central countries to seek better living conditions for our families, among others. Likewise, we are also united by resistance processes in the face of inequality and injustice.

Although this film cycle expanded our view of the region, it also became apparent that our cinema education has been through big-budget cinema, especially

from Hollywood. Our film references in this genre are *Back to the Future, Star Wars, Gulliver's Travels or RoboCop*, so for some of the audience, this aesthetic was not as attractive, and they perceived some of the films as slow-paced and long. Therefore, educating spectators in other narrative structures is essential.

This film series revealed the urgency of thinking about the future we want as a geopolitical region rather than as isolated countries. Shared problems demand collective solutions. As a producer and reproducer of social senses, cinema is a powerful tool for this purpose.

Panel 'from science fiction to design: influence of science fiction on 20th-century design'

During the opening talk of the SUR-FIcciones cycle, our guest, Carlos Mario Cano, a researcher on the relationships between science fiction and human sciences, gave a talk about how science fiction influences the design of everyday objects. He is a psychologist and also holds a Masters in Political Science and Doctorate in Human and Social Sciences.

During this panel, we talked about how futurology, speculative design, and science fiction from the Global North have defined how we outline our idea of the future and how we understand progress, which is associated with thinking about society from the utopian and naive place of continuous and linear development. According to Cano, science fiction is a bastard genre, an intermediate between two forms of literature that refused to recognise its parenthood: literature and scientific literature. Like all stories, it creates archetypes, stereotypes, and prototypes and shapes a horizon of expectations regarding a society's objects, activities, and behaviours.

Thus, science fiction created during the mid-20th century set the parameters to imagine how things would be today, as thought by artists, engineers, and scientists, thus shaping our present context. At the same time, this period's political, technological, and anthropological conditions affected architecture, bodies, and objects.

This conversation revealed the value of listening to different fields of knowledge to explain the historical processes that have led to the present social conditions. Understanding the origins of our context can help us understand the changes we must promote and make to transform our futures.

Challenges and lessons learned

One of the main challenges we observed throughout the SUR-FIcciones cycle is the urgency of decolonising imagination. We cannot deny the cultural impact of Europe and North America through the iconic novels and films of our childhood. These stories, however, impose a model of the future, society, and even of apocalypse, perhaps far removed from stories constructed from other geopolitics. What would a dystopia be like in La Guajira, Colombia, where people experience a reality similar to some 'irreal' dystopian Hollywood films? We believe that to imagine is to resist; it is an act of liberation that should not be the privilege of a few.

Therefore, solving the structural problems of the South, such as hunger and insufficient access to education and healthcare, are essential steps to enhance creativity, give room to hope and walk to fulfil our dreams.

Science fiction also allowed us to intertwine affections with those who attended the different activities. The possibility of talking about our experiences, family histories, what hurts us, and what we dreamed about created a community around SUR-FIcciones. For example, in the workshop *Firulais and michis cyborgs*, we grieved our pets because we remembered them, modelled them in clay, and used technology to think of fictitious ways to save or heal them. This idea of community is fundamental in our territories because we know that the capacity to transform our future lies in the strength of being together.

Conclusion

As social institutions whose production of knowledge enjoys public support, museums have a great responsibility. What is the future we want for our territories? Particularly those who live in contexts where solving day-to-day problems is a priority and dreams are a privilege.

Thanks to the SUR-FIcciones cycle at Parque Explora, we could think of science fiction as a methodology for creating and experimenting while thinking about our social and political realities. This allowed us to build, together with the communities and the public, narratives that seek sovereignty over the representations and the models that resemble them without copying hegemonic models. We travelled to the past to discover our roots and understand where we come from, who we are, and what we want for tomorrow.

Challenging the dominant narratives and thinking about the future from the South allowed us to remember that we are capable of dreaming, that our knowledge matters, and that we are capable of walking towards an alternative future in which we have agency to make our own decisions and fight for good living.

References

Aguilar Gil, Y. 2019. *Un nosotrxs sin Estado*. Valencia, Chiapas: Ona ediciones.

Haraway, D., 1991. *Ciencia, cyborgs y mujeres: la reinvención de la naturaleza*. Madrid: Cátedra.

Haywood Ferreira, R., 2011. *The emergence of Latin American science fiction*. Connecticut: Wesleyan University Press.

Mignolo, W., 2007. *La idea de América Latina. La herida colonial y la opción decolonial*. Madrid: Editorial Gedisa.

Pinto, J.P., and Vásquez, J.M., 2018. The contribution of science fiction and design to the materialization of Scenarios [online]. *In: 6th International Conference on Future-Oriented Technology Analysis*. Available from: https://joint-research-centre.ec.europa.eu/system/files/2018-05/fta2018-paper-a5-pinto.pdf [Accessed 29 February 2024].

Zaidi, L., 2019. Worldbuilding in science fiction, foresight and design. *Journal of Futures Studies*, 23 (4), 15–26. Available from: https://worldbuildingparatodos.com.br/wp-content/uploads/2021/02/Worldbuilding-in-Science-Fiction-Foresight-and-Design-Zaidi-2019.pdf [Accessed 29 February 2024].

2.9 Futures forged by children

Fostering STEM Identity at The DoSeum

Meredith Doby

Our approach to futures thinking is skills-based. We do not offer what to think but rather teach children how to think. In this gamified exhibition, children solve a series of future-based challenges and develop a personalised Science, Technology, Engineering, and Mathematics (STEM) Identity. The challenges are delivered in the form of play-based physical and digital interactives.

Futures thinking needs to be community-based. To create *Dream Tomorrow Today*, The DoSeum used a co-creation methodology with tiers of community partners. The inclusion of these partners allowed us to target economically disadvantaged populations and hear directly from families throughout the development and design process.

Using these approaches, we give agency to children to create their own desired future. They will live in the future the longest out of anyone who is collectively creating the future right now. We can give them the skills necessary to make it happen.

Case study

Children will create the future. If we want to engage the community in futures thinking, we must include children. The DoSeum in San Antonio, Texas, USA, is a museum with a target audience of children ages 0–11 and their caregivers with a mission to grow minds, connect families, and transform communities through joyful learning and discovery. With this mission in mind, we created the travelling exhibition, *Dream Tomorrow Today*, where play and imagination allow children to positively impact the future and build STEM Identity to become empowered agents of change. We want children to leave the exhibition saying, 'With STEM I can shape our future!'

To create *Dream Tomorrow Today*, The DoSeum used a co-creation methodology with tiers of community partners to engage economically disadvantaged youth. Our goal is to offer all youth the chance to imagine their desired future and build the skills necessary to achieve it. We offer space to develop a STEM presence, enrich foundational concepts, and take risks. Our process reveals accomplishments and challenges for those looking to engage the generation who will live the longest in our collective future.

DOI: 10.4324/9781003474975-16

Futures thinking at the museum

Museums must make a conscious effort to consider the future and its possibilities when designing for children. Many children's galleries include activities of the present or recent past: children driving cars to banks or dressing in costumes of traditional job roles. While The DoSeum has some of these long-established elements, in recent years, we have implemented a more futuristic approach. For example, we used the Center for the Future of Museums' Strategic Foresight Kit to create our Strategic Plan, we have included Futurists in our exhibition charrettes and worked to integrate cutting-edge technology into our exhibitions (Doby *et al.* 2022).

For children currently in kindergarten, the careers that they will ultimately have likely do not yet exist. At The DoSeum we ask ourselves: What skills will children need in the future? What tools, resources, and knowledge will be necessary? How can we provide equitable access to a positive future for all children? We cannot predict the future but we can certainly provide skill-building activities to develop future-proof skills.

The need

A synthesis of research evidence indicates that children can think about the future, they *need* to think about the future, but they may have difficulty doing it on their own. Research has found that 4- and 5-year-olds are able to mentally travel into the future, 3-year-olds only show the rudiments of these abilities, and children as young as 2 and 3 talk about the future (Atance and Meltzoff 2005, 2013). An investigation of 4- and 5-year-olds asked children about their hopes and fears for the future. They 'had difficulty defining the future from an adult perspective but they were nonetheless able to envisage the world they would like when they grew up' (Hicks and Holden 2007). The researchers emphasise the importance of beginning early when developing futures awareness. They believe children need guidance on how to think more critically and creatively about the future, both locally and globally.

Our exhibition had a goal of helping children develop a STEM Identity, which we defined as when someone identifies themselves as a learner of nature and technology – as someone who knows about, uses, and wants to contribute to science and engineering to answer questions or solve challenges. STEM education creates critical thinkers and opens new opportunities – crucial today in the wake of the COVID-19 pandemic and with a growing climate crisis. However, San Antonio students consistently underperform in STEM-related subjects. According to data from UP Partnership (2021), only 53% of non-economically disadvantaged children in San Antonio meet standards, compared to just 30% of economically disadvantaged children. On a national level, minorities and female students are underrepresented in STEM identities. The work of *Dream Tomorrow Today* is to show that **every** child can imagine the future and build a STEM Identity.

Designing with the community

The future of all museums is intimately connected to our ability to be relevant and meaningfully connect with the community. In *The Art of Relevance*, Nina Simon

writes, 'Something is relevant when it is connected to where a person wants to go. What you want to know. Who you want to be' (Simon 2016). Our target audience during our community development was under-served and economically disadvantaged communities in San Antonio. To create a relevant exhibition, we needed to first speak deeply with our target audience to understand who they wanted to be.

We targeted under-served populations by employing a tiered partner system. We held a series of Community Conversations in which we invited participants to test our content and exhibit ideas. Our first-tier partners were paid local organisations working directly with economically disadvantaged populations, Intercultural Development Research Association (IDRA) and 1st-Gen Scholars. The second tier were families who participated in our Community Conversations throughout the development of the exhibition. To provide the most equitable access to our events, we offered food, drinks, transportation, and additional child care for participants to remove any potential barriers. Our third-tier partners were participants in our DoSeum Outreach programme which brings DoSeum programming to neighbourhoods with barriers of access to our physical location.

At our Community Conversations we discovered most participants were very familiar with the acronym and concept of STEM Identity. Most children associated it with classic job roles such as doctor and scientist. We worked to expand this association by adding a STEM Personalisation element to our exhibition. After participating in the exhibition game, children receive two of four Personalised STEM Identities: Creative, Collaborative, Innovative, and Curious. The exhibition does not try to predict your career but rather expands the idea of how STEM Thinking can be applied to any career and any future solutions.

Most children did not understand a timeline and had difficulty conceptualising the difference between 10 and 50 years in the future. To ground this, we organised the exhibition into two sections: 'when you are a teenager' and 'when you are an adult'. This also allowed for intergenerational connections within visitation groups. When asked to imagine a change in the future most children imagined a personal change in the near future (e.g., I can drive) and a societal change in the distant future (e.g., We'll live on Mars). We, therefore, added a feedback station in the exhibition that encouraged guests to imagine the opposite: a societal change in the near future and a personal change in the distant future.

Participants also encouraged us to push the exhibition towards a positive vision of the future. As one parent said, the future shouldn't be all challenges. For this reason, we added more open-ended, play-based exhibit experiences. The information gathered during the community input phase of the project was invaluable to creating a relevant and accessible exhibition for everyone.

Walking through the future

In *Dream Tomorrow Today*, play and imagination allow children to positively impact the future and build STEM Identity to become empowered agents of change. The exhibition begins with a tunnel that transports guests from the museum into

the future, complete with costumes to enhance the transformation. A game element drives movement throughout the exhibition, a successful method used in prior exhibitions to engage children deeper in content. In the evaluation, 77% of children did the 'game' and collected a wristband. Children are 'recruited' to work in the Future Lab as STEM Thinkers. Here they will solve challenges to create a more positive future. Throughout the exhibition, the Radio-Frequency Identification (RFID) system tracks their progress. Children are working to earn Planet Powers in Health, Happiness, Nature, and Equality to help the Earth. The ambient audio becomes more positive depending on how many future challenges the children have completed. Children's individual choices affect the entire environment. If a Planet Power is low, everyone in the exhibition needs to do a collective action to help, such as making a funny face to the person next to you or clapping in unison.

In each life-stage section, there are touchscreens with multiple-choice questions in which children select their answers to a future challenge. For example, 'You get to drive now! But car fuels are hurting the Earth. How can you use STEM to solve this challenge?' You can choose from three answer options each with their own unique effects on the Planet Powers.

Each section also has play-based and open-ended exhibits. In the teenager section, there is a ball pit simulating a lake. Children must place the 'rubbish' (differently sized balls) into a bin to earn Planet Power points. The water (light effects) appears cleaner as the children pick out the balls. Nearby, children can create new places to hang out together by weaving strands of webbing through house-like structures.

As adults, children can use STEM to make a meal. There is a Grocery Store and Online Store with future foods created by children such as 'Infinity Cake' and 'Ice Cream that Never Melts'. Children can tend future foods in a Community Garden. Children use Nature Points to purchase the food, recognising that different foods have different carbon footprints. If children are short Nature Points to purchase their food, they may work in the Community Garden to earn more. Two hand-cranked conveyor belts allow children to return items to their designated places by composting them or recycling them. Nearby, children can help plan and design a future city. They can arrange futuristic Augmented Reality tiles to create a community that is strong enough to survive a flood.

Makerspaces are an important aspect of STEM skills building (Clapp *et al.* 2017). The Future Makerspace uses Visual Thinking Strategies (2018) to allow children to determine their own challenges and solutions for the future. Participants are presented with an enigma in the form of an image and encouraged to use it as inspiration. The Makerspace is fully stocked with reusable materials for creating their future invention.

As a final experience, children's avatars join a Future World projection of all the children in the exhibition. The system has tracked their personalised STEM Identity and their avatar's costume reflects their unique identity. The exhibition establishes that all children already have a STEM Identity and they are actively using their STEM skills to solve future challenges in their own unique way.

Summative evaluation

According to summative evaluation, children who visited the exhibition felt empowered to make a change and understood that what they do has an effect on the future. The cumulative number and depth of words used by children to express what 'Future' and 'STEM Identity' brought to mind increased upon visiting. *Dream Tomorrow Today* was highly memorable to children, and they were able to recall many activities and messages. Cleaning pollution and conservation of resources were the most memorable takeaways.

Children came into the exhibition with a strong, but traditional familiarity with STEM Identity. Most children did not feel that their identity increased from their visit while most adults did. Children tended to not associate the work they were doing with STEM. This is perhaps an extension of what we previously witnessed as a relatively narrow definition of STEM work. We hope that the exhibition and other programmes will continue to expand this definition.

Most interesting was that according to adults, they assumed that children felt slightly less hopeful about the future after leaving the exhibition. Interestingly, children's responses did not indicate this decrease in hope, their responses saw themselves as agents of change with an increased focus on environmentalism. There are some potential explanations for the adults' assessment including adults' state of mind and generational differences.

Naomi Klein writes in her essay 'On Fire' about the climate crisis (Johnson and Wilkinson 2020), 'Our current moment is markedly different, and the reason for that is twofold: one part having to do with the mounting sense of peril, the other with a new and unfamiliar sense of promise'. The climate crisis can feel both hopeless and hopeful at the same time. Not everyone is thinking about climate change all the time, so parents may need time to process a 'sense of peril' before shifting attention towards their children's hopeful solutions. Our intention with the exhibition is to instil hope for the future, so we rewrote some challenges to better focus on the hopeful solutions, for example adding 'You can help!' into the text.

Additionally, there is a generational difference in the attitudes towards climate change. According to a US Study interviewing 1,000 members of Generation Alpha, 95% said they feel strongly about protecting the planet (Kappler 2019). Younger generations (Gen Z and Millennials) are more likely to express an interest in addressing climate change than older generations (Gen X and Boomers) (Funk 2021). Importantly, children can change their parent's views on climate change (Denworth 2019). If they are left more hopeful than their parents, that hope can be passed on.

Conclusion

Using a community-driven, skills-based, and playful approach, we give agency to children to create their own desired future. Hope will emerge from the recognition of children's own STEM skills and applications leading to new and innovative future solutions. As museums, we must give them the skills and space necessary to

create those solutions. The future belongs to the children – let's all offer our support to them to create the best possible outcomes.

References

Atance, C.M., and Meltzoff, A.N., 2005. My future self: young children's ability to anticipate and explain future states. *Cognitive Development*, 20 (3), 341–361.

Atance, C.M., and Metcalf, J.L., 2013. Future thinking in young children. *In:* M. Taylor ed. *The Oxford handbook of the development of imagination*. New York: Oxford University Press, 305324.

Clapp, E.P., et al., 2017. *Maker-centered learning: empowering young people to shape their worlds*. San Francisco: Jossey-Bass.

Denworth, L., 2019. *Children change their parents' minds about climate change*. Scientific American [online]. Available from: https://www.scientificamerican.com/article/children-change-their-parents-minds-about-climate-change [Accessed 11 November 2023].

Doby, M., Kissel, R., and Menelly, D., 2022. Futurism, technology, and inclusivity: preparing today's learners for tomorrow. Exhibition, Spring 2022, 33–41.

Funk, C., 2021. *Key findings: how Americans' attitudes about climate change differ by generation, party and other factors* [online]. Washington, D.C.: Pew Research Center Available from: https://www.pewresearch.org/short-reads/2021/05/26/key-findings-how-americans-attitudes-about-climate-change-differ-by-generation-party-and-other-factors/ [Accessed 11 Nov 2023].

Hicks, D., and Holden, C., 2007. Remembering the future: what do children think? *Environmental Education Research*, 13 (4), 501–512.

Johnson, A.E., and Wilkinson, K.K., 2020. *All we can save: truth, courage, and solutions for the climate crisis*. New York: One World.

Kappler, M., 2019. *Generation Alpha' will be more open-minded, fair, climate-focused than their parents: study*. New York City: Huffington Post. Available from: https://www.huffpost.com/archive/ca/entry/generation-alpha-demographic_ca_5ded4fefe4b00563b853120f [Accessed 11 November 2023].

Simon, N., 2016. *The art of relevance*. Santa Cruz: Museum 2.0.

UP Partnership, (2021). Data Resources [online]. Available from: https://uppartnership.org/data-resources/ [Accessed 1 November 2023].

Visual Thinking Strategies, 2018. *Critical thinking and inclusive discussion* [online]. Visual Thinking Strategies. Available from: https://vtshome.org/ [Accessed 11 November 2023].

2.10 Designing MOD. to enable young people to think about futures

Kristin Alford, Natalie Carfora, Brooke Ferguson, and Lisa Bailey

Introduction

MOD. (museum of discovery) is a future-focused museum of discovery located in Tarndanya/Adelaide at the University of South Australia. Since opening in 2018, the museum has aimed to engage its 15–25-year-old target audience by showcasing research in exhibitions and programmes that engage with science, technology, art, and innovation, considering the ways that these intersect to create futures. The exhibitions and programmes are changed annually to expose the audience to a wide range of research and to stay at the edge of emerging futures. The mission is to provide an expanded set of opportunities for young adults, meaning it is important to grow their capacity to think about the future.

This is supported by the adoption of six key principles that draw on concepts from the field of futures studies. Embedding these directly into MOD.'s' design processes ensures that futures are layered throughout concept and exhibition development and extended to the visitor experience.

Cognitive development

The first futures principle considers the cognitive-developmental phase of young adults. Cognitive development theory suggests that it's not until post-conventional thinking that people are likely to be concerned with key questions relating to dynamic interconnected systems (Rooke and Torbert 2005). These later-stage constructs are also more likely to move beyond linear notions of time and be concerned with the longer-term view and the welfare of future generations (Cook-Gruter 2014, p. 89).

In contrast, a young adult audience is likely to be concerned with the key questions of exploring their identities and sense of belonging (Allen 2020, p. 27). With that in mind, exhibitions and experiences are designed to respond to these concerns, while scaffolding inquiry into futures thinking.

These key questions for young adults are addressed in the visitor experience – emphasising a place to be (belonging) and be inspired (navigating their futures). A Youth Advisory Board was first created during the development phase of the museum. While the structure of the group has evolved over the life of the museum,

DOI: 10.4324/9781003474975-17

the core purpose is consistent. The Youth Advisory Board's objective is to provide feedback and advice on concepts, designs and prototypes for exhibitions and programmes, as well as to provide insights on the visitor experience journey. The participants on the Youth Advisory Board enter a competitive application process and are selected to ensure that diverse perspectives are present, mindful of gender, cultural and language backgrounds, and study disciplines.

The Youth Board has also been helpful in assessing how to scaffold futures thinking. The first youth advisory session used Lego Serious Play to imagine desirable museum and cafe experiences. Other futures sessions used *The Thing From the Future* from Situation Lab (Candy 2018) to prompt longer-term thinking, surfacing responses to the future of education and the climate crisis.

Additionally, exhibitions centre young people to help them imagine themselves in different plausible futures. In the IT'S COMPLICATED exhibition (2021), *Custom Made* was created by a group of engineering and animation students. This exhibit was designed to showcase systems thinking concepts around technology advancing in sensing, robotics and machine learning that comprise the concept of Industry 4.0. Videos of the students describing the project and their notebooks were presented alongside the robotic vehicles and interactive software they built. These layers of representation situated young people at the centre of innovation as well as scaffolding futures thinking skills through the exploration of systems thinking.

Futures negotiated through dialogue

The exploration of futures is not a solitary pursuit. It must be a collective endeavour that generously listens to multiple voices in conversation with each other. The future is negotiated through dialogue with open-minded perspectives and attention to emerging insights (Donnelly and Montuori 2023, p. 76, Raupach *et al.* 2013, p. 117). These types of conversations create a foundation for ideas from which new visions of futures can emerge (Wilkinson and Flowers 2022, p. 76).

Underground, in the INVISIBILITY exhibition (2022), explored climate change through the lens of the Eyre Peninsula in South Australia, incorporating geological research there and in Antarctica, creative arts research through animation and sculpture, and First Nations perspectives in connection to Country, that is the ongoing spiritual relationship with land. Through this approach, a new narrative emerged for the region.

Conversations are also built into the exhibition design process. Exhibition themes are drawn from the museum's Future Themes Forums. These forums are held biannually and gather high school and university students, educators, artists, researchers, and innovators together in the museum. The forum participants are asked to explore topics that they feel are critical to consider for the future. Their conversations are recorded, analysed for common themes and ideas, and ultimately shaped to produce the exhibition themes for the following years.

The importance of conversations is emphasised further in the museum experience, which encourages visitors to engage with front-of-house staff to delve deeper. These front-of-house staff are empowered to share their own unique perspectives

on exhibit elements whilst encouraging visitors to share theirs too. This requires appropriate training as this approach is different from the expected role of an expert guide – not all enthusiastic science communicators can hold an open listening conversation. By asking open-ended questions, the staff spark imaginative and thoughtful ideas.

Two-way minded

One of the concepts informing views about a future is the assumed model of social change and patterns of power (Inayatullah 2008). In the Australian context, the history of colonisation and continuing disadvantage for Aboriginal and Torres Strait Islander Peoples represent entrenched views about power and privilege in current society.

For museums to do genuine futures work, dominant cultural power hierarchies must be challenged. At MOD., this is enabled by rejecting narratives of disadvantage and modelling 'post-reconciliation' futures to give people glimpses and experiences of what a shared and thriving future could look like for Aboriginal and non-Aboriginal Australians.

This means making the contributions of Aboriginal artists, creators, and researchers visible in the space as a counterpoint to Australia's 'great forgetting'. In addition to Western notions of knowledge, especially prominent in the science and technology disciplines, Aboriginal knowledges such as, connection to place and the importance of Country, practices of deep listening and the importance of reciprocity are folded into the design and expression of exhibitions and programmes. This 'two-way minded' principle has resulted in the only permanent work in MOD. called *Kuri Kurru* which represents the turning cycle of the Aboriginal seasons on Kaurna Country. For the INVISIBILITY exhibition (2022), the artwork *Ngapulara Ngarngarnyi Wirra (Our Family Tree)* was commissioned with Australian Rules Football player Adam Goodes to explore questions of data collection and use in elite sports, and whether that data might also hold cultural knowledge given his Aboriginal identity. In the FLEX exhibition (2023), an exploration of ethics in emerging technologies featured both questioning and deep listening as valid approaches.

There are challenges in doing this work in the context of museums as colonial constructs. At MOD. there has been an additional cultural load for Aboriginal staff beyond their work to bring these perspectives, and the demands on Aboriginal peoples to fulfil a range of responsibilities is significant. Furthermore, in working in an emerging field, at the intersection of futures and technology, there is a continued need to grow the capacity for the sector.

Productive struggle

The educational principle of the 'productive struggle' is embedded through the design principle of being 'open-ended', This is enacted through the use of provocations to stimulate visitors to come to their own conclusions, encouraging problem-solving skills and sitting in periods of uncertainty. This is important for futures

thinking – as David Suzuki once said 'the future doesn't exist' (as cited by CBC 2023) and therefore it is inherently uncertain.

The educational approach of 'productive struggle' has been associated with the study of mathematics (see Baker *et al.* 2020). However, recent research has shown that negative emotions, for instance, confusion, have been linked to deeper engagement and satisfaction in informal learning including exploring science exhibits (as cited by May *et al.* 2022).

MOD.'s exhibits aim to ask questions without providing explicit answers. In *Biophilic Fantasies* by Ani Liu for the HEDONISM exhibition (2019) the provocation was 'Does nature need to be natural?' Visitors were encouraged to walk through a structure surrounded by real and fake plants and objects, reflecting on the way that the space made them feel. Some context was provided by a researcher interview and a short length of written text at the beginning, but otherwise, visitors were encouraged to draw their own conclusions about the impact of the environment on the way that they felt.

There are options to help visitors move through this learning state. Some visitors engage in conversation with peers or front-of-house staff and some scan the exhibit QR codes to discover additional text and video. Not all visitors are willing to engage in this uncertainty. For instance, some of the feedback is that there is not enough text or explanation about the exhibits and the research or engagement with front-of-house staff is limited to wayfinding. Yet overall, the time spent in struggle generally evokes curiosity, permission to sit with a sense of uncertainty, and the opportunity to rethink initial assumptions.

Experiential futures

Experiential futures are used to provide visitors with a felt experience of futures, encouraging them to learn and enquire through sensation and play. Experiential futures is a method of participatory futures practice that creates an immersive or sensory world that is effectively used to immerse people in possible future worlds (Candy 2014, p. 34). These experiences are more likely to elicit an emotional response in the visitor, resulting in the individual taking action to work towards (or away) from the future that they experienced. Additionally, experiencing a sense of different possible futures can expand the capacity of people to imagine more diverse possible futures.

Adapted from the exhibition at Heureka in Helsinki, Finland, the exhibition SEVEN SIBLINGS FROM THE FUTURE (2020) explored the plausible fictional world of Eucalara modelled on southern Australia in 2050. Visitors met with seven siblings to complete tasks related to long-term issues facing the future of Australia, including climate, food security, and healthcare.

Not all of our experiential futures have been immersive and world-building. It's possible to provide felt senses of the future through smaller and more intimate interactions. In the WAGING PEACE exhibition (2018), the film *Trigger Warning* by design studio Superflux (UK) plunged visitors into an increasingly tribal and aggressive future influenced by social media. IN INVISIBILITY (2022),

Mirror Mirror by Nina Rajcic placed visitors in the context of a smart home, where a mirror might read your mood and provide daily feedback in the form of poetic affirmations. The online narrative game POINT OF IMPACT (2022) asked visitors to play as an employee at a fictional company called Greenmind to use artificial intelligence to solve the climate crisis.

Each of these experiences requires visitors to suspend current reality and enter a state of play, which not all visitors are prepared to engage with. The other risk of developing experiential futures is longevity, as images of the futures become stale over time. MOD. manages this by forgoing permanent exhibitions in favour of changing exhibitions annually, prioritising expenditure on reusable technologies where content can be updated, but this style of dynamic content may be challenging for some museums.

Cultivation of hope

With a young target audience, it is important that MOD. does not add to media that glamorises dystopian futures or contributes to a sense of hopelessness or despair. Instead, the future is an invitation to the target audience to play a role in its creation, cultivating a sense of hope enabled through agency and optimism (Polak 1973, p. 17–19).

This principle is the theoretical foundation for the exhibition called BROKEN (2024). Born from stakeholder frustrations voiced at a Future Themes Forum, the exhibition explores how society feels broken, especially in terms of housing, universal services, democracy, education and collaboration. BROKEN seeks to counter this, by allowing visitors to explore alternative systems. As they progress through the exhibition, visitors use a token to respond to questions, which results in the presentation of a short, customised narrative about their own capacity for hopeful action. Hope is not simply wishful thinking, rather it is an active agent that drives action through goal-setting, personal agency and visualising the pathways to achieve them (Polak 1973, p. 17–19, Snyder 2012).

The aforementioned futures principles of dialogue and experiential futures become valuable tools for hope-building. As visitors explore BROKEN, they are immersed in alternate worlds where systems are different. Housing is equitable due to the reimagining of land ownership, long-term collaboration for climate futures is experienced through participating in a collective puzzle, and the provision of universal services is explored by rebalancing private, public and volunteer contributions. While motherhood statements of hope can be deflating, drawing on hope theories allows visitors to explore agency, examine their goals and visualise alternative pathways of getting to desired futures.

Conclusion

Designing with consideration of the cognitive-development phase of your target audience, facilitating conversations so that futures can be negotiated through dialogue, adopting a two-way minded approach, encouraging the productive struggle

through open-endedness, creating a felt sense of possible futures through experiential futures and fostering agency, goal-setting and visualisation to cultivate hope are the six key principles driving the capacity of futures thinking in MOD.'s visitors.

The beauty of the way that futures principles are designed into MOD. comes from the ways that they work together. Experiential futures spark curiosity, kickstarting the productive struggle, the productive struggle encourages conversations, conversations build a sense of belonging, and belonging evokes hope. This interconnected approach of layering different futures principles together allows for futures thinking to be built in different ways for different people.

References

Allen, K.A., 2020. *The psychology of belonging*. London: Routledge. Available from: https://doi.org/10.4324/9780429327681 [Accessed 13 October 2023].

Baker, K., et al., 2020. Productive struggle in action. *Mathematics Teacher: Learning and Teaching*, 113 (5), 361–367.

Candy, S., 2014. Experiential futures: stepping into OCADU's time machine. *The Futurist*, September–October 2014, 34–37.

Candy, S., 2018. Gaming futures literacy: the thing from the future. *In:* R. Miller, ed. *Transforming the future: anticipation in the 21st century*. London: Routledge, 233–246.

CBC, 2023. David Suzuki shares life lessons as a proud elder [online]. CBC Ideas Podcast. Available from: https://www.cbc.ca/radio/ideas/david-suzuki-elder-lessons-1.6868994 [Accessed 20 October 2023].

Cook-Gruter, S., 2014. Ego development: a full-spectrum theory of vertical growth and meaning making. Self-published. Available from: https://www.researchgate.net/publication/356357233_Ego_Development_A_Full-Spectrum_Theory_Of_Vertical_Growth_And_Meaning_Making [Accessed 20 October 2023].

Donnelly, G., and Montuori, A. eds., 2023. *Routledge handbook for creative futures*. London: Routledge.

Inayatullah, S., 2008. Six pillars: futures thinking for transforming. *Foresight*, 10 (1), 4–21. Available from: https://doi.org/10.1108/14636680810855991 [Accessed 21 October 2023].

May, S., et al., 2022. Measurement of science museum visitors' emotional experiences at exhibits designed to encourage productive struggle. *Curator: The Museum Journal*, 65, 161–185.

Polak, F., translated by Boulding, E., 1973. *The image of the future*. Amsterdam: Elsevier Scientific Publishing Company.

Raupach, M.R., et al., 2013. *Negotiating our future: living scenarios for Australia to 2050*. Canberra: Australian Academy of Science. Available from: https://www.science.org.au/publications/negotiating-our-future-living-Scenarios-australia-2050 [Accessed 10 October 2023].

Rooke, D., and Torbert, W.R., 2005. Seven transformations of leadership. *Harvard Business Review* (April). Available from: https://hbr.org/2005/04/seven-transformations-of-leadership [Accessed 21 October 2023].

Snyder, C.R., 2012. Hope theory: rainbows in the mind. *Psychological Inquiry*, 13 (4), 249–275.

Wilkinson, A., and Flowers, B.S., 2022. Creating the future. *In:* G. Donnelly and A. Montuori, eds. *Routledge handbook for creative futures*. London: Routledge, 74–80.

Approach 3: Anticipating futures by exploring and responding to drivers of change

2.11 Engaging with futures at the Museum of Tomorrow in Rio de Janeiro

Fabio Rubio Scarano, Bruna Baffa,
Luís Gustavo Costa Araújo,
Beatriz Lima Rangel Carneiro,
Andrea Lombardi, Amarílis Lage de Macedo,
Camila Oliveira, Nina Pougy, and Ricardo Piquet

Introduction

After five years of planning, consultations, and construction, the Museum of Tomorrow ('Museu do Amanhã', in Portuguese), Rio de Janeiro, Brazil, was opened to the public on 17 December 2015. By introducing the rationale and practice of a futures-oriented museum (Candy and Oliveira 2017), it inspired others globally, and gave birth to the FORMS (Futures-Oriented Museum Synergies) network in 2019, which gathers many actors involved in the production of this book. Described as a 'place of pilgrimage' (Biancardi Filho and Arantes 2019), it soon became one of the most visited museums in South America, with over 6 million visitors in eight years, nearly 1 million per year, if one subtracts the two years of the COVID-19 pandemic. Perhaps even more so because the preparation years of this Museum (2011–2015) were eventful ones in many fronts (e.g., science, policy, and diplomacy), both in Brazil and globally. In 2014, the 5th Assessment Report of the Intergovernmental Panel on Climate Change (IPCC) informed that the world had entered the 'Era of Adaptation' since mitigation of greenhouse gases would no longer suffice to avoid human-driven dramatic changes in the planetary climate system. Thus, in 2015, the United Nations' (UN) Climate Convention reached the Paris Agreement with parties announcing ambitious mitigation and adaptation targets to be reached by 2030, which, however, remained insufficient. Before that, the city of Rio staged the UN Conference on Sustainable Development (Rio+20) in 2012, which produced the document 'The Future We Want' – the trigger of what was later to become the UN Sustainable Development Goals (SDG) announced in 2015. By then, the debate around the notion of a new geological era, 'Anthropocene' – that resulted from human action leading to trespassing of planetary boundaries – was of public domain (for a review, see Scarano 2024).

In late 2015, when the Museum of Tomorrow was inaugurated, the present was overwhelming and, globally, aspirations were set for 2030. In parallel, in Brazil, accusations of corruption and mismanagement affected the stability of the federal government, which in early 2016 was impeached by the Congress, shortly

DOI: 10.4324/9781003474975-19

before the Olympic Games started off in Rio. What would the future hold? During its first seven years of functioning, the Museum outlived two years of transition government in Brazil, followed by four years of extreme-right-wing governments, science-denialists, in Brazil and Rio. By late 2022, history took another (now positive!) turn: almost simultaneously, the United Nations Educational, Scientific and Cultural Organization (UNESCO) approved the Museum's Chair on Futures Literacy, and Rio and Brazil elected democratic governments concerned with culture, science, and education.

This chapter describes the strategy of the Museum of Tomorrow to engage collaborators, visitors, and partners with futures thinking. We divided this account into three milestones: (1) the setting up of the long-term exhibition; (2) activities and projects developed by the Museum since its inauguration; and (3) the onset of the UNESCO Chair that the Museum holds since January 2023.

The long-term exhibition

The long-term exhibition of the Museum of Tomorrow is structured around the five cosmological questions: (1) where do we come from? (2) who are we? (3) where are we? (4) where are we going? (5) how are we getting there? The narrative is linear (origins – present – projected futures) and science-based (for more on the rationale, see Candy and Oliveira 2017, Oliveira 2015). The linearity partly results from the constraints imposed by the shape of Santiago Calatrava's building (Lupo 2021, for more on the relationship between architecture, museology and museography of the Museum). The strong scientific orientation has to do both with the spirit of that decade (as described in the Introduction) and with the fact that the Museum was originally thought of as a science museum about Earth and sustainability (Candy and Oliveira 2017, Lupo 2021). Thus, the tools used by the exhibition to address the future are scientific projections, scenario building, and forecasting. The inaugural institutional book of the Museum of Tomorrow (Oliveira 2015) is further evidence of this approach to futures. Interestingly, the presence of science is evident not only in content but also in form: for instance, both the building and the exhibition have been described as a 'mathematical beauty' (De Las Peñas 2020).

The Anthropocene is depicted in the third section of the Museum, to address the question 'where are we?' This is often perceived by visitors as the most impactful segment of the exhibition, with its six rectangular pillars (10 m tall × 3 m wide), arranged like totem poles in a 'Stonehenge-like circle' (De Las Peñas 2020), which serve as screens for videos that display data and images on the human impact on Earth. It is followed by the final two sections that address 'where are we going?' and 'how are we getting there?' – the former, using digital tools to project possible futures, and the latter a space for reflection. While some perceive this display as a form of dialogue between the Museum and the public that is both informative and liberating (Manso and Olinto 2016), others see it as being of a colonial nature (Daróz and Sousa 2019). Digital and artificial intelligence tools mediating such dialogue have been interpreted as pioneering experiments in deep learning (Gaia *et al.* 2019), and, contrastingly, as an expression of the tension between techno-future visions and local colonial history (Reyes Carranza 2023).

Activities and projects

Museums are more than their long-term exhibition, and the Museum of Tomorrow develops a variety of futures-engaging activities and projects with a decolonial nature. These initiatives address and dialogue with non-modern, ancestral world-views, and with the territory where the Museum is inserted. This location, by the Guanabara Bay, is a key land/seascape in Brazilian history. The bay has a millenary presence in Amerindian mythology, has been the place where millions of enslaved African people arrived in Brazil (the neighbourhood where the Museum is located is known as 'Little Africa'), and has set the stage for pivotal moments of Brazilian contemporary history. Based on an ethics of care, the Museum's foundation principles are those of conviviality (including aspects related to accessibility and diversity) and sustainability (as care with self, with other people, and with non-human elements of nature).

Futures-engaging activities and projects with a decolonial nature are found in all five executive units of the Museum. They include knowledge production and exchange (publication of books, hosting seminars, etc.), educational activities with children, disabled people, and students (among other audiences), artistic expression, engagement with the neighbourhood, temporary exhibitions, a vegetable garden for activities outside the museum building, and other activities. Examples include (see more at the Museum's webpage):

- *Neighbours of tomorrow* (since 2015): This initiative offers free access to exhibitions and various special programmes to residents of the neighbourhood enrolled in the programme, aiming to help democratise access to art, culture, and scientific knowledge, and create plural spaces for futures thinking.
- *Ten-year-old girls* (since 2017): Series of meetings with girls from territories with distinct socioeconomic realities in Rio to discuss women's stand in society and presence and representativeness in science.
- *Inspire Science* (since 2018): A training programme for elementary education teachers that seeks to update their knowledge in science-related topics, while also delving into the exploration of innovative educational futures and decolonial themes.
- *'Sai-fai'* (2021–2023): Residence programme for 19 young Brazilian science-fiction writers, who covered themes such as Afrofuturism and Amerindian futurism. The novels inspired an exhibition in 2023.
- *Amazon* (2022–2023): Alternative and desirable futures for and inspired by the Amazon were covered by three exhibitions: 'Fruturos – Tempos Amazônicos' (Futures of the Amazon) discussed the need for dialogue between science and traditional knowledge to overcome socio-ecological challenges. Sebastião Salgado's 'Amazônia' is a photographic display of the diversity of people and nature in the region. 'Nhande Marandu' focused on indigenous ethno-media with artworks by Denilson Baniwa, Zahy Guajajara, Jaider Esbell, and Brisa Flow, among many other contemporary artists.

While some see these as a complement to the narrative of the long-term exhibition, others might see them as a contradiction. Indeed, *contradictions* have

been described as one of the three C's of post-normal times, alongside *chaos* and *complexity* (Sardar 2010). Post-normal times are periods of accelerating change and transition, such as those we are currently going through. Symptoms include globalisation challenges, climate change, economic and humanitarian crises, wars, fast communication and transportation, and even a sanitary crisis that resulted in the COVID-19 pandemic and the risk of other disease outbreaks.

This movement of recognising the need for a transformation in the relationship with the world, the dialogues with futures, and the production of meaning in museums stems from a critique of the functioning of institutions in general. How can we deal with the contradiction of institutions that are inherently colonial in their structure and origin? This way of thinking and creating museums dialogues with the transformations in art and culture. It has been developed and widely embraced since the early 2000s (Bishop 2016). Furthermore, it has spilled over into institutions with different guidelines and can be observed by looking at who and what occupies cultural and dialogical spaces. This collective, non-hierarchical model now spreads in other fields as well. All this is evidence of how the micropolitics of everyday life can be both transformed and transformative.

We live in times of 'post-everything': post-normal, post-truth, posthumanism, post-feminism, postmodern, and even post-postmodern. Post-concepts establish a 'fence' around a given part of reality and label it as something past (Paul 2021). They suggest transition into something unknown or uncertain in describing the present situation (Salazar 2021). Recently, Wahler (2020), in conversation with Szantó, used the term 'post-museum' to refer to how art museums might function in the future. He said that when visiting a 'post-museum', one would truly experience art, which would be offered by a curator who would be like a 'magician', helping visitors to see things differently. We think that this abstraction can also be applied to futures-oriented post-museums: to truly experience active hope for diverse and sustainable futures. In the case of the Museum of Tomorrow, this is where the UNESCO Chair on Futures Literacy might be a good fit.

The UNESCO Chair on Futures Literacy

Since January 2023, the Museum of Tomorrow holds a UNESCO Chair on Futures Literacy, the first of its kind to be hosted in and by a museum. The Federal University of Rio de Janeiro (UFRJ) is a key partner in this initiative, by having one professor and six graduate students dedicated to fostering the activities of the Chair jointly with the Museum's team. The Chair's running title is 'Planetary Wellbeing and Regenerative Anticipation' because its research premise is that future states of planetary wellbeing will emerge from regenerative processes. We understand regeneration as based on dialogues that repair systems, relationships, and rights. Modernity and reductionism have fractured the whole into isolated modules that need to (re)converge: science/arts/spirituality, self/us/planet, body/mind/soul, past/present/future. To anticipate futures that regenerate the connections between these modules involves building dialogues (Scarano 2024). The investigation developed

by the Chair is organised under three lines that aim to converge different temporal perspectives when imagining futures:

- *Ancestral futures*: How ancestral ways of life (Amerindian futures and Afro-futurism; Gama *et al.* 2023, Kopenawa and Albert 2018, Krenak 2022) use the future to deal with the present? How do other types of intelligence, such as plants (Santos *et al.* 2024) anticipate futures?
- *Seeds of a Good Anthropocene*: The term coined by Bennett *et al.* (2016) refers to present-day experiences drawn from a diversity of practices, worldviews, values, and regions that can inspire and accelerate transformative change. The Chair is interested in futures of cities and settlements.
- *Futures of futures*: Two fronts – (1) research on post-development alternatives to sustainable development examines convergences and divergences between worldviews from the Global South (e.g., Buen Vivir and Ubuntu), the Global North (e.g., degrowth and ecofeminism), and the hegemonic SDG; (2) research on novel ecosystems investigates how humans can possibly relate to new ecosystems that emerge from their own interventions on the planet.

In addition to the research objectives, the Chair is also involved in education and outreach. Educational activities are performed mostly by applying Futures Literacy Labs (FLL; Miller 2018). During 2023, over 400 people participated in the labs, including Museum staff, school teachers, university professors and students, and participants of the Latin American network for the popularisation of science (RedPOP). During 2024, the outreach of the Chair's FLLs will extend to small farmers, our urban neighbours and corporations.

Last but not least, a key goal of the Chair is to provide subsidies for the process of redesigning the long-term exhibition of the Museum of Tomorrow, which shall be launched in late 2025, when the Museum celebrates its 10th anniversary. It is also already providing material that feeds into book publications, seminars, and temporary exhibitions. By promoting greater coherence and dialogue between the long-term exhibition and the other projects and activities of the Museum, we expect that the emerging new narrative can be one that provokes feelings of active hope and drive for transformative action in visitors, collaborators, and partners.

Final remarks

The Museum of Tomorrow houses the science-based logic of forecasting and scenario building of its long-term exhibition, the decolonial approach of most of its projects and activities, and the focus on anticipation and regeneration of its UNESCO Chair. These different approaches coexist in complementarity within the same space. Critics see contradictions that, then again, are typical of our post-normal times. The redesign of the long-term exhibition that will take place during 2024 and 2025 might reduce or circumvent potential contradictions, but new ones will emerge, since – as much as the universe is unfinished – the desirable future is a persistent state of 'not-yet', even as we move towards it at fast speed. Perhaps more

importantly, the conversations that lead to a new Museum logic – with collaborators, visitors, and partners – shall bear in mind Plato's advice on dialectic: may it be a therapy to the souls that leads to knowledge, overcoming the pathological modern ignorance that drives multiple planetary crises (Stephens 1993).

Acknowledgements

This chapter was written within the scope of the Museum's UNESCO Chair on Futures Literacy. We thank Instituto de Desenvolvimento e Gestão (IDG), the organisation that manages the Museum of Tomorrow, for support, guidance, and funding. We also thank Instituto Humanize, Porticus Foundation, EY, and Volvo for funding; UNESCO Brazil and UFRJ for support; Raul Corrêa-Smith and Alexandre Fernandes for their leadership in building the Chair's concept; Ana Célia Castro, Loes Damhof, and Felipe Koch for stimulating exchanges; and the Museum's and IDG's teams for partnership and friendship.

References

Bennett, E.M., et al., 2016. Bright spots: seeds of a good anthropocene. *Frontiers in Ecology and the Environment*, 14 (8), 441–448. Available from: https://doi.org/10.1002/fee.1309 [Accessed 6 November 2023].

Biancardi Filho, C., and Arantes, P., 2019. The interaction of the public with the show museum: a case study about the Museum of Tomorrow. *In*: C. Stephanidis, ed., *HCI International 2019 – posters. HCII 2019. Communications in computer and information science*. Cham: Springer, Vol 1034, 543–548. Available from: https://doi.org/10.1007/978-3-030-23525-3_74 [Accessed 6 November 2023].

Bishop, C., 2016. A virada social: colaboração e seus desgostos, 2008. *Concinnitas – Revista do Instituto de Arte da UERJ*, 1 (12), 145–155 [translation to Portuguese of a 2008 paper].

Candy, S., and Oliveira, L.A., 2017. Always tomorrow now. *World Futures Review*, 9 (3), 180–185. Available from: https://doi.org/10.1177/1946756717697336 [Accessed 6 November 2023].

Daróz, E.P., and Sousa, L.M.A., 2019. In the museum, history and memory embrace tomorrow. *Revista Letras Raras*, 8 (2), 134–149.

De Las Peñas, M.L.A., 2020. Mathematical sightings at the Museum of Tomorrow. *The Mathematical Intelligencer*, 42, 24–28. Available from: https://doi.org/10.1007/s00283-020-09967-z [Accessed 6 November 2023].

Gaia, G., Boiano, S., and Borda, A., 2019. Engaging museum visitors with AI: the case of chatbots. *In*: T. Giannini and J.P. Bowen, eds. *Museums and digital culture*. Cham: Springer, 309–329.

Gama, V.C., Sá, A., and Diniz, G.G., 2023. Afrofuturism, amazofuturism, indigenous futurism, and sertãopunk in Brazilian science fiction. *In*: Taylor, T.J., et al., eds. *The Routledge handbook of CoFuturisms*. London, New York: Routledge, 286–295.

Kopenawa, D., and Albert, B., 2018. *A Queda do Céu*. 2nd ed. São Paulo: Companhia das Letras.

Krenak, A., 2022. *Futuro ancestral*. São Paulo: Companhia das Letras.

Lupo, B.M., 2021. Architecture, museography and museology in dialogue: analyzing the Museum of Tomorrow. *In*: Collotti F., Verdiani, G. and Brodini A., eds. *Proceedings of the first ArCo conference*. Firenze: Didapress, 19–31.

Manso, B.L.C., and Olinto, G., 2016. Museu do Amanhã e os desafios do Antropoceno: Uma proposta de alternativa museológica. *XVII Encontro Nacional de Pesquisa em*

Ciência da Informação. Salvador: Bahia. Available from: https://brapci.inf.br/index.php/ res/download/ 191163 [Accessed 26 October 2023].

Miller, R., 2018. Futures Literacy Laboratories (FLL) in practice: an overview of key design and implementation issues. *In*: R. Miller, ed. *Transforming the future: anticipation in the 21st century*. New York: Routledge, 15–50.

Oliveira, L.A., ed., 2015. *Museu do amanhã*. Rio de Janeiro: Edições de Janeiro.

Paul, H., 2021. Introduction: post-concepts in historical perspective. *In*: H. Paul and A. van Veldhuizen, eds. *Post-everything: an intellectual history of post-concepts*. Manchester: Manchester University Press, 1–14. Available from: https://doi.org/10.7765/9781526148179.00006 [Accessed 26 October 2023].

Reyes Carranza, L., 2023. *A museum for the anthropocene: memory, race and future-making at the Museum of Tomorrow in Rio de Janeiro, Brazil*. Thesis (PhD). Queen Mary University of London.

Salazar, N.B., 2021. Post-national belongings, cosmopolitan becomings and mediating mobilities. *Journal of Sociology*, 57 (1), 165–176.

Santos, L.S., Santos, V.H.S., and Scarano, F.R., 2024. Plant intelligence: history and current trends. *Theoretical and Experimental Plant Physiology* (in press).

Sardar, Z., 2010. Welcome to postnormal times. *Futures*, 42, 435–444. Available from: https://doi.org/10.1016/j.futures.2009.11.028 [Accessed 26 October 2023].

Scarano, F.R., 2024. *Regenerative dialogues for sustainable futures*. Cham: Springer (in press).

Stephens, J., 1993. Plato on dialectic and dialogue. *Journal of Value Inquiry*, 27, 465–473.

Wahler, M.O., 2020. The post-museum. *In*: A. Szantó, ed. *The future of the museum: 28 dialogues*. Berlin: Hantje Cantz, 344–355.

2.12 Designing the Exhibition at Futurium

Translating futures thinking into an exhibition context

Gabriele Zipf and Rosalina Babourkova

Introduction

How does one exhibit something that does not yet exist? Futurium was founded in 2015 and the first big task in preparation for its opening was the creation of a permanent, but annually updated exhibition on futures – hereafter referred to as the Exhibition. Spanning over 2500 sqm, it addresses many different future topics, including the future of cities, energy, health, food, work and production, mobility, digitalisation as well as democracy. All of these topics are significantly shaped both by systemic path dependencies as well as drivers of change, such as urbanisation, migration, and climate change. The Exhibition is conceptualised around three so-called 'thinking spaces' (*Denkräume* in German): Nature, Technology and Human. Currently, the Exhibition is updated every year to include a new topic. The question 'How do we want to live?' runs as a central theme throughout the Exhibition.

From the very beginning, the aim was to create an Exhibition that takes away any fears people might have about the future. An Exhibition that takes account of key drivers of change – from technological developments to ecological and societal questions and challenges. An Exhibition that features an entire range of futures actors – from scientists and politicians to local citizen initiatives. An Exhibition that showcases inspirational futuring practices from different areas of life and that thus builds up resilience and trust in one's own capacities for shaping the future. Getting there was a curatorial journey with many twists and turns. We invite you to travel back with us to the years of 2015–2017 to recapitulate some of the key 'roadmaps' that helped us along the way.

A light and heavy backpack

Embarking on this curatorial journey, we always felt that we carried a metaphorical backpack. In it, there was, for example, the immense creative freedom in creating an exhibition about something that does not yet exist. This made the backpack feel light and the curatorial process very exciting. The theme of futures is virtually infinite, opening up new possibilities of communication and conveyance beyond the conventions of classical museum collections. There were no fixed objects and exhibits that had to be included. Rather, as curators we had the freedom of curating

DOI: 10.4324/9781003474975-20

the specific content within the given topics of cities, energy, food, health, etc., as well as the freedom to develop the storytelling and formats.

However, with great freedom comes great responsibility. So, our light backpack also felt very heavy at times. If we as curators take our social mission seriously, we do not only want to break down and explain complex contexts, but we also want to trigger something in our visitors. At the very least, we want to awe them and foster their curiosity, better still to encourage them to reflect on their own and to discuss with others, and at best to encourage them to become active in shaping the future themselves. We were clear that our approach to achieving those aims had to include presenting concrete scenarios to stimulate the imagination and to encourage people to look at the world and its futures from different perspectives. We deemed presenting visions and lived utopias important but were also acutely aware that we had to simultaneously nudge visitors to critically deconstruct those same utopias (Schaper Rinkel 2020, pp. 83–88).

Starting from a place of hope

Futurium's mission is to provide a space and a platform for people of all ages and backgrounds to explore, discuss, and experiment with different future options and grapple with the grand challenges facing humanity from a place of hope. What better way to do that than to invite visitors to voice their wishes and hopes for the future? So, the very first exhibit that we conceived in 2016 was the *Database of Hopes*. This interactive media station was used for outreach purposes to represent the idea of Futurium as a House of Futures at events and fairs before the opening of the actual museum Futurium. It was then set up as a permanent installation in the foyer of the building in 2019. Visitors are asked to complete the sentence 'For the future I hope....'. Their articulated wishes then flow into a seemingly endless network of wishes and hopes for the future. More soberly put, they are recorded in a large database. Futurium does not set any guidelines on what people can enter into the *Database of Hopes*. On the contrary, this great openness is important to us, and above all the questions and discussions that go along with it. We often observe visitors discussing among themselves: What should one enter? Is it about very big wishes, or can small, private ones also be expressed?

The most common wishes range from world peace and a healthy planet to flying cars and time travel machines to unicorns and 'weed for all'. Many hope for more equitable and solidary futures. This is expressed in wishes like: 'that world trade becomes fairer', 'that politicians don't lie anymore', 'that old knowledge is preserved' or 'more respect for those who think differently'. There are very personal and intimate hopes, such as 'that my grandmother gets well' or 'that I can have a child', as well as funny and goofy ones like 'a price brake on kebabs', 'that cats rule the world' or 'a robot that talks to my mother on the phone'.

An algorithm assigns the wishes to thematic clusters. Visitors see which cluster their wish has been assigned to. Besides entering a wish into the *Database of Hopes*, visitors can also explore the wishes of others and thereby get a feeling for the diversity in the individual wishes and themes – and at the same time see

their universality. Additionally, our hope as curators is that browsing through other people's wishes and hopes would also amplify one's own sense of hope. Thus, encourage and empower them to imagine and put out into the world one's wishes and visions for the future.

From pathways to thinking spaces

The geoscientist and Anthropocene scholar Reinhold Leinfelder was Futurium's Founding Director, and his idea of future pathways served as our first conceptual framework for the Exhibition. The framework comprises five different pathways into the future: a high-tech pathway, a bioadaptive pathway, a sufficiency pathway, a reactionary pathway, and a business-as-usual pathway (Leinfelder 2016). The first three pathways strive towards making the world more sustainable – especially in terms of reducing greenhouse gas emissions and resource consumption, albeit by different means. In a high-tech pathway, technological development is seen as the solution to all problems, and sustainability is achieved through efficient technologies. In a bioadaptive pathway, technological and socio-economic development is inspired and informed by biological processes and structures. In a sufficiency pathway, human resource consumption is reduced to a bare necessary minimum. There is a focus on the small-scale, on low-tech developments, on reuse and repair. In the business-as-usual and reactionary scenarios, humanity continues to develop and simultaneously consume the Earth's resources in the same exponential manner that is the hallmark of the Anthropocene.

The challenge was to think about the first Exhibition topics through the lens of each of the different pathways. That proved relatively easy for energy as a topic. We could imagine a high-tech energy future around nuclear fission and nuclear fusion and a bioadaptive energy future around renewable energy sources like wind, solar, or wave power. The sufficiency energy future featured decentralised solar power generation in combination with drastic personal quotas on energy consumption. But applying the pathways framework to something as complex as cities – with all their different social, economic, political, spatial and environmental aspects, and the multiple actors that make up cities – turned out to be a very frustrating and superficial endeavour, as there was a seemingly infinite amount of assumptions we had to make about how such a complex system might look in the different pathways.

So, we condensed the theoretical concept and arranged the topics and approaches to solutions in three *Denkräume* or 'thinking spaces'. These are simultaneously physical spaces, each with its own distinct architecture and design, as well as conceptual spaces that each offer a particular lens to look at the afore-mentioned future topics. The high-tech pathway morphed into the Technology *Denkraum*, the bioadaptive pathway into the Nature *Denkraum* and the sufficiency pathway into the Human *Denkraum*. This new framework enabled us to be more open and less deterministic about approaching each topic and its drivers of change and thus more honest and inclusive of the different possibilities, emphasising the plurality of futures.

The possible, the desirable, and the plausible

Central to the Anthropocene futures framework is the notion that possible futures range from desirable to undesirable, the undesirable being the business-as-usual scenarios. Somewhere in between the desirable and undesirable end of the spectrum are the plausible future options, which depend on understandings and assumptions about planetary change (Bai *et al.*, 2016). In researching and framing the topics, we found it particularly productive to systematically contrast desirable and plausible futures throughout the Exhibition. We consulted a range of experts for each topic – scientists, but also artists, designers, politicians, and local changemakers. From this wide-ranging input, we pieced together technological, ecological, or societal visions for each topic and the drivers, trends, and barriers that inevitably shape and affect those visions, as well as the concrete options and solutions that could help move us closer to those visions.

Let's provide a concrete example of how desirable, plausible and possible futures mesh together in the Exhibition. In the Nature *Denkraum*, there is an area called 'Urban Jungle', which centres around the vision of future cities harmonising with nature. This vision is showcased through a large collage wall of speculative architecture designed by architects from around the world. Examples include 'Wetropolis'– a vision for a floating settlement in times of sea-level rise, 'Tower of Nests'– a skyscraper housing birds, insects and humans, 'Rising Canes' – a vertical city made from bamboo or 'Lunar Testlab' – a building prototype for extraterrestrial environments. The trends and drivers that shape this vision include accelerating climate change and the increasing urbanisation rate worldwide. The concrete options and tools available to make cities more sustainable include urban greening, river and coastal restoration and employing climate-friendly building materials and construction methods. These are presented through a range of physical objects, prototypes, images and texts. An interactive media station enables visitors to navigate the barriers to achieving this vision. These include the limited availability of urban space for new construction and the often difficult political trade-offs about what should be built and for whom. Engaging with the interactive media station, visitors explore four options for developing something on an empty plot of land: a luxury green residential building, a community-run indoor farm, a social housing complex made of wood, or an urban forest. They can then analyse the pros and cons of each development and decide what should be built.

The idea of different possible futures enabled us to convey that we – at least people in the rich democracies – have possibilities to influence to a certain extent what our future can look like and that we already (unconsciously) shape the future in many decisions in everyday life.

Playing with possible futures

While we consciously moved away from the idea of pathways at the conceptual level, we use speculative scenarios as a tool for visitors to discuss and evaluate desirable futures throughout the Exhibition. There is one such scenario for each thematic cluster in each of the three 'thinking spaces' (*Denkräume*). These scenarios

are fictitious but are based on existing scientific visions or societal utopias. The scenarios are set in everyday life, so that visitors can easily imagine and position themselves in them. In the Human *Denkraum*, for example, there is a scenario around the idea of a passport lottery: At birth, every individual is assigned a nationality at random. In the Technology *Denkraum*, there is a scenario about managing a personal carbon budget related to personal mobility. In the Nature *Denkraum*, there is a scenario about half of the territory of Germany being placed under nature protection with the consequence that all people have to move out of the protected part in order to give space to nature. Visitors are actively called upon to evaluate the scenarios by choosing one of the following options: 'yes, I would like to live like that…'/'well, I don't know…'/'no, I will not participate in that…'. While they cannot see how others have positioned themselves in relation to each scenario, our hope is that a critical thought process around the (un-)desirability of future options has been activated in visitors' minds.

Conclusion

Five years into its operation, Futurium continues to draw significant numbers of visitors. Our curatorial journey continues, as the futures theme implicitly creates an all-round pressure to showcase something new, at the very least, every year. The seemingly simplistic *Denkräume*-framework of Nature, Technology, and Human allows us a great deal of flexibility and openness to update and include new topics and to re-evaluate their drivers of change as well as to generate engaging scenarios about what is possible, plausible and desirable at the level of concrete exhibits. It allows us to set future topics and options against the background of the multiple and intertwined challenges of our time: the climate crisis, biodiversity loss, global injustices, pandemics, wars, and a decoupling of an established global economic system.

So, our curatorial journey continues along an ever more bumpy road. The notion of desirable futures is still an important tool for this journey. Because we cannot lose hope. It takes form in our very concrete future scenarios and also in the *Database of Hopes*, which we will share with museums and institutions worldwide and thus create a global network of – hopefully mutually reinforcing – wishes and hopes for the future.

References

Bai, X., et al., 2016. Plausible and desirable futures in the anthropocene: a new research agenda. *Global Environmental Change*, 39, 351–362.

Schaper Rinkel, P., 2020. *Fünf prinzipien für die utopien von morgen. wiener vorlesungen band 196*. Picus Verlag: Vienna.

Leinfelder, R., 2016. Das haus der zukunft (Berlin) als ort der partizipation. *In:* R. Popp, N. Fischer, M. Heiskanen-Schüttler, J. Holz and A. Uhl, eds. *Einblicke, ausblicke, weitblicke. aktuelle perspektiven der zukunftsforschung*. Münster: LIT-Verlag, 74–93.

2.13 Interview: The Mind Museum

Community engagement to imagine futures at The Mind Museum

Brooke Ferguson, Maria Isabel Garcia, and Kristin Alford

Background

An interview with Maria Isabel Garcia (known as Maribel Garcia), The Mind Museum.

The Mind Museum in the Philippines finds itself located at a central hotspot for the climate crisis and threats to biodiversity. To engage its diverse and decentralised communities in these issues, it has started to apply and develop techniques in participatory community futures, experiential futures, and imagination and creativity cultivation through a series of recent projects. These include Mind S-COOL, 2020+, International Ocean Station, 2021+ and Biodiversity Crisis Escape Room, 2022+. As of 2024, all projects are ongoing, as they continue to enhance one another and expand their community's ability to think about the future.

The Mind Museum

Maribel describes The Mind Museum as 'a place of imagination' that works with both the arts and science, which she describes as 'both very imaginative and creative, future-oriented endeavours and fields'. The Mind Museum, like other science centres, champions science and technology as being critical skill sets for the future of people, immediately linking the museum to an aspect of futures. Although, when naming the science centre 'the word science was deliberately excluded, based on a survey that showed our populace wasn't in love with it, so we avoided the word science*', displaying The Mind Museum's approach to include the community from the outset. Although a science centre, The Mind Museum strives to be a *new* kind of science centre, that Maribel describes as 'going beyond the facts that science centres are fundamentally required to present to pose questions that make people think*'.

The Mind Museum and futures

Before her time at The Mind Museum, Maribel notes that her career as a science writer enabled her to become 'quite familiar with the school of futures thinking and the encouragement for futures thinking from the United Nations'. This knowledge

DOI: 10.4324/9781003474975-21

she brought into her work at The Mind Museum, with a specific focus on what futures meant in the context of the Philippines, stating 'we're really tired of the record of the past, in shaping futures, we wanted to be part of an endeavour that was actively and aggressively imagining alternative futures'. 'We deliberately stayed away from focusing on heritage and history', instead focusing on values and actions created in the present.

The three key futures methodologies being employed through The Mind Museum's exhibitions and programme are imagination and creativity cultivation, participatory community futures, and experiential futures. The cultivation of imagination and creativity is a critical skill that offers itself naturally to ideas of thinking about the future, as the future is determined by our ability to imagine and then create said futures (Mecartney 2022). Participatory community futures are important because, as Maribel explains, 'our collective futures are important'. If a community can create a vision of a preferred future together, they hold more power as a collective to take action towards creating that vision together (Dunne and Raby 2013). Thirdly, experiential futures can give visitors a felt sense of the future (Candy 2015). A felt experience, presented along with the facts that science centres present, can affect a visitor's willingness to take action in the present to work towards their preferred futures. All address different ways of imagining alternative futures, thus growing the futures thinking capacity of the museum's visitors.

Cultivating creativity and imagination – Mind S-COOL

Mind S-COOL is a TV program that The Mind Museum first developed as a response to the COVID-19 pandemic in 2020. Maribel notes that she and her team 'reimagined ourselves to be a fantastical school where the galleries were, in the first place, naturally designed sets'. 'A fantastical place where anyone, not just kids could learn'. Whilst many other museums were creating online exhibitions during this period, The Mind Museum went on TV because as Maribel explains, 'this was so important in a poor country like ours [the Philippines], where the majority of low-income families do not have constant access to digital learning'. 'So we went on TV, which was still 96%, accessible to Filipinos, and then produced a science TV show called MIND S-COOL, where we reimagine problems like biodiversity, the climate crisis, and even mental health. Presenting it in a new way. Not lecturing, but instead working with characters and exhibits'.

In the following three years, Mind S-COOL has continued to receive full funding and support to continue. At the time of writing, the show had aired over 30 episodes and remained the number one science show in the Philippines. Television (episodes are also available online for free) as a medium of communication encourages shared viewing, with many members of a household viewing programme together. This shared viewing experience is crucial to creating the conditions for conversations about futures to occur, which are themselves a useful part of developing futures thinking capabilities (Donnelly and Montuori 2023, Raupach *et al.*, 2013). Ratings for Mind S-COOL have remained high, which Maribel explains 'is

a good indication that it is helping shape future attitudes and shared values about the challenges that we face'.

Repurposing museum galleries as backdrops from which problems were re-imagined and discussed added visual and conceptual interest for viewers. Working with a space that was originally designed for another purpose also required The Mind Museum team and Mind S-COOL viewers to engage their imaginations about where the stories being told were taking place. This essence of imagination and creativity is a fun approach for viewers that creates the conditions for overcoming the stuckness of preconceived ideas from the past in a novel way, which can be less frightening for most than change presented as change. The stretching of this imaginative way of thinking creates a good entry point to grow the ability of these viewers to envision alternative futures.

Although Mind S-COOL was born out of a crisis, The Mind Museum team has learned deep lessons on how to build futures capability from creating it. 'So much insight that would be so useful in moving us forward. Not on a TV show, but actually moving forward with the futures agenda for the museum. I learned deep insights on how to communicate. Remember, when you do a TV show, you don't see who you're talking to. But counterintuitively, if you don't, you are more considerate. You become more mindful of your impact. So that you are more careful about the language, more flexible, more sympathetic and empathetic'.

Participatory community futures – International Ocean Station (IOS)

Through Mind S-COOL, Maribel and her team learned 'this jewel of an insight into how shared viewing was paramount in terms of imagining futures'. 'Because if you don't share values, you wouldn't put a valence on any imagined possibility. Because it's just yours alone. You don't talk about it with the members of your family or community'. Shared viewing is enabled by the tradition of watching television with the members of one's household. Reaffirming the importance of having the community participate in futures thinking because as Maribel continues 'our collective futures are important'. Including the community is integrated into The Mind Museum's methods, from the museum's operations through to its exhibitions and programs.

Firstly, The Mind Museum prioritises ensuring it is accessible to the local community. Maribel explains that one way this is achieved is through 'subsidising the museum admission of a big portion of the majority of guests who are public school students'. 'When you say public school students in the Philippines, it would generally mean students who come from low-income families, so we subsidise their admission by about 70%'. Including the community in participatory futures begins by making sure they are welcomed through the doors.

The International Ocean Station (IOS) exhibit is also an example of how The Mind Museum relates to and works with its community for mutual benefit. Based on the International Space Station, the IOS is a project in development that works with artist Ceasar Harada, and the community group, Emerging Islands to reimagine how our oceans are cared for. When speaking of the themes Maribel says,

'anything that has to do with the seas, always roots in people like us who live on islands'. Demonstrating how the topics explored are directly rooted in issues relevant to the local community. Maribel continues,

> The International Ocean Station is just one idea among many other absolutely wonderful, imaginative, creative things that Cesar Harada has conceptualised as one of the things he wanted to work on, especially with communities. He was really very keen on having voices for imagining futures, many, many voices. There's a local community group called the Emerging Islands, which is a group of young people – very active, wonderful, brilliant young people who help these communities thrive. With their limited livelihood in fishing, they teach them other things and make sure they're well aware of their rights as communities.

Maribel continues that IOS 'includes aspects for community action where people can respond with their own messages of action', extending agency to the community to create their own solutions.

An inclusive, interconnected approach like this allows for change on multiple levels. Communities collaborate with the museum, the museum collaborates with stakeholders and then it is presented back to the community and beyond through the museum, thus creating the possibility for change on multiple levels. Changes which are much harder to achieve when these complex problems are discussed in isolation from the communities facing them (Smith and Peach 2019).

Experiential futures – Biodiversity Crisis Escape Room (BCER)

From IOS, the team learned the importance of working with diverse voices to create rich experiences and a deeper understanding of futures. They took these lessons to the *Biodiversity Crisis Escape Room* travelling exhibition, an experiential futures experience that engaged multiple stakeholders to create a participatory activity that allowed participants to feel what a biodiversity crisis could be through a simulation of the issue. Experiential futures is a method that helps people imagine what a future world could be by putting them into one (Candy 2015). 'Rather than the usual travelling exhibition, we are now creating a biodiversity escape room. We're trialing this with the United States Agency for International Development (USAID) on three critical islands in the Philippines. Actual stakeholders like politicians, park rangers, community members, and community leaders go inside, and sometimes their roles may be switched. So they would understand each other's perspective, requiring them to do that in order to escape'. These tangible images of a possible future enable deeper engagement with futures, making it easier for more people to begin imagining themselves in that situation. Furthermore, Maribel explains that 'a young Filipino artist is working with us on the escape room, creating endemic species puppets made of indigenous materials, so that even the voices of wildlife will be heard in this kind of project'. Further broadening the community voices present in the travelling exhibition.

Using this as a travelling work not only allows key stakeholders to go inside and experience the biodiversity crisis from each other's perspective to build empathy, understanding and a shared vision of the future but this emotive future world can also encourage those with decision making abilities to take action in the present to minimise, or at least prepare for such a crisis.

Local context – climate themes

Themes that are geographically connected are used to explore issues relative to the community such as climate change and biodiversity loss. Maribel explains these choices saying 'The Philippines is in the crosshairs in terms of the climate crisis, we're either number one or number two in the climate risk index, depending on the year and we're also a biodiversity hotspot, meaning that the rates of biodiversity are enormous'. 'So we're a double-whammy country. It would seem like we're in a coma if we don't address those things head-on'. This relevance is meaningful for the community, leading to a cycle of mutual benefit between the museum and its community. We see this perspective reflected in conversations with other futurists from the region (Cruz 2022).

Building diverse and driven teams

When asked what advice Maribel would give to somebody wanting to create similar projects to those of The Mind Museum she would 'really advise them to work with their teams'. 'Because nobody can do this by themselves. No matter how brilliant you are. You really need a group. And I think that is what I'm proudest of helping to build'. The Mind Museum team is 'quite a young team, with only 25 people'. 'There is no science wing or art wing, it was deliberate on my part. I wanted to create a whole new set of leaders in this industry, to be able to think in borderless ways on how to imagine better tomorrows'. Furthermore, the team comes from a mix of socioeconomic statuses in an effort to 'bridge social equity'. Maribel also notes that along with the diverse team, a driven team matters too, 'when we all agree to do it [a project], we all seem to never have a sense of not doing it'.

In particular, Maribel is proud of building a team that 'is exceptionally responsive and sensitive'. 'A lot of observations, a lot of our programs come out of my team saying, you know, when we were doing the demos this morning, we observed that the security guard was very interested in something like this'. Maribel explains that 'often it is very strong observational skills that have nothing to do with being articulate with words' that lead to the team altering their processes and outcomes. She goes on to explain that these observation skills demonstrate the importance of considering the cultural norms and context of the community you are working in. If you are not in tune with your community it's not as easy to connect with them authentically. It is important to have people from the communities you are serving working in your team to embed these types of knowing.

Conclusion

The Mind Museum utilises participatory community futures, experiential futures, and imagination cultivation, by drawing on the context of their location and communities, alongside a diversely skilled team to grow futures thinking capability in its visitors. Furthermore, the work that the team does is constantly learned from, with unexpected findings being harnessed and reused. The projects they are undertaking, with their specific focus on the climate crisis and threats to biodiversity are drivers of future change with significant relevance to the range of local communities served by the museum.

References

Candy, S., 2015. Experiential Futures Show and Tell. *Economist* [online]. Available from: https://www.researchgate.net/publication/305316754_Experiential_futures_Show_and_tell [Accessed 2 December 2023].

Cruz, S., 2022. "Our future is where the heart is": how futures literacy can enhance youth voice and the case of youth policy development in Laos [online]. *Journal of Futures Studies,* 27 (1). Available from: https://jfsdigital.org/2022-2/vol-27-no-1-september-2022/our-future-is-where-the-heart-is-how-futures-literacy-can-enhance-youth-voice-and-the-case-of-youth-policy-development-in-laos/ [Accessed 29 February 2024].

Donnelly, G., and Montuori, A., eds, 2023. *Routledge handbook for creative futures.* London: Routledge.

Dunne, A., and Raby, F., 2013. *Speculative everything: Design, fiction, and social dreaming.* Cambridge: The MIT Press.

Mecartney, S., 2022. Futures and the power of imagination for transformation. *Journal of Futures Studies* [online]. Available from: https://jfsdigital.org/2022/10/05/futures-and-the-power-of-imagination-for-transformation/ [Accessed 10 December 2023].

Raupach, M.R., et al., 2013. *Negotiating our future: Living scenarios for Australia to 2050.* Canberra: Australian Academy of Science. Available from: https://www.science.org.au/publications/negotiating-our-future-living-Scenarios-australia-2050 [Accessed 10 December 2023].

Smith, L., and Peach, K., 2019. *Our futures: By the people for the people* [online]. Nesta. Available from: https://www.nesta.org.uk/report/our-futures-people-people/ [Accessed 12 December 2023].

2.14 Climate, sustainability, and resilience in action

A case study from the Anchorage Museum

Julie Decker

Introduction

The Anchorage Museum opened its doors in 1968 with an exhibition of borrowed works. Today, the Museum is recognised as a leading centre for scholarship, engagement, and investigation of Alaska and the North. It is home to Seed Lab, focusing on climate change and sustainable communities. The Museum organises hundreds of public programmes annually, including artist residencies, public art installations, convenings, workshops, classes, concerts, performances, conferences, design weeks, festivals, and summits, as it partners with hundreds of other organisations and efforts. The Museum's emphasis on Indigenous voices, diverse communities, climate change and justice, access, and innovation provides a distinct set of activities that place the Museum at the centre of communities and conversations around change.

Rising temperatures, reduced ice coverage, shrinking glaciers, retreating sea ice, thawing permafrost, changes in precipitation, droughts, reduced snowpack, changes in sea level, ocean warming and acidification, wildfires, and heatwaves – the form a now-familiar language in Alaska, and not one of anticipation but, rather, lived experience. It is in this environment that we think about the role of museums and how they can be meaningful in the lives of people, creating a vision for the future to support well-being.

Museum as reflection point

We are in a deep experiment of finding new ways of telling stories. We examine methods of being a platform, a convener, a listener, a voice, a place, and a narrator, offering stories and perspectives of place and people, creating and highlighting radical new forms of research, practice, and placemaking. We work with Indigenous healers, artists, and community leaders, to think about community wellness. We gather a rich community of thinkers, creative practitioners, and changemakers. We are working to see beyond traditional spaces, think outside of the confines and predictability of galleries.

In 2019, we renovated an empty building and transformed it into Seed Lab, a humble space with an ambitious mission to host communities and consider ideas

DOI: 10.4324/9781003474975-22

of sustainable places and practices. There, we host conversations, repair work-shops, food conversations, forums on housing and energy transitions, provide space for artists and writers, lend tools, host an alternative materials library, and offer a podcast studio.

Throughout our practice and spaces, and into the community fabric, parks, and natural spaces, we experiment with new practices around how we programme and how we construct exhibitions. We try new materials. We open exhibition spaces for convenings and host conversations around futures, far outside the traditional audiences and partners of a museum. We move beyond the museum as a facil-ity, working in the community fabric on Indigenous place names and murals. We collaborate with Indigenous communities around sovereignty, considering what it means to give back–in all forms.

In 2012, I curated the exhibition *True North* for the Anchorage Museum, work-ing with contemporary artists on a 10,000-square-foot exhibition that looked at the defining qualities of the region. This was, in many ways, the Museum's first exhibi-tion that began to talk about the critical issues around climate change, biodiversity, Indigeneity, colonisation, exotification of place, food systems and sovereignty, en-ergy dependence, and more, it was what the artists of Arctic places saw as acutely relevant to time and place. This came after curating the Freeze project in 2008, an outdoor exhibition in downtown Anchorage with contemporary artists and design-ers from around the world. When the works were being installed, the city recorded some of the coldest January temperatures on record. When the project opened to the public, the temperatures swung to some of the warmest, melting installations made of ice and snow in days. The unusual nature was part of bearing witness to a place undergoing change.

In 2016, when the Museum hosted events with the Arctic Council and Presi-dent Barack Obama visited Alaska, we placed giant words on our façade read-ing, 'Chi'nan gu ninyu', or, 'Welcome, you came here' in the Dena'ina language. Today, the façade reads, 'This is Dena'ina Ełnena'. This is Dena'ina homeland. It was a moment that marked the Arctic as the centre of a discussion of the climate crisis, of geopolitics, or economy, of Indigenous sovereignty, and an indicator of issues and impact soon to come for many regions.

Climate change poses a compelling scenario for audiences – a worldwide experiment with survival. In a time of urgent and widespread activism, finding something to say about critical, contemporary issues can be hard work and require new museum skillsets not often found in traditional practice. It's in a long-term, deeply embedded, and informed response. True efforts to address climate change can prompt museums to think differently about core concepts of care, healing, con-servation, and stewardship and to push forward alternative forms of collecting, preservation, and interpretation. The Anchorage Museum recently opened an exhi-bition titled *How to Survive*, which considers the idea of survival through hope and care and asks how gestures and practices of love, protection, nurturing, and sharing can help us face climate change. Examining ideas of interconnectedness, listening, and caretaking, works on display invite reflection, encourage action, and urge us to consider our responsibilities to each other as well as to the plants, animals, lands,

and waters of our shared planet. Installations by contemporary women artists, cultural belongings from the Museum's collection, recent design innovations, and a Community Climate Archive featuring voices from across Alaska prompt us to consider the habits we must nurture to bring forth more positive futures.

Also in winter 2023, the Museum opened *Salmon Culture*, an exhibition curated by and featuring Alaska Native voices and artists, celebrating the connections between salmon and Alaska Native peoples and honours salmon as a resource that has nourished communities physically and spiritually for thousands of years. Fish is a richly meaningful resource in Alaska, impacted by climate change. We host a guest curator who writes about the impact of climate on fish for outlets such as *The New York Times* and the *Anchorage Daily News*. The *Anchorage Daily News* has been a regular collaborator with the Museum, as we work to share stories and reach people outside of traditional museum methods. We recently featured interviews with several museum directors around the world to share visions of museums related to climate change and futures literacy as part of the Museum's Chatter Marks podcast (the series was hosted by Cody Liska and Sandro Debono).

As a museum, we move past the approach of episodic exhibitions and an exhibition that looks at climate change; rather, it is embedded in each exhibition, artist residency, and many public programmes. An upcoming publication uses the DEW Line as an entry point to examine climate change, geopolitics in the Arctic, and artists as an early warning system. Museums can spur action by working across disciplines and across agendas, aiding the breakdown of silos between knowledge bearers and in rethinking the structures that maintain the status quo.

The Museum's Teen Climate Communicators work on tangible projects, co-creating messages and outputs with artists, working on sound ecology, or working in public space on planting, foodscapes, and rewilding. We commission artists to create murals into the urbanscape of the city, including Warming Stripes, a 300-foot mural tracking temperature changes in Anchorage over the last 100 years, occupying the façade of a former department store.

Across platforms

In 2022, *TIME* Magazine (Vince 2022) published an article about where people might migrate to in the face of climate change. By 2047, Alaska could be experiencing average monthly temperatures like Florida today. Alaska braces for the potential 'tropical migrants' seeking new homes as we collectively seek to find or restore a livable globe. At the Museum, we see the potential impact on land, food, housing, transportation, and the sovereignty of self-governed Indigenous communities. We see a responsibility for the museum to support futures literacy, to work with Indigenous communities, start-up companies, government, universities, housing organisations, transportation and energy entrepreneurs, architects and designers, food specialists and others to think about how we will prepare ourselves. We investigate multimodal ways of hosting content, from a museum virtual and printed journal with guest writers and editors, city bike and bus tours, free online curriculum and resources for teachers, videos and films, and large-scale projections on the Museum façade.

Internally, the Museum has a staff working group informally referred to as 'Team Climate', which helps to set organisation goals around climate, hosts climate cafes, and works with the national organisation Ki Culture. The museum works to evolve practices around collections care and carbon footprints, conducting carbon audits and working with collaborating museums across the world to exchange ideas and share approaches, successes, and failures.

Redefining the centre

For Indigenous communities, human relationship with the land is not episodic; it is continuous, expanding across millennia, and reciprocal. Museums can recognise the centres of lived experience as important knowledge centres of climate change. The Anchorage Museum serves as an intermediary for artists, researchers, visitors, ambassadors, and others, asking for a consideration of this complexity and de-centring of Western ideas before supporting residencies, exhibitions, or other public projects. The Indigenous curators at the Anchorage Museum work not just on exhibitions and programmes, but with communities. Senior Curator Aaron Leggett, Dena'ina Athabascan, serves as President/Chief of the Native Village of Eklutna and in both roles focuses on land, language, and Indigenous place names.

A 2023 project at the Anchorage Museum was co-created with an Indigenous healer. Good Medicine *Good Medicine* brought together Indigenous healers and medicine people to collectively create, share knowledge, and practice in the community. Unfolding over the course of a year with the work of different Alaska Native healers, this multidisciplinary exhibition offered diverse opportunities for gathering and exchange. Colonialism has attacked and suppressed medicine people and Indigenous knowledge systems for hundreds of years. The exhibition addressed harmful legacies and showed how the revitalization of healing practices and traditions provides ways of being in alignment with oneself, with community, and with our planet. Curated by Tlingit traditional healer Meda DeWitt, *Good Medicine* emphasised spiritual renewal, cultural renascence, and the importance of co-creating futures where nature can thrive.

Contemporary artists as catalysts

Solastaglia, the term combining the Latin word solacium (comfort) and the Greek root algia (grief and suffering), references the existential human distress caused by environmental degradation and the loss of the known relationship with the landscape. Museums can connect and reconnect people to the natural world to better understand concepts of deep time and the climate crisis. In partnership with contemporary artists, the Anchorage Museum works to connect to the natural world, to complexify and contextualise ideas of land and human impact. Creative response helps with understanding climate change and envisioning futures relative to our actions.

Alaska River Time is a project with artist and philosopher Jonathon Keats. It engages a network of glacial and spring rivers to regulate a new kind of clock,

which speeds up and slows down with the waters. The clock can be used to re-calibrate all aspects of life from work schedules to personal relationships. River Time is applicable locally and globally, a new standard of ground truth that will be increasingly relevant as we reinforce and reimagine our relationships with the natural world.

Working with artist John Grade, the Museum moves out of its building and into the landscape with installations such as *Spark*, a long-term project exploring how wildfires are becoming more frequent and intense and impacting our shared land-scapes and lives in meaningful ways, and *Emeritus*, which in 2024 will be installed on a remote island in Yukon-Charley Rivers National Preserve in Alaska. It will be suspended from spruce trees in a 'drunken forest' where trees have begun to tilt as the permafrost melts. Forests of the Arctic were also part of a long-term resi-dency and exhibition with photographer Jeroen Torikens, whose project *Borealis* highlights the boreal forests, a band of mainly coniferous trees that extends across Europe, Asia, and North America, which form an essential part of the ecological balance on earth, converting carbon dioxide into oxygen on a large scale.

Conclusion

The Anchorage Museum works to address the climate crisis through implement-ing sustainable practices in our organisations and addressing climate change with our communities. We work with constraints of systems, expectations, dollars, and capacity to meet the needs of our community, centring, as best we can, actions that will have the least environmental impact and ideas for the future that embraces positive change across generations and prepare for a tomorrow. We hold firm in our belief in the imagination. As Xiye Bastida (2020) wrote, 'It's time to change our mindset toward implementing solutions. A vibrant, fair, and regenerative future is possible – not when thousands of people do climate justice activism perfectly but when millions of people do the best they can'.

In her 2019 Nobel Lecture, writer Olga Tokarczuk (2019) offered:

> Today our problem lies — it seems — in the fact that we do not yet have ready narratives not only for the future, but even for a concrete now, for the ultra-rapid transformations of today's world. We lack the language, we lack the points of view, the metaphors, the myths and new fables. Yet we do see frequent attempts to harness rusty, anachronistic narratives that cannot fit the future to imaginaries of the future, no doubt on the assumption that an old something is better than a new nothing or trying in this way to deal with the limitations of our own horizons. In a word, we lack new ways of telling the story of the world.

The issues of our time are forcing an assessment of the strategic value of muse-ums and prompting essential work to prioritise, message, plan, respond, and create. Perhaps 'no waste' is a new core principle going forward – do not waste energy, do not waste relationships, do not waste knowledge.

We embrace the real work in preparing with communities for empowered fu-
tures. The practice requires a new understanding, experimentation, willingness to
fail, emotional labour, and a commitment to shared values with place and people.

References

Bastida, X., 2020. *All we can save: truth, courage, and solutions for the climate crisis.*
New York: One World.
Tokarczuk, O., 2019. *Nobel Lecture: Olga Tokarczuk, Nobel Prize in Literature.* Video. Nobel
prize. Sweden: Swedish Academy in Stockholm.
Vince, G., 2022. Where We'll End up Living as the Planet Burns. *TIME* August 31, 2022.

2.15 *Someday, all this*

The Climate Museum Pop-Up in Manhattan

Samira Siddique and John Linstrom

Introduction

In a narrow gallery, nestled among the rumbling brick streets and luxury cloth-ing stores of SoHo, visitors from across New York and around the world came together to ask the question: what kind of climate future will I help to create? 'Free for All', declared a prominent decal on the front window, defying both the hyper-consumerism of the brand-name storefronts surrounding it and the gimmickiness of the for-profit Museum of Ice Cream a few blocks away.

In a brightly lit space, amply staffed by a team of visitor liaisons, high-school docents, and multigenerational community volunteers, visitors spent time in front of a stunning mural by David Opdyke titled *Someday, all this*, depicting a surre-alistic representation of climate chaos, before progressing into the Climate Action Incubator. There, on one wall, a cascade of text and images unpacked the findings of recent social science research pointing to a supermajority of support for cli-mate justice in the United States. The rest of the space was devoted to simple but meaningful actions that visitors could take to help build a climate-just future, and whatever they could not do directly in the exhibition, they could publicly commit to do after leaving.

The authors of this case study had many opportunities to play the part of visi-tor liaison in the one-room exhibition, and one encounter early on stuck with us. As she left the space, a young woman said to one of us in passing, 'You know, my concern about the climate crisis has often felt really isolating. This show made me feel less alone'.

Contending with the climate crisis at scale, and building climate futures that centre justice and equity, requires a transformation of our public culture – a trans-formation away from the isolation of perceived powerlessness toward communities of collective action. The Climate Museum mobilises the power of arts and cultural programming to accelerate this shift toward climate dialogue and action, connect-ing people and advancing just solutions. We believe that the Climate Museum, as the first climate-dedicated museum in the United States, holds a unique change-making capacity.

This case study focuses on the seven-month run of the Museum's first transit-accessible pop-up exhibition, which opened in October 2022. Central to the social

DOI: 10.4324/9781003474975-23

science structuring the pop-up was a crucial question of futures literacy: as it turns out, most people in the United States are worried about the climate crisis and would support major legislation on climate justice, but this majority thinks themselves to be in a minority and has consequently remained largely silent and inactive. The exhibition focused on helping people learn how and why to break this 'climate silence' and recognise their agency in a wider community of action.

A theory of change

Across its exhibitions and programmes, the Climate Museum is committed to help-ing visitors reflect on what it means to be human at this moment of profound chal-lenge, how to increase our self-understanding in light of such knowledge, and how to act. To the extent that museums will live up to their social potential as cultural institutions for the public good, we believe that such experiments linking the cul-tural authority of museums to the mobilisation of movements for climate justice are urgently needed across the museum sector. The Climate Museum is engaged in New Museology, a movement among museum professionals that sees museums as potential sites for civic engagement. The Museum utilises the public's deep civic trust in museums to engage visitors in education about the climate crisis, create a sense of agency, and inspire collective action (Carnell 2023).

Today, facing the existential threat to all futures posed by climate change, the phenomenon of specifically climate-centric museums has gained traction interna-tionally, all seeking to galvanise climate action (Newell 2020). Empirical research is catching up with the experientially rooted intuition of these efforts. A recent study of US residents indicates that artistic representations of climate data elic-ited more positive emotions in viewers than bare graphs, without impacting the information's credibility. The same study also found that such depictions mitigated political division among respondents, whereas the graphed information actually exacerbated those same divisions (Li *et al.*, 2023).

This power held by the arts is particularly significant in the context of a public climate sentiment characterised by a paradoxical mix of overwhelming public sup-port and individual perceptions of isolation. Recent studies of the US public bear this paradox out: two-thirds – a supermajority – of Americans support progressive policies to mitigate climate change, including 69% in support of diverting federal funds specifically to low-income communities and communities of colour who are so often treated as the sacrifice zones of the fossil fuel industry (Leiserowitz *et al.*, 2022). Yet the American public perceives the opposite: while roughly two-thirds of Americans support such policies, nearly all believe that only one-third are in sup-port, a phenomenon that Sparkman, Geiger, and Weber describe as a 'false social reality' (2022). The Climate Museum Pop-Up's social science wall told the story of these two studies on American perceptions of climate sentiment, busting the myth of American climate indifference and calling on visitors to bust the myth in their own lives.

The curators also noted that the isolation and overwhelm heightened by this false social reality are further compounded by the intentional efforts of fossil fuel

companies. BP, for instance, notoriously invested in popularising the concept of the carbon footprint to shift blame from producers to consumers. The greenwashing of companies like Shell, which loudly advertised its intentions to achieve net-zero carbon emissions while internally describing those commitments as having 'nothing to do with our business plans', obfuscates their global culpability in the climate crisis (Tabuchi 2022; Yoder 2020). The result is a culture of climate silence – despite two-thirds of Americans supporting bold climate action, only about six percent describe themselves as taking action on climate in their own lives, and that includes the action of merely discussing climate change (Leiserowitz *et al.*, 2022).

In the face of such silence, the potential energy of the supermajority for climate justice remains merely theoretical. The Climate Museum team discovered early on that virtually none of their visitors needed to be convinced of the reality of anthropogenic climate change. Rather, their mission is to build a culture for action – to facilitate the activation of that supermajority to imagine and build futures centred on climate justice.

The Museum directs its exhibitions and programming toward that largely unactivated supermajority, with the goal of pushing them toward civic engagement. The Museum's interactive cultural programming (whether workshops on poetry-writing and climate communication, or expert panel discussions, which always involve action tasks and moments of audience participation) allows visitors to gain understanding, agency, and resolve, and to become cultural ambassadors themselves. The Museum's youth engagement and advocacy programme, the Climate Action Leadership Program (CALP), includes high school students primarily from New York City but also from across the United States and internationally. It seeks to empower young people so that they can begin their own climate conversations and host campaigns in their schools, neighbourhoods, and communities. This is also the emphasis of adult-focused programming: every panel, book talk, social hour, or artmaking event concludes with an action task. But the core of the work is the curation of spaces that bring people together around a shared artistic and emotive experience and a set of empowering information that leads to climate engagement and agency.

This curatorial orientation shapes the Climate Museum's approach to education as well. Educators are embedded in the exhibition space, interacting with walk-in visitors as well as giving tours to scheduled groups. They are trained not only in the exhibition content, but also in strategies for hospitably engaging in productive dialogue. Solo-oriented visitors who are comfortable in museum spaces and would prefer a quiet walk-through are allowed to engage in that way, but educators attempt to extend to everyone the invitation to conversation.

Experiencing the Climate Museum Pop-Up

A visit would go something like the following. Walking through SoHo, you come upon a sidewalk chalking drawn that morning, an illustration of the Earth with the written invitation to 'take action on climate' and an arrow pointing down the block. Several storefronts down, a simple sign reads 'The Climate Museum'.

Inside, a museum educator in a blue apron greets you. They explain that the show centres around a twofold message: that Americans supporting bold action for climate justice represent a supermajority, and that every visitor to this space has agency to affect climate policy and build a better future. The show itself consists of two parts: the educator continues. Opdyke's monumental postcard mural dominates the wall to your right, illustrating a vision of climate and political chaos. Further into the space is the climate action incubator, where you will read about some surprising social science research concerning American perceptions of support for climate action. You will have several opportunities to take action before you leave.

You are invited to spend some time with Opdyke's mural. Each of the 400 postcards that constitute the mural depicts a real landscape from somewhere across the United States. They have been individually mounted on the wall like pixels and worked into a surrealistic landscape that turns around itself: a landmass of right-side-up postcards spanning the bottom of the mural is roughly mirrored by an upside-down landmass along the top, with a sealike expanse of water and sky separating the two. All the micro-landscapes forming this macro-world carry a patina of age and a certain kind of American nostalgia – they all date to the period of lithographic printing in the early twentieth century. That nostalgia has soured under the artist's brushwork, which blends uncannily well into the lithography. Some of this is tasteful kitsch: giant moths and caterpillars destroy buildings and bridges; purple tentacles emerge out of estuaries. One postcard depicts only a flying fish over a field of water and a sunset horizon with a barcode painted across its abdomen, wryly encapsulating the indelible stamp that capitalism has placed upon the most 'wild' of places. No sources of nostalgia are safe – there is nothing to look back to.

Comic moments collide with scenes of violence and uprooting – pleasure boats and ferries have been repurposed as transports for the dispossessed, and the world of the mural is filled with climate refugees seeking safe havens. At all ports, boats are met with billboards screaming slogans like 'GO HOME' and 'REFUGEES NOT WELCOME HERE'. Beyond its occasional gallows humour, this is a bleak dystopia, with political violence simmering just below every surface. The ships are all called 'Ark' (numbered I, II, III, IV, etc.), but no dove appears, no sprig of promised relief. Meanwhile, dozens of rockets you might imagine to be carrying billionaires streak across the mural's far background – but, to where? With the world curled around itself, it is not clear they have anywhere to go but toward further destruction. A moth demolishes one of them in the foreground in a satisfying display spanning several postcards. Meanwhile, the mural's 400-card grid twists and rips, broken along several fault lines suggesting movement. This unseen centrifugal force is counteracted only by giant bungee cords hooked around buildings and mountains seeking to hold the world together. Even they begin to snap under the pressure.

The more time you spend with it, the more ways the mural invites you to consider how our own physical and political landscapes strain under the pressures of so many unsustainable forces. You engage in a kind of conversation with the artist, if not literally with the museum educator nearby, that is made bearable by the mural's humanity and range of emotion.

As you step farther in, another educator shows you the social science wall, where much of the information presented earlier in this essay is described and illustrated with simple pie charts and bright accents. To know that others around you share the anxieties that the mural may have rekindled in you moments before and that one of the most powerful changes we can make in our lives is to act out of the confidence of that knowledge is to reject the sort of future the mural invokes. Moreover, to know that your felt isolation stems from the deliberate obfuscations of bad actors in the fossil fuel industry clarifies that your sense of despair is neither your fault nor preordained.

An educator gestures around the space for you: beside the social science wall stands a soundproof booth set up with a wall-mounted tablet for video recording and some simple prompts to help you reflect on your own climate anxiety and the messages you are taking away from this experience. Beside that is a display of books scattered around some spacious benches where you can sit and peruse a novel by Octavia Butler, an essay collection by Naomi Klein, or illustrated children's books on climate change. Next is a table stocked with postcards reproduced from the altered cards of Opdyke's mural, where you can concretely turn the despair of those images into constructive action. A tablet is programmed to let you quickly look up your political representatives. Simply write the politician's name on the card, and the staff will finish the address and mail it for you after you leave, even internationally. A couple of laminated sheets provide numerous prompts, encouraging you to write from your own emotional experience. You could easily write several in five minutes.

Finally, you come to the Climate Action Wall. The left side is covered in colourful prints of different sizes, listing concrete climate actions you might take after you leave the space, emphasising collective and civic action: join a march, write to your representatives, join or start a climate justice organisation in your community, or simply commit to more climate conversations to 'bust the myth' of climate indifference. To the right of that space of colourful text, separated by a structural column, is a space of equal size that began as a blank white slate when the exhibition opened with these words in the middle: 'Here's the truth'. An educator stands behind a table with rolls of brightly coloured stickers, each one proclaiming a different commitment to climate action and encourages you to select one or as many of the stickers as you would like and place them on the wall. Within weeks, the wall's indifferent blankness was filled with the colourful representation of the community of climate action coming through the space. You see concretely represented your own agency and commitment and that you are not alone.

Here's the truth. Visitors already intuitively know that meaningful futures cannot be built by individuals in isolation. Just like the young woman we met in the early weeks of the exhibition, who left the space empowered by the mobilisation of art, data, and action, we hope every visitor who comes through the Climate Museum leaves feeling less alone and ready to be part of the safe and just climate future we all deserve.

References

Carnell, H., 2023. Picturing the end of fossil fuels: inside the first climate museum. *Mother Jones*. Available from: https://www.motherjones.com/environment/2023/10/climate-change-museum-environment-justice-new-york [Accessed 12 October 2023].

Leiserowitz, A., et al., 2022. *Politics & global warming [online]*. New Haven: Yale University and George Mason University. Available from: https://climatecommunication.yale.edu/publications/politics-global-warming-april-2022/ [Accessed 12 October 2023].

Li, N., et al., 2023. Artistic Representations of Data Can Help Bridge the US Political Divide over Climate Change. *Communications Earth & Environment* [online] 4,195. Available from: https://doi.org/10.1038/s43247-023-00856-9 [Accessed 12 October 2023]

Newell, J., 2020. Climate museums: powering action. *Museum Management and Curatorship*, 35 (6), 599–617. Available from: https://doi.org/10.1080/09647775.2020.1842236 [Accessed 6 October 2023].

Sparkman, G., et al., 2022. Americans experience a false social reality by underestimating popular climate policy support by nearly half. *Nature Communications*, 13, 4779. Available from: https://doi.org/10.1038/s41467-022-32412-y [Accessed 16 October 2023].

Tabuchi, H., 2022. Oil executives privately contradicted public statements on climate, files show. *The New York Times*. Available from: https://www.nytimes.com/2022/09/14/climate/oil-industry-documents-disinformation.html. [Accessed 14 October 2023].

Yoder, K., 2020. Footprint fantasy: is it time to forget about your carbon footprint? *Grist.* Available from: https://grist.org/energy/footprint-fantasy/ [Accessed 6 October 2023].

2.16 Interview: Museo Interactivo de Economia

Futures-orientation for improved decision-making with MIDE

Brooke Ferguson, Silvia Singer, Paloma Salgado, and Kristin Alford

Background

An interview with Silvia Singer and Paloma Salgado, Museo Interactivo de Economia (MIDE).

The mission of Museo Interactivo de Economia (MIDE) is to grow critical and creative thinking through the lens of the economy, to improve the decision-making capabilities of its young adult audience to lead to better well-being on individual, familial, communal, national, and global levels in the future. Everything in the museum refers back to daily life to create a sense of belonging and relatability for visitors, which can increase motivation to take action towards preferred futures. Science centre methodologies such as interactivity, sparking dialogue and science communication techniques are implemented in exhibits to prompt people to enquire rather than conclude. These approaches are addressed through the museum's economic focus, encompassing long-term topics such as sustainable development, the economy, and finances. This interview explores these themes and the methodologies that MIDE uses to grow futures thinking capability for the improved well-being of MIDE's visitors both now and in the future.

What is MIDE?

Silvia notes that 'MIDE opened in 2006 as the first museum that dealt with economy in an interactive way… as a proposal from the Mexican Central Bank, who thought very correctly, that the general public and society needed to know a little more about the economic part of living'. She also explains that the museum's target audience is 'youngsters ranging from 15 to 25 years old'.

Paloma outlines the key themes threaded throughout MIDE. 'Our main focus is economics. We define economics as decision-making. What lies behind the decisions we make as individuals, as families, as communities and countries and then the world… With topics branching out into finance and sustainable development, as we believe it's [the economy] a whole narrative'.

Throughout its 22 years, MIDE has regularly updated its content to best fit the interests of a changing society. For example, the sustainable development theme was introduced in 2011, in response to these changing needs. Now, the museum is

DOI: 10.4324/9781003474975-24

going through another phase of transformation, which puts futures thinking at the forefront, because as Silvia noted 'we know there's an urgent need to change, to take care of new things that our audience cares about'.

Critical and creative thinking for decision-making

The MIDE team is working to instil in their visitors the capabilities to make more thoughtful decisions, as our decision-making processes inform the kinds of decisions we make about the present and our futures. As such, building critical and creative thinking skills is at the core of MIDE's vision, aiming to improve how visitors build a broader understanding of present situations and consider future possible alternatives and consequences.

In Combs *et al.* (2009), the authors noted that critical and creative thinking are vital skills needed by students to thrive in complexity. Paloma defines these thinking processes as follows – 'Critical thinking is the ability to discriminate information, transform it and use it in a different way... Creative thinking is the ability to think outside of the box, to think the impossible, and to try to build that'. Silvia added that 'one is impossible without the other'. Paloma notes that these skills are important for our futures because 'If you have the ability to obtain information, discriminate information, get what is valuable and what is responsible and ask the questions, that are needed to transform it into something that's working for your well-being and the well-being of your community that's the future, that's working for not only myself but thinking next steps'. Silvia adds, 'Once you start analysing or opening conversations about how you make decisions, and what lies behind your decision making, or the country's decision making, automatically you have to talk about the future, right? Because what's going to happen next? What are my decisions? How am I going to allocate different resources? My time, my money, the country's resources. We need to be creative and critical about our choices because we're responsible for the future... my family's future, my community's future, the global future'.

Although critical thinking is a vital skill for futures informed decision-making, Tonn (2003) notes that making decisions about futures is difficult and it helps if people can be provided with methods that allow them to organise information from which thoughts and decisions can be made. Furthermore, Doncean and Doncean (2022, p. 123) emphasise that the world is a direct representation of our thoughts – 'we build the world with our thoughts' – suggesting that more creative thinking could lead to a greater range of futures alternatives for consideration, and a reframing of the opportunities available in the present. An example of how MIDE works to build these thinking skills can be found in their 2011 exhibition *Foro del cambio climático* (Climate Change Forum), a collaborative role-playing experience where participants in groups of three are given a set of data pertaining to a specific country. After analysing their countries' data, all participants engage in dialogue in order to arrive at international agreements that may lead to the common goal of reducing global CO_2 emissions and the rise of global temperature. In order for the exercise to be completed, the participants must utilise their critical thinking skills as they

engage in constructive dialogue to discover how countires have different standing points and interests around climate change, and the difficulties of coming up with solutions to protect the planet.

Belonging, daily life and well-being

Recent studies in the field of psychology from Pardede *et al.* (2021) describe belongingness as a fundamental need to fuel human motivation, leading to action in the present towards preferred outcomes and goals. MIDE seeks to facilitate feelings of belongingness for visitors by incorporating examples from everyday life that link visitors to their place in the world, both now and in the future, with the hopes that motivation to work towards preferred futures will grow.

According to Silvia, this sense of belonging is important because 'Futures literacy requires that people can envision the future and how they picture themselves in the future'. 'Let's try to make an identification between the visitor and the topics in the museum, a sense of belonging, so they can open themselves up to thinking that they are part of this [futures-building] process'. MIDE creates this sense of belonging in their exhibitions through incorporating objects and ideas that are familiar to visitors, 'every example/figure/image used in the museum relates to people's daily lives', Silvia elaborates, explaining that MIDE 'addresses some of the real problems we have in Mexico… we don't want to make this a horror film, but we don't want to make it a fairy tale'. The incorporation of daily life objects and tropes is made particularly evident in the exhibit, Vivir en sociedad (Living in society), 2006, where a mix of audiovisual tools with real everyday life objects (such as a shower, a juice stand or a football stadium) guide visitors through the different ways in which we are all connected through the work we do to contribute to society's well being. The use of these everyday objects in combination with themes of connectedness can help visitors to feel a sense of belongingness in both the physical space of the museum and the subjects at hand.

Silvia states that its also important for MIDE to create a sense of belongingness for those who may often be excluded. 'Why design something for the future, that is not inclusive? Is it really producing the well-being we want? Is it really for everybody? Is it really going to make us live better?… So access is another thing that has to be present in our exhibits, how can you think of well-being if you don't have access to clean water, clean air or education? So, if you're a woman, you stay at home helping with chores, instead of going to a high school or university. So this is the kind of things, real things, that are in these youngsters' minds. They live it every day. So that's the kind of thing that we call daily life. We try to make it real'.

MIDE further draws links between their exhibits and belonging through the representation of a future that many prefer: better well-being for all. Silvia explains 'We all want to live with a certain degree of well-being. I don't know anybody in this world that doesn't want well-being'. Paloma then brings this back to critical and creative thinking and how they 'allow us to appreciate or discriminate what is valuable, to make different decisions, decisions that can build a better well-being'. The methods that MIDE implements in its museum design do not sit on their own

but instead link back to and layer on top of one another, working together to build futures thinking capacity of its visitors for improved well-being.

Science centre methodologies

The next set of methods that MIDE considers when designing for the museum comes from the theories informing science communication and the development of science centre models. These include communicating complex topics in accessible ways, sparking dialogue through collaborative activities and engaging audiences through play and interactivity. Silvia explains how MIDE's work 'act as bridges between the experts and the audience, for them to understand a certain idea'.

Science communication

In contrast to futures work that might prompt visitors to imagine speculative futures, the exhibits at MIDE draw on an evidence base from which to prompt discussion around probable and preferred futures. Silvia explains 'We use only information that has proof that it's real'. The exhibit, La huella de las cosas (The footprint of things), 2011, is a sound example of scientific research acting as the foundation of an exhibition element. Visitors can explore the impact that different products related to their everyday life have on water consumption and CO_2 emissions. The interactive draws on multiple evidence bases, providing visitors with different sources of information so that they can explore these impacts with nuance, whilst contemplating their personal values now and looking forward.

Collaborative activities to spark dialogue

Collaborative activities to spark dialogue between visitors is another key tool MIDE facilitates to provoke conversations around alternative and preferred futures, as it is through these conversations that imaginations can be shared and explored (Wilkinson and Flowers 2022, p. 76). Paloma explains that at MIDE 'Most of our experiences are collaborative. If you mix provocations, if you mix games and experiences that ask you, push you in a kind of friendly way to talk with the person next to you, so that you can both make decisions together and resolve a game automatically, you're going to create a conversation, you're going to create dialogue. That's one of the main tools that we have in the museum design-wise, to start up these conversations'. A representative example is the exhibit, *Pongámonos de acuerdo* (Let's come to an agreement), 2011, a multiplayer game where each participant is a fisherman and tries to catch as many fish as possible. Soon they realise that they need to put some rules in place in order to preserve the fish population. The game moves in different directions depending on whether or not all players are able to reach several agreements. The way this interactive game is designed pushes people to talk to one another and fully depends on the agreements reached amongst them.

Furthermore, museum floor staff referred to as facilitators are scattered throughout the museum, with the purpose, as Paloma states, 'to provoke conversations, be part of the dialogue and encourage the exchange of ideas among the visitors'. 'We open conversations for them and for us to reflect on how these definitions, or topics, or ways of exploring society impact me, impacts my family, impacts my country and how that allows me to make different or better decisions. Which is linked to the future'.

Futures exhibition hall development

The *Futures Exhibition Hall* is a project being developed by MIDE centred on futures thinking. Paloma explains the project as 'an exhibition hall specifically dedicated to futures thinking that reflects or opens up conversations about probable and possible futures… and what skills and tools we might need to develop or strengthen our ability to not only imagine and dream those possible futures but construct them as well'. As the exhibition is still in the development phase the specificities of what it will involve are not yet finalised. However, basic design principles to guide development have been established. These include an emphasis on ideas, rather than objects, giving audiences set topics from which futures envisioning can launch from, questioning the impact of decision-making and emphasising futures thinking as a tool for human survival and well-being.

Conclusion

With over 22 years of experience communicating topics such as the economy, finance and sustainable development, the MIDE team has gained valuable insights into how to deliver this information effectively. Science centre methodologies such as interactivity, sparking dialogue and research communication techniques are implemented in exhibits that include examples from daily life to create a sense of belonging and relatability for visitors. Growing critical and creative thinking to improve the decision-making capabilities of its young adult audience is a key goal that guides their work on the techniques being implemented in the development phase of MIDE's current work-in-progress the *Futures Exhibition Hall*. It is this focus on making better-informed decisions for the benefit of well-being on individual, familial, communal, national and global levels that aligns with building futures thinking capabilities.

References

Combs, L.B., Cennamo, K.S., and Newbill, P.L., 2009. Developing critical and creative thinkers: toward a conceptual model of creative and critical thinking processes. *Educational Technology* [online], 49 (5), 3–14. Available from: https://www.jstor.org/stable/44429711 [Accessed December 18 2023].

Doncean, M., and Doncean, G., 2022. Critical and creative thinking. *Journal of Public Administration, Finance and Law* [online], (24), 123–132. Available from: https://www.jopafl.com/uploads/issue24/CRITICAL_AND_CREATIVE_THINKING.pdf [Accessed December 18 2023].

Pardede, S., Gausel, N., and Høie, M.M., 2021. Revisiting 'The breakfast Club': testing different theoretical models of belongingness and acceptance (and social self-representation). *Frontiers in Psychology* [online], 11. Available from: https://www.frontiersin.org/articles/10.3389/fpsyg.2020.604090/full [Accessed 14 December 2023].

Tonn, B.E., 2003. The future of futures decision making. *Futures* [online], 35 (6), 673–688. Available from: https://www.sciencedirect.com/science/article/pii/S0016328702001064 [Accessed 18 December 2023].

Wilkinson, A., and Flowers, B.S., 2022. Creating the future. *In:* G. Donnelly and A. Montuori, eds. *Routledge handbook for creative futures*. London: Routledge, 74–80.

2.17 How to make visions of the future accessible?

The Deutsches Museum Nuremberg

Andreas Gundelwein, Melanie Saverimuthu, Maike Schlegel, and Aron Schöpf

Introduction

The city of Nuremberg, Germany, has been transforming from an important industrial location into a high-tech region for years. Renowned research institutes have been established next to the long-standing Friedrich-Alexander-Universität Erlangen-Nürnberg (FAU). In this setting, the idea of the Future Museum was born to showcase current and expected technical innovations and their potential structural and social impact.

The Zukunftsmuseum opened in 2021 as the newest branch of one of the world's largest science and technology museums, the Deutsches Museum in Munich, Germany (Deutsches Museum 2023). Based on a classic exhibition entitled 'science or fiction', technological prototypes – contextualised by ethical and social aspects – offer insights into technology-based images of the future. A deliberately created field of tension between technology and visions of the future borrowed from science fiction creates space for discussion.

But how might visions of the future be experienced? How to report on a time that has not yet occurred – with objects not yet invented? And what are we to make of forecasts that tell us of futures where technologies such as flying cars will be the norm by 2030? (Partridge 2021).

Making images of the future accessible

The Zukunftsmuseum uses scenario methods to present current research and explore possible futures (Godet 2000, Meinert 2014). Prototypes from science and industry research laboratories, future technologies, and innovations are presented in the form of classic museum exhibits. These objects are combined with visions from science fiction as a way to reflect '[the] hopes and dreams and fears […] of a technically based society' (Campbell cited Bereit 1969, p. 897). Consequently, science fiction narratives provide an ideal basis for encouraging visitors to think in terms of possible futures, and to imagine and verbalise their hopes and fears associated with the technologies presented. The combination of these objects and science fiction visions serves to create a starting-point for the exploration of possible

DOI: 10.4324/9781003474975-25

scenarios with endings that may be utopian, dystopian or anything in between. The positioning of these scenarios in a future time captures visitors' curiosity and offers them the opportunity to cast aside existing ignorance, fear and hesitancy concerning innovations and replace them with interested participation.

Current research shows that the visions from science fiction are often actually perceived as more real and closer than the actual state of scientific research and the resulting possible scenarios. This is the case, for example, with artificial intelligence (Prohl 2021); beliefs in the omnipotence and dominance of artificial intelligence are shaped by the portrayal of this technology in science fiction and the media.

These perceptions and the hopes and fears of each individual are given space to be discussed in the field of tension between science and fiction that is prompted by the exhibition. A discursive space is created to encourage the free expression of opinions, a change of perspective and the development of multiple points of view.

Interactive exhibits intensify the engaging experience. They draw the visitors into specific scenarios based on the technologies presented, and see that they grasp the possible consequences first-hand. The 'planned child game' exploring genetic technologies, for example, inspired by the movie *Gattaca* (1997), assumes such an advanced level of DNA analysis technology that within a given financial budget, several choices to 'design' a baby can be made. The interventions range from 'intelligence' to 'social competence', from 'health' to 'colour of hair, eyes and skin'. By engaging, visitors are automatically confronted with questions concerning personal priorities – and with ethical frontiers and boundaries: Is this the way we want to act personally – and as a society?

Thus, by juxtaposing science and fiction, utopia and dystopia, the Zukunftsmuseum creates a space of possibility that can be shaped, a place for technical-ethical discourse, and makes images of the future accessible.

Designing on both science and fiction: Building by design

The juxtaposition of science and fiction was taken literally and implemented throughout the exhibition design. The room is shaped by a grid that is very clear and concise in the 'science' area, but dissolves in the 'fiction' area. The science area tends to have lighter colours, and symbolises the apparent clarity and security of science. White furniture dominates, displaying prototypes like the 'Audi Pop.Up Next', an air-based mobility study. Together with demonstrations and explanatory graphics, the objects form the starting-points for imagining various futures.

In the 'Fiction' area, the grid increasingly dissolves into fragments, leaving a darker overall spatial mood. Here, emotions are more in focus as visitors leave the 'Science' area of seemingly secure knowledge and enter uncertain, undefined terrain. Black display units present both familiar and unfamiliar visions from film and literature, utopias and dystopias, and social and ethical dilemmas.

Based on this underlying structure of 'science or fiction', five future-relevant topic areas were identified to frame expected technological changes and resulting social

changes (European Commission 2014; Franklin 2017; Lynch 2018). These topics start in the very personal environment of the individual, in categories such as 'work & everyday life' and 'body & mind', then broaden the perspective to a larger environment, the 'system city', and even further to the 'system earth', and finally culminate in humankind's still-current dream of 'space & time', the conquest of space.

Interaction and discussion

The exhibition at the Zukunftsmuseum repeatedly confronts visitors with provocative questions about technologies and the possible ethical conflicts that arise from them. In connection with common narratives of utopian and dystopian worlds, of dreams and fears, these questions demand decisions from the visitors. But none of the possibilities are only 'good' or without disadvantages for themselves or others. In this field of tension, it is important for individuals to develop their own attitude to technical-ethical questioning. To encourage visitors to make decisions and think about solutions to the questions and dilemmas raised in the exhibition, we have developed an overarching game. It enables the visitors... to discover a wide variety of exhibits in the exhibition by themselves and take them along into 'their personal future'. Based on their collected selection of exhibits, each visitor receives an individual kaleidoscope of utopian and dystopian future scenarios that project possible consequences of the chosen 'future technologies'.

All thematic areas offer interactive stations with questions that stretch the field of tension between science and fiction. Visitors are confronted with extreme choices like the 'planned child game' described above. In the exhibits, the focus is on physical experience where visitors might encounter science-centre elements such as the 'zero-gravity tower', as educational interactives for various technologies are presented. Yet there is also thought to the visitors feelings and emotional empathy. Both these approaches are intended to encourage visitors to deal with difficult ethical questions and to adopt and discuss new perspectives.

With regard to the motivation for discussing a certain technology, the provocation here is not to evaluate the technology, but to put the visitors into a possible scenario, to follow it through and to use it as an entry point for a discussion. Each scenario contains questions for the visitor: 'What does this do to you?', 'What kind of emotions does it trigger?', 'Do you feel good using this technology?'.

Visitors will find their personal future scenarios, as well as information on which technologies are most frequently taken into the future by other visitors, in the forum – the central space of the museum. Here, these personal future scenarios and ethical choices can be compared with those of other visitors. This fosters a direct dialogue about the shaping of the future, the importance of the individual and society within this process, and the extent to which technology should influence our personal lives and society in the future. Additionally, these statistics can be evaluated and thus also provide conclusions, for example, whether visitors' selection of exhibits for their journey into the future has changed in step with a changed political or ecological situation.

Ideally, the interactive nature of the exhibition and the multi-player games allow visitors to enter into direct conversation with each other and to engage in a dialogue about the future. Knowing that this is an ideal case, that not every visitor sees strangers as welcome interlocutors and that some technological developments also trigger strong reservations and fears, we had to create a low-threshold mediation and discussion offer. This is the role of Future Communicators colleagues who are trained in rhetoric and well versed in the ethical issues of the exhibition, who are available to our visitors for questions and exchanges throughout.

As the name suggests, our Future Communicators have a clearly differentiated task within the framework of the exhibition. Unlike in classic museums, their task is not primarily to impart knowledge, but can rather be described in terms of what has been known since Plato as the Socratic method (Benson 2000). Their task is to encourage our visitors to find out facts for themselves by means of appropriate conversational offers and queries.

Insights, outlooks, foresights

After initial teething troubles due to the large number of media technologies used, we can now look back on two years of the Zukunftsmuseum, with more or less consistently positive feedback from visitors. The new discursive approach, which no longer focuses on the exhibit but on the ideas and feelings surrounding it, also ensures greater diversity among visitors.

The approaches to the technologies and images of the future associated with them are not purely technical, but also offer space for personal, social, economic, political, and emotional knowledge.

What can be observed is the importance of direct personal exchange, especially at provocative interactive stations, and thus the importance of an adequate number of Future Communicators. What remains is the continued attempt to find emotionally intelligent, empathetic colleagues for the exhibition and, at the same time, to look for new technical solutions that can more or less cushion the possible loss of personal contact because discussion only works with at least two people in direct exchange.

Nevertheless, it is clear that we want to continue in this way, because this is where we can really make a difference. We can dispel fears and uncertainties, include visitors in the technical-ethical debate and encourage them to actively shape the future.

References

Benson, H., 2000. *Socratic wisdom*. Oxford: Oxford University Press.
Bereit, V.F., 1969. The genre of science fiction. *Elementary English*, 46 (7), 895–900.
Deutsches Museum, 2023. *Leitbild* [online]. Available from: https://www.deutsches-museum.de/museum/ueber-uns/leitbild [Accessed 26 October 2023].
European Commission, 2014. *Future and Emerging Technology* [online]. Available from: https://wayback.archive-it.org/12090/20220124102605/https://ec.europa.eu/programmes/horizon2020/en/h2020-section/future-and-emerging-technologies [Accessed 27 October 2023].

Franklin, D., ed., 2017. *Megatech: technology in 2050*. London: Profile Books

Gattaca, 1997. *Film*. Directed by Andrew Niccol. USA: Columbia Pictures.

Godet, M., Roubelat, F., and Guest Editors, 2000. Scenario planning: An open future. *Technological Forecasting and Social Change*, 65 (1), 1–2.

Lynch, G., 2018. *Get technology: be in the know. Upgrade your future*. London: Quarto Publishing.

Meinert, S., 2014. *Field manual – Scenario building* [online]. Available from: https://www.etui.org/sites/default/files/2014_Scenario_Building_DEF.pdf [Accessed 27 October 2023].

Partridge, J., 2021. Flying cars will be a reality by 2030, says Hyundai's europe chief. *The Guardian,* 29, Jun [online]. Available from: https://www.theguardian.com/business/2021/jun/29/flying-cars-will-be-a-reality-by-2030-says-hyundai-europe-chief [Accessed 26 October 2023].

Prohl, I., 2021. Material religion and artificial intelligence. *Material Religion*, 17 (4), 540–543.

Approach 4: Imagining immersive experiences of futures

2.18 Future narratives in screen culture

Chelsey O'Brien, Seb Chan, and Keri Elmsly

Introduction

Since reopening in 2021, the Australian Centre for the Moving Image (ACMI) has solidified its reputation for innovation, originality, and ground-breaking exhibitions. Lead by a visitor-first approach, ACMI seamlessly bridges both online and in-gallery experiences to be a multiplatform museum. Under the leadership of new Director and CEO Seb Chan and Executive Director of Programming, Keri Elmsly, ACMI is redefining its primary role for the 2020s as a future-focused museum (ACMI 2023). Together with museum-wide programmatic shifts, showcasing this change in direction is the development of a new major exhibition, *The Future & Other Fictions,* exploring the people, artworks and ideas that are shaping futures through screen media.

Speculative fictions of the past have shaped the realities we live in. From ancient myths and legends to Victorian-era experiments in technologies, cyberpunk, and climate fiction (cli-fi), future worlds have long fascinated and inspired us. In the 20th century, film and TV became vital to how different publics around the world envisioned different futures.

This process of bringing futures to life on screen is an active process of 'futuring'. Futuring as a project is one that we can all actively shape and define. As late 20th century US businessman and futurist Alvin Toffler and co-author Heidi Toffler are often paraphrased, 'The illiterate of the 21st century will not be those who cannot read and write, but those who cannot learn, unlearn, and relearn' (Toffler 1970, p. 367). Museums are increasingly turning to futuring as a means to explore their relevance as civic institutions in their communities. As informal learning spaces, museums can seed the kernels of new practices.

By juxtaposing visions of the future influenced by the predefined paradigms established in the 20th century with new world visions, the exhibition reveals the positive possibilities of tomorrow. At the time of writing, this new exhibition, *The Future & Other Fictions,* is still being crafted by ACMI curators Chelsey O'Brien and Amanda Haskard and director and speculative architect Liam Young. Positive futuring is collaborative. This exhibition develops rich perspectives of futures through the collaborative design of themes and experiences, embracing diverse voices through a range of artists, production designers, screenwriters, poets, costume designers, gamemakers, and speculative designers.

DOI: 10.4324/9781003474975-27

This case study explores ACMI's curatorial methodology and audience-centred approach to exhibition making, which hopes to result in museum visitors building futures literacies and feeling empowered to create the futures they need now.

Exhibition content parameters

Within screen culture, there is a wide range of narratives that incorporate either dystopian or utopian visions of the future. The exhibition reframes these to embrace a third option: protopian visions where improvements are made incrementally through realistic solutions (Kelly 2010). From Channel 4/Netflix series *Black Mirror* (2011-ongoing) to *Blade Runner* (1982) to the blockbuster video game *BioShock* (2007) and many contemporary artworks, there were countless narratives to consider. Thus, it was important to establish some parameters that would allow us to refine or, more specifically, limit the content:

- Content should be from 1970 to the present day. It is from the 1970s onwards that special effects became more sophisticated and visually spectacular. Additionally, the visual quality of screen narratives from this period shifted to what contemporary audiences are familiar with seeing today, maintaining a consistent visual aesthetic for screen displays.
- So that visitors can relate to on-screen narratives, future worlds should be 'plausible' in relation to our current world. They should not include time travel or fantasy themes such as monsters or zombies. Similarly, narratives should primarily take place on Earth rather than in space, as this reflects most people's lived experiences.
- Content should challenge predefined paradigms and hierarchies, presenting imaginings that question traditional constructs and embrace imagining beyond the dystopian-utopian spectrum.

Of course, all rules are made to be broken, and with such parameters, we are faced with exceptions. This is especially true within the science fiction canon, which we see as a clear entry point into contemporary understandings of futuring onscreen.

First Nations voices

Like Afrofuturism, Indigenous Futurism is an activist practice that imagines Indigenous people in the future (Saunders 2022). Indigenous Futurism expert Grace Dillon considers Indigenous Futurisms as a form of 'survivance'. Survivance stories 'are about persistence, adaptation, and flourishing in the future, in sometimes subtle but always important contrast to mere survival, or the self-limiting experience of trauma and loss' (Dhillon, 2016). For Dhillon, survivance is expressed not only as surviving, but flourishing. This means existing on

First Nations terms in a tradition of future-making that embodies complexity and ever-flourishing life.

As ACMI curator Amanda Haskard articulates, 'for Australian First Nations people, the apocalypse was the beginning of the "colonial utopia"'. Australian First Nations people have been resisting and surviving against the colonial dream, one that makes no space for Blak futures (Australian First Nations futures). Australian First Nations stories have always reflected Indigenous futurism, with ancestors shapeshifting, time-shifting, sky knowledges, and natural science. First Nations people are the oldest scientists in human history. These First Knowledges, coupled with the cyclical nature of Blackfulla time, encapsulate how Blak futures look to the past to envisage the future. In this way, Blak futures look to the past to envisage the future. This experience is of both yesterdays and tomorrows.

In curating the exhibition, we must ask what qualifies as Indigenous Futurisms, and crucially, how can we investigate this topic with care? Working closely with co-curator Amanda Haskard, a proud Gunai/Kurnai woman, an Australian First Nations framework was established, outlining key questions that we can return to throughout the exhibition-making process.

- Intention of terminology:
 How are we framing and contextualising our use of terminology?

- Acknowledging and dismantling hierarchy:
 To put it plainly, are we tokenising First Nations people or ideas?

- Artistic intention and process:
 What are the artist's and maker's intentions? What drives their practice?

- Artist and curator relationship:
 Are we creating a culturally safe space for artists? How are we accessing and providing resources so artists may execute their ideas?

- Sustainability & connectedness:
 How do we maintain artistic integrity when curating in an institutional space? And how does this curation foster connectedness?

Visitor-centred approach and outcomes

Since ACMI's major redevelopment (2019–2021), ACMI has formalised its approach to visitor outcomes by developing a two-stage working methodology.

Stage one documents the ways in which our exhibition development and the exhibition design will work towards centring the visitor and delivering thematically tied exhibition outcomes. It is also a process that ensures we are aligning our work back to our organisation vision, mission and strategic plan. Developing visitor outcomes is an iterative and cross-divisional task, with curatorial and exhibitions teams working with our experience, digital and insights team and research group to collaboratively think through what such outcomes will look like.

Developing our visitor outcomes requires answering a series of questions. Firstly, we ask what our desired or ideal outcome would be and the most effective platform through which to deliver it (for example, in gallery or online). We ask why ACMI *specifically* would do this, rather than other galleries, museums or science centres in our city, ensuring we have a clear and distinct connection back to our organisational mission, vision and strategies. For *The Future & Other Fictions*, an exhibition premise that could lead us in a myriad of directions, it was imperative to showcase screen culture and highlight its ever-present influence on how we all imagine what futures could be.

We also consider appropriate measures of success. We measure how successful we are by considering what kinds of feedback we get or what types of actions we want our visitors to take. We also consider what metrics and data sources we can collect. This then forms the basis of our research and evaluation practices in Stage Two.

Visitor outcomes are developed over time and are routinely checked against the exhibition as it develops. Regular meetings ensure that updates in exhibition design are captured in the outcomes and vice versa. Such outcomes simultaneously inform and evolve the curatorial narrative and exhibition themes.

Stage Two begins after the exhibition opens to the public. Throughout an exhibition run, we conduct remedial and summative evaluations. Remedial research allows us to check in with our visitors in the early stages of an exhibition season, whilst summative research gives us the ability to focus on what our visitors got out of the exhibition and whether we delivered on the promised visitor outcomes at the end of the season.

Through this process, we incorporate market research and audience testing into the exhibition-making process, allowing us to refine the narrative and design changes necessary to bring audiences on the journey with us. This is an area we are keenly aware of for *The Future & Other Fictions*.

As a major exhibition in a prominent public museum, it needs to appeal to a broad audience, who are likely not aware of structured approaches to futures thinking. We know that exhibitions need to meet audiences where they are and then meet and exceed their expectations.

The following outlines the three exhibition-specific outcomes developed for *The Future & Other Fictions.*

Visitor outcome 1: Establishing the narrative

'*Visitors will learn about how popular screen media has shaped dominant images of the future*'.

By envisioning different futures, individuals become more aware of their capacity to cultivate the futures they believe they need. It is through actively imagining the future that we develop our ability to adapt and feel better prepared in times of intense change. Yet speculative visions of the future do not exist in a vacuum. On-screen narratives are shaped by many, and more often financially successful,

narratives that have come before. The neon lights and perpetually raining East Asian cityscapes of *Blade Runner* (1982) went on to influence a whole genre of 'cyberpunk' tropes, replicated throughout three decades of film, TV and video games that followed the original *Blade Runner*.

In 1954, anthropologist Kalervo Oberg coined the term 'culture shock' to describe the discomfort felt by people who move into a culture vastly different from their own. In the 1960's, Toffler adapted the term 'future shock', to provocatively describe a cultural and personal sense of 'dizzying disorientation' (Toffler 1965) brought on by the ever-accelerating pace of social and technological developments. Toffler's book of the same name went on to be an international bestseller. As science fiction academic Gary Westfahl asserts, 'our civilisation today is in a state of constant flux, and numerous people are struggling because they cannot readily adjust to constantly changing conditions' (Westfahl 2011).

More recently, future shock is compounded by grim, ever-present realities. Government inaction on the intensifying climate crisis, continuing global conflict and political tensions and the rising cost of living make it difficult to *collectively* imagine a different future, let alone a positive one.

Like all storytelling, speculative fiction has historically been constrained by generations of cultural and gender biases in terms of whose stories are able to be told to wide audiences. This has further limited our ability to imagine possibilities beyond those biases and hampered our ability to think differently.

In establishing the 'canon' of on-screen narratives at the beginning of the exhibition, we can illustrate how such popular and widely held ideas have defined what we imagine as 'the future'. This establishes the framework of the future, which we can then deconstruct in the rest of the exhibition.

Visitor outcome 2: New visions

'Visitors will be introduced to alternative futures imagined by lesser-known screen creators and how these lead to new ways of thinking and different imagined futures'.

Through new visions of the future, which celebrate a plurality of ideas, cultures and visual aesthetics, we can start to dilute existing paradigms and begin scaffolding visitors to become more futures literate. Futures literacy enables us to become aware of our hopes, fears, and biases, improving our ability to both discern and harness the power of representations of the future (Miller, 2018). This enables us to overcome pessimism and actively work to realise more transformative futures in the present.

In our early research, it was determined that showing such a vast array of content in one exhibition would be an overly ambitious task. We asked ourselves how the mix of content would sit together in a cohesive and beneficial display for a generalist audience.

To tackle this challenge, we implemented a process-based structure into the exhibition narrative, allowing us to focus on craft and production to give a clear

through line to the show. The exhibition is divided into three thematic parts with an introduction and conclusion:

- Introduction: Science Fiction plays a role in the present
 Establishing the narratives that have come before.

- Section 1: How do we imagine? Concept/story development
 Exploration of Story development, Scripts, Treatments, Page to Screen Graphic novels, Videogame gameplay design, Fan Fiction, Research, Concept Art and Play.

- Section 2: What worlds will exist? Worldbuilding/production design
 Exploration of Production Design/Sets, Miniature models, Visual effects, and Props.

- Section 3: Who will we be? Culture/character
 Exploration of Character Design and Costume Design.

- Conclusion: The Future is Now
 Exploring connection and possibility through a large-scale moving image commission.

Visitor outcome 3: Empowering visitors to see futuring as a practice

'Visitors will be inspired to imagine and create their own futures emphasising the need for collective, rather than individualist, approaches to futures-making'.

'Futuring' is a project that we can and must actively shape and define. The exhibition aims to inspire visitors to engage in futuring and show that we already have the tools to create positive futures.

By actively producing their own version of a future within the exhibition, we hope that audiences will cultivate resilience and feel better prepared during these times of intense change. Through ACMI-created interactive experiences that encourage creative play and experimentation, audiences will learn to overcome pessimism and actively work together. We plan to create an interactive for each of the three thematic sections of the exhibition, with each allowing visitors to engage with a different part of the production process: story development, world-building and character/costume design.

Conclusion

The exhibition will cultivate a hopeful vision of the future through investigating positive representations of future worlds and encouraging visitors to create their own futures. Such methodologies are the backbone of the exhibition and are fundamental to supporting futures literacy in general and family audiences. As the exhibition continues to develop and is eventually mounted, we will have the opportunity to assess the outcomes of such methodologies in earnest but at this stage, guide our curatorial and exhibition-making journey.

This exhibition does not claim to present specific solutions or predictions. It is not encyclopaedic. Rather, it will explore examples of alternative futures that disrupt stereotyped paradigmatic futures, showcasing radical and imaginative possibilities. It will trace how these future narratives exist within our lived reality from the 1970s until today. It will be less a catalogue of futures than a methodology for future making. In an Australian and Indo-Pacific context, it will show that First Nations ways of being, knowing and doing are critical on these lands and waters.

The exhibition will juxtapose the dystopian realities of the 20th century with new pluralistic 21st-century visions, championing the history of speculative futures making and revealing the possibilities of tomorrow.

References

ACMI, 2023. *Strategic plan, 2023–2028* [online] Available from: https://web.archive.org/web/20231129033359/https://acmi-website-media-prod.s3.ap-southeast-2.amazonaws.com/media/documents/ACMI_Corporate_Strategy_20232028.pdf [Accessed 12 November 2023].

Dillion, G., 2016. Introduction. *In*: H. Nicholson, E. Cossar and S.M. Beiko, eds. *Love beyond body, space and time: an indigenous LGBTI sci-fi anthology*. Winnipeg, Manitoba: Bedside Press.

Kelly, K., 2010. *What Technology Wants* [online]Available from: https://web.archive.org/web/20230314100353/https://www.nytimes.com/2023/03/14/special-series/protopia-movement.html [Accessed 6 November 2023].

Miller, R., 2018. *Transforming the future: anticipation in the 21st century*, Paris: UNESCO Publishing.

Saunders, M., 2022. *This all come back now, an anthology of aboriginal and Torres Strait islander speculative fiction.* Queensland: UQ Press

Toffler, A., 1970. *Future shock.* New York: Random House.

Toffler, A., 1965. *Horizon*, Vol. VII, 3 Summer. New York: American Heritage.

Westfahl, G., 2011. Introduction of futures imagined, and futures inhabited. *Science fiction and the prediction of the future, 1*. North Carolina: McFarland & Company, Inc.

2.19 *Journey of the Pioneers* at Museum of the Future in Dubai

*Lāth Carlson, Brendan McGetrick,
and Majed Al Mansoori*

Introduction

Journey of the Pioneers is an ambitious immersive experience created by the Museum of the Future, which is located in central Dubai. Across three floors and 3,000 square metres of exhibition space, the Pioneers' Journey combines elements of immersive theatre, exhibition and attractions to transport visitors on a thrilling voyage to the year 2071. Every object, environment and interaction along the Journey was designed to place the visitor at the centre of an inspirational adventure.

The origins of Museum of the future

As far back as in 2014, the Dubai Future Foundation created annual pop-up Museums of the Future designed to be experienced in conjunction with the World Government Summit (WGS). WGS is an annual event held in Dubai that brings together governments, international organisations, thought leaders, and private sector leaders from around the globe, the aims of which are to promote international cooperation and enable governments to identify innovative solutions for future challenges.

At most conferences, the content is composed mostly of keynote presentations, panel discussions and workshops. Within the context of the World Government Summit programme, the Museum of the Future pop-ups offered a radical alternative (Chayka 2017, The Government Summit, 2014). Rather than limiting themselves to the standard media of presentations, videos and reports, these pop-up experiences confronted the attendees with living, breathing future worlds that could be experienced. By mobilising speculative design and immersive storytelling, the Museum transported its visitors to possible futures in which the political, technological and economic possibilities being discussed at the conference were fully manifested. Unlike 'predictive futures', which might seek to credibly establish a vision of the future, 'speculative futures' are less concerned with prediction and more focused on provocative possible futures that may be less likely to occur but encourage bolder imaginings (Dunne and Raby 2013).

Each of the six Museum of the Future pop-ups focused on a different topic, such as the future of food arising from technological and climate changes, climate and

DOI: 10.4324/9781003474975-28

environmental impacts or Artificial Intelligence. The experiences aspired to make these often overwhelming and abstract topics feel urgent and rich, inspiring the Summit's attendees to return to their countries and companies committed to positively shaping the future. This approach was intentionally adopted to address the 'poverty of imagination' that hinders our ability to envision diverse potential future scenarios (Mulgan 2020). In mainstream media, the vast majority of stories about the future tend to invoke anxiety and fear, with more than 70% of Americans seeing a nation in decline over the next 50 years (Daniller 2023). Although the Museum of the Future experiences are grounded in, at times, disconcerting data and scientific findings, we have made a deliberate choice to present optimistic adaptations to these challenges. This serves as a counterbalance to the prevailing disempowering narratives.

From pop-up to permanent

Although highly effective within their context, the Museum of the Future pop-ups were limited in their reach. Each lasted for only the three-day Summit and could be experienced by attendees only. Starting in 2018, the team at the Dubai Future Foundation began to envision how to create future experiences for a mass audience within the permanent Museum of the Future, which was then under construction. Three guiding concepts were developed to direct the development of these immersive experiences. The first was to create environments at three scales, each corresponding to a floor of the museum, uniting in a storyline that takes participants 'from outer space to inner space'. The second was to develop the Guiding Principles, a creative manifesto that explicitly establishes the values that shape our futures, informs all content and guides how we treat participants. Finally, to tie these ideas and environments together, we established a visitor path modelled on the arc of the classical Hero's Journey. The goal of this approach is to first inspire visitors about what might be possible, and then to empower them as 'heroes' to work toward making these possible futures real.

From outer space to inner space

Recognising that the Museum will cater to an exceptionally diverse audience, many of whom may have limited exposure to speculative futures or even traditional museum settings, we have crafted storylines designed to resonate with a broad spectrum of interests. One of our key techniques was to establish a narrative scale that ranged from epic and abstract visions of multi-planetary existence to tiny and intimate interactions with inhabitants of these possible futures, as well as fellow visitors.

As visitors embark on their journey through the Museum's three-floor experience, the narrative scale gradually transitions from the cosmic perspective of a space station to the planetary and environmental challenges confronted by a speculative climate science organisation and down to the individual and interpersonal needs addressed by a future wellness space. By adopting this approach, our aim is

to provide visitors with multiple narratives and experiential entry points into the future, ensuring an inclusive and engaging experience for all.

The Guiding Principles

The permanent Museum of the Future presents three floors of speculative futures based on the year 2071. In developing the narrative and design of these floors, we relied on a few basic principles to guide the content. First, we would focus on futures in which the universal human experience was more central than technological advancements. When technology is featured, it acts as an extension of human abilities and not a means of eliminating them. The futures we present include a diversity of human experiences and are enticing as places to live, even if you do not know what role you might play. Consistent with that diversity, we recognise different ways of knowing and contributing, and do not exclusively focus on science. As adaptation to the effects of the climate crisis is the most central theme of the museum, we base the experience on a post-growth world where renewal and circularity are defining features.

The Hero's Journey

Within the future world that we have created, we seek to transform passive visitors into active participants and, ultimately, into a network of Pioneers committed to making a better future. Each visitor's journey is focused on themselves – but also as part of a greater positive movement. Through individual choices, each visitor becomes part of a collective effort to create a better future for everyone. Participants make choices related to engagement in different areas of the experience, as well as via interactive exhibit components and the companion museum app. The sum of these choices forms a character arc that is unique to each visitor, but consistent in its overall trajectory. This arc follows the shape of the classical Hero's Journey. This narrative structure is found across the world's mythological traditions and was described by mythologist Joseph Campbell in this way: 'A hero ventures forth from the world of common day into a region of supernatural wonder: fabulous forces are there encountered, and a decisive victory is won: the hero comes back from this mysterious adventure with the power to bestow boons on his fellow man' (Campbell, 1949). In the Museum, visitors experience settings of 'supernatural wonder', filled with objects and interactions that they may never have imagined possible. In altering their definition of what's possible, we hope to inspire our audience to see themselves and the world anew. By placing them at the centre of an adventure, we hope to spark feelings of empowerment that propel them far beyond their trip to the Museum. Ultimately, the aim is not to create a museum of the future but to help develop the people of the future.

In order for our visitors to be at ease in this role, we take great care in how they are welcomed to the museum and on-boarded to the core experience. Our staff are extensively trained in an empathy-based approach to guest service, warmly welcoming our new Pioneers with open arms. Our communications and content

maintain an accessible and friendly tone, with a strong emphasis on inclusivity. Given that most visitors arrive as part of a social group, our exhibitions are thoughtfully designed to encourage group engagement. Additionally, we offer experiences that require multiple groups to collaborate.

Recognising that this museum journey is a unique experience for our visitors, we strategically position helpful staff at key points and utilise digital technology to guide them throughout their visit. In many stories based on the Hero's Journey, you will find aiding characters, or sidekicks; on the museum journey our staff plays that role while maintaining character 'in world'.

One of the surprising features they find is the diversity of experiences within the museum, and how well they respond to their changing energy levels and emotional states. This is by design: in developing our exhibit floors, we carefully considered the visitors' intellectual and emotional load, increasing and decreasing the demands that we place on them by offering moments of active engagement and solitary reflection.

The *Journey of the Pioneers*

The *Journey of the Pioneers* begins with a preflight briefing from our digital avatar and AI Guide, Aya, at the Mohammed Bin Rashid Spaceport in February 2071. New Pioneers are introduced to the museum and then to the start of their journey, venturing into space. In groups of 40, they enter the Falcon Space Launch Vehicle and blast off to a rendezvous with the Orbital Space Station Hope (OSS Hope). This rich fantasy experience is, in fact, a multimedia show inside a very large elevator, which takes visitors from the Museum's lobby to the fifth floor.

After docking, the doors open, and the Pioneers walk through a cleansing wall of mist and onto the deck of OSS Hope, where they are immediately confronted by a large window framing a view of the moon. But, aside from the space debris passing by, there is something odd about the moon: it appears to be ringed by a band of gold. Beyond the window, visitors notice a space station unlike any they've seen on television or in movies. 'The floor beneath your feet', our staff explain, 'is made from asteroids and space debris. The walls around you are 3D printed from powder collected from the surface of the moon'.

Passing into the next area, a massive model of the space station is suspended over a screen and explains the mysterious ring around the moon. It is part of the SOL Project, a solar energy collection initiative that harvests clean energy from panels on the moon and transmits it to stations back on Earth. The staff explains that the space station is rapidly expanding and is currently looking for new recruits. Their next stop is the OSS Hope's recruitment centre, where they are invited to learn about the community living and working on the station and to explore the missions they undertake, study the things they invent and discover and ultimately decide if they'd like to become a part of it.

Before returning to Earth, the visitors are given a chance to apply for a range of jobs on OSS Hope and to see themselves in those roles. The experience concludes with a descent back to Earth on a 'drop pod', where the travellers can gaze

upon a changed Dubai and consider how the city could be transformed over the next decades.

Having returned to Earth, the next floor introduces the visitors to a more planetary scale. The Pioneers enter the 'HEAL Institute', which, from a 2071 view out the window, seems to be located in Dubai, near the current museum. The Institute is a speculative research laboratory devoted to the study and repair of our planet's natural habitats. Its primary focus is on climate science and ecological restoration.

The visitors first encounter the digital twin of a Ceiba tree found in the Amazon rainforest. This mixed reality experience reveals the highly complex ecosystem around the tree, both above and below ground, as well as the interconnectedness of the organisms. The installation itself was based on original research conducted by the museum in Colombia in 2020.

Next, our visitors explore a vast genetic library where the DNA of thousands of species are stored in holographic form. With the aid of a purpose-built device, the visitors are transformed into citizen scientists and invited to explore the library's species and reveal their prospects for avoiding extinction by 2071. Their journey then continues to a wrap-around digital simulator, where the Pioneers have a chance to grow their own species, genetically modified to respond to a specific environmental challenge, and then see how they fare. Finally, the Pioneers can explore how the HEAL Institute is testing out modified organisms and monitoring the impact of climate change from OSS Hope.

Transitioning to the individual human scale, Pioneers venture into 'Al Waha', Arabic for 'the oasis', which proves to be one of the most unexpected segments of their journey. Upon entering this soothing and enveloping environment, their senses are gently embraced. Aya, their AI guide, encourages them to 'disconnect from their devices and reconnect with their mind, body, and spirit'. Inside a spacious arched hammam, visitors have the opportunity to partake in a range of sensory treatments, such as an ultrasonic hand massage and a group humming activity. As they conclude their journey, they recline in a meditation room adorned with calming lighting and a central water installation. With a sense of serenity, focus, and rejuvenation, our Pioneers are invited to leave a wish for the future before returning to the present day.

From immersive to expansive experiences

The term 'immersive' is a buzzword that paradoxically manages to be both ubiquitous and elusive. It was initially coined to describe digital creations that possess a 3D quality, vaguely simulating the richness of real-life experiences (Tullin 2023). However, as the digital realm continues to encroach on more aspects of our daily lives, non-virtual environments and activities, such as theatre, exhibitions, and theme parks, suddenly find themselves compelled to demonstrate that they too can offer an immersive experience. As Janet Kraynak pointed out in 2020 regarding museums, 'rather than being replaced by the internet, they are increasingly being reconfigured by it' (Kraynak 2020, p. 122).

Naturally, all lived experiences are inherently immersive, and as screens have become ubiquitous in public spaces, this term has lost most of its meaning. As it is pointless to aspire to something that we'll achieve no matter what and that lumps us in with thousands of other projects and places, we choose instead to look beyond the exhibition floors' form and focus more on their effect. The authors of a study in the *International Journal of Market Research* conclude that: 'Emotions induced in the museum context lead to increased levels of engagement that, in turn, affect visitor behaviours. The emotions – engagement – behaviour relationship is particularly evident in contexts characterised by spectacular consumption' (Piancatelli *et al*. 2021).

The environments and experiences that comprise the Journey of the Pioneers are not only immersive but, more importantly, expansive. They are designed to expand what the audience thinks possible – for the world, for the future and for themselves. The exhibition floors and all their settings, scenarios, objects and interactions are crafted to achieve this effect. For example, on OSS Hope our Pioneers can hear from a vast diversity of people working on the space station and see physical models of their innovations and tools. This expands to typical conceptions of space being only for astronauts working in science or engineering. Similarly, the red-hued walls of the space station are made from 3D-printed simulated lunar material in a woven pattern, upending the assumption of stainless steel or white plastic materials and adding a cultural reference connected to the Arab world.

We strive to seamlessly merge the digital and physical realms in a way that leverages the unique qualities of each, directing them to evoke wonder, inspiration, and agency among our visitors. When complemented by empathetic interactions with our staff, the resulting experience far exceeds the stereotypical, sterile, and technology-driven displays that people might anticipate from a future-oriented museum.

Our dual objectives in crafting this experience are to spark the imagination of our guests, encourage them to explore new possibilities, and to equip them with the motivation to actively contribute to a brighter future. As Jane McGonigal aptly stated, 'Imagination is not only enjoyable but also a practical skill. We can shape any future we can envision' (Frauenfelder 2016).

Response to the *Journey of the Pioneers*

Since its inauguration on 22 February 2022, the Museum of the Future has hosted more than one million guests a year, representing visitors from over 163 countries, including numerous heads of state and government delegations (Jalal 2023). It has become clear that the world is eager to visit a place that presents a hopeful vision of the future and introduces a new type of museum to many. As the experience was developed on three scales, makes use of innovative principles for visitor experience, and empowers participants by making them the heroes, it has been able to achieve relevance with this highly diverse audience. The main challenge that remains is helping those guests understand that we are presenting possible futures and are not predicting the future, nor are the projects featured in the experience 'real'.

This corresponds to the challenge faced by futurists and foresight practitioners in other settings. The Museum of the Future is iteratively adjusting our experiences, and the tools we make available to guests, in order to address this challenge.

References

Campbell, J., 1949. *The hero with a thousand faces*. New Jersey: Bollingen Foundation.

Chayka, K. 2017. *The Future Agency: inside the big business of imagining the future* [online]. The Verge. https://www.theverge.com/2017/3/30/15113162/future-utopia-tellart-design-agency-world-government-summit-dubai [Accessed 26 February 2024].

Daniller, A. 2023. *Americans take a dim view of the nation's future, look more positively at the past* [online]. Washington DC: Pew Research Center. Available from: https://www.pewresearch.org/short-reads/2023/04/24/americans-take-a-dim-view-of-the-nations-future-look-more-positively-at-the-past/ [Accessed 31 October 2023].

Dunne, A., and Raby, F., 2013. *Speculative everything: design, fiction, and social dreaming*. Cambridge, USA: MIT Press.

Frauenfelder, M., 2016. *Imagining the Future is Creating the Future* [online]. Urgent Futures, Medium. Available from: https://medium.com/institute-for-the-future/imagining-the-future-is-creating-the-future-81b011d16a3 [Accessed 31 Oct. 2023].

Jalal, M., 2023. *Dubai's Museum of the future welcomes one million visitors in first year* [online]. Abu Dhabi: The National. Available from: https://www.thenationalnews.com/arts-culture/art-design/2023/02/22/dubais-museum-of-the-future-attracts-one-million-visitors-in-first-year/ [Accessed 31 Oct. 2023].

Kraynak, J., 2020. *Contemporary art and the digitization of everyday life*. Oakland: University of California Press.

Mulgan, G., 2020. *The imaginary crisis* [online]. UCL STEaPP and Demos Helsinki. Available from: https://www.ucl.ac.uk/steapp/sites/steapp/files/2020_04_geoff_mulgan_swp.pdf [Accessed 28 February 2024].

Piancatelli, C., Massi, M., and Vocino, A., 2021. #artoninstagram: Engaging with art in the era of the selfie. *International Journal of Market Research*, 63, 134–160.

The Government Summit, 2014. *Government Summit: leading government services*. United Arab Emirates: Ministry of Cabinet Services. Available from: https://www.worldgovernmentsummit.org/docs/default-source/publication/2014/english/gov-summit-2014.pdf?sfvrsn=60a43b0a_4 [Accessed 26 February 2024].

Tullin, P., 2023. *The Immersive Revolution* [online]. Remix. Available from: https://www.remixsummits.com/media/The-Immersive-Revolution-REMIX-Summits.pdf [Accessed 28 February 2024].

2.20 Plausible immersive futures with *Seven Siblings* in Finland, Southern Australia, and Arizona

*Natalie Carfora, Lisa Bailey, Kristin Alford,
Mikko Myllykoski, Rae Ostman, and Paul Martin*

Introduction

To celebrate the 100th anniversary of the independence of Finland in 2017, Heureka and Sitra, a Helsinki-based Innovation Fund established by the Finnish Parliament, presented an exhibition called *Seven Siblings from the Future*. Co-created with 32,000 people around Finland through f a pre-exhibition roadshow, the exhibition communicated that Finns create their future together. *Seven Siblings* transported visitors to Finland in 2067, where they were able to explore the natural environment, wellbeing, transportation, housing, work and leisure, education, healthcare, and food. The exhibition presented a plausible future inhabited by seven characters, siblings who inherited a plot of land called Jukola in southern Finland. As visitors moved through the exhibition, the siblings shared their ideas for how Jukola might become more sustainable and assigned open-ended tasks. Each sibling was driven by a core value based on the theory of universal values by Schwartz (2006). At the end, visitors learned which sibling and corresponding value aligned most closely with the choices they made throughout the exhibition.

The exhibition was later adapted for Australian audiences by MOD. (also known as a museum of discovery), a future-focused museum of discovery at the University of South Australia, and then reimagined for North American audiences visiting the Arizona Science Center in Phoenix. Each iteration shared similar core messaging, encouraging visitors to explore future worlds to understand drivers for the future. However, the Australian and American adaptations both consisted of a number of cultural and thematic differences to make them relevant to their audiences and meet local goals.

MOD.'s adaptation of the Finnish original introduced visitors to a place called Eucalara, located in southern Australia in 2050. The exhibition stayed loyal to that at Heureka, with visitors exploring this future place by meeting the seven siblings who lived there and navigating a series of tasks related to the same themes. However, MOD. made significant alterations to the siblings' characters and the unique world of Eucalara drawing on data modelling from the Australian Academy of Science. The exhibition was on display from November 2019 to November 2020.

The Arizona team was inspired by both versions of the exhibition to create an exhibition called *Mission Future: Arizona 2045* for the Arizona Science Center.

DOI: 10.4324/9781003474975-29

Mission Future was set in Yucca Canyon, Arizona, and engaged visitors in thinking about how the next generation might experience life on Earth and in space. *Mission Future* shared *Seven Siblings'* goals and approach, but its storyline, characters, sets, and interactives differed substantially. The scenario was developed through collaboration with Arizona State University and NASA, showing from February 2023 to late 2025.

At each venue, visitors were transported to a future world to better understand perspectives and drivers for the future through films and interactives. This was done through a number of futures principles, which include experiential futures, the inclusion of multiple perspectives, and an emphasis on conversation. Together, these principles ensured that the exhibitions were successful in taking visitors on a journey into a plausible future for these places and helping them to understand the role that they would play in creating it.

Building believable worlds

Each of the worlds inhabits a plausible future, consistent with what we think 'could happen based on our current understanding of how the world works' (Raupach *et al.* 2013, Voros 2017). There are a range of methods for building scenarios, and these often result in multiple alternative futures (Bishop *et al.* 2007). In these exhibitions, however, the plausible futures are less about exploring tensions and wild card alternatives but instead developed by drawing on expert input from existing trends and models and engaging with a spectrum of community perspectives about likely trajectories.

Experiential futures have emerged as an effective method of engaging publics with possible, probable, and preferable futures (Candy and Dunagan 2016, p. 26). While the format of experiential futures can vary, almost all instances of this framework make use of narrative worldbuilding to immerse people in a future world, something which Zaidi (2019) emphasises as an effective method of engaging individuals in ideas about the future. The sense of narrative worldbuilding was the foundational underpinning of each of these exhibitions.

At Heureka, visitors were transported into the year 2067, and in the fictional Jukola, the name derived from the first Finnish novel, *The Seven Brothers* by Aleksis Kivi, originally published in 1870. The worldbuilding of the exhibition presented a future Finland that had been strongly influenced by climate change; native species such as conifer trees were gone and invasive species like golden jackal had entered, emphasising to visitors that they were in a future land. The film production at the heart of the exhibition created a sense of immersion. Visitors approached each of the siblings in turn through life-size videos, who addressed visitors directly. This meant that visitors were able to see themselves participating in the future through this cast of characters. In the spirit of learning-by-doing, the visitors were able to augment their understanding of this plausible future through the interactions and decisions they had to make for the siblings (Das 2015, Falk *et al.* 2004). These occurred in different settings to demonstrate considerations for robotic farming, and also a robotic

hairdresser, hyperloop trains, synthetic food production, precision medicine, and astronaut training.

The Australian version of *Seven Siblings from the Future* at MOD. was informed by the projects at the Australian Academy of Science (AAS), importantly *Australia 2050* (AAS 2012, Raupach *et al*. 2013). This project resulted in a large body of data and modelling about the future of the country including climate and migration, which MOD. used to inform evidence-based worldbuilding. While Eucalara bore many similarities to Jukola, there were several key differences. The landscape further emphasised a future world, with coastal cliffs and dry land setting the scene for the sibling Julia, who was hiding in a bushfire refuge and afraid of what might come. Changes were also made to each of the seven siblings to reflect a realistic vision of the future population of Australia, with siblings reflecting Aboriginal peoples as well as significant waves of migration post-colonisation, including a speculative future wave of climate refugees. Together, the worldbuilding worked to communicate that the future does not look like the present.

In Arizona, *Mission Future* was about half the size of *Seven Siblings* and it had a tighter focus on imagining climate solutions and space exploration. It also looked ahead just 20 years, corresponding roughly to the next generation of Arizonans. These changes were made for several reasons, including the time horizon of the scientific scenarios that the team in Arizona were drawing from, information on how children grasp abstract concepts such as the future, the public engagement priorities of core partners, and practical considerations such as gallery size. Through the views of five characters from the future – four humans and one artificial intelligence (AI) – the exhibition explored the local impacts of climate change in the southwestern US, as well as opportunities that future humans may have to study, live, and work in space. The fictional Yucca Canyon reflected a number of social, environmental, and economic challenges for central Arizona, including population growth, land development, extreme heat, and water scarcity, as well as less familiar plans for space exploration and the commercial space industry in the state. The exhibitions' characters were developed to create a culturally sustaining learning environment for Arizona's racially and ethnically diverse population, especially Hispanic/Latino communities. To align with the focus and storyline, *Mission Future's* interactive components differed from those of *Seven Siblings,* but they provided similar opportunities for open-ended exploration of the characters' challenges.

Both versions of *Seven Siblings* and *Mission Future* had narratives that hinged on transporting visitors to different points in the future and asking them to imagine what life might look like there. These experiences with worldbuilding successfully immersed the visitors in these places and enabled them to see their current lives reflected in a plausible future.

Different values bring different ideas about the future

Navigating the future through diverse perspectives is a key element of *Seven Siblings from the Future.* As visitors journeyed through each of the siblings' stories,

it was clear that there was not one correct view of the future. Rather, there were a variety of perspectives that both the siblings and visitors were working through in their choices. Problems such as the development of futures are best navigated through a variety of perspectives and subsequently values. The values that we hold are fundamental to our views on a wide range of topics, but are integral in our discussions about the future (Mills and Wilner 2022). Each iteration of the exhibition had a strong focus and explicit messaging on this concept.

As visitors travelled through *Seven Siblings from the Future*, both in Heureka and at MOD., they discovered that each of the siblings had their own perspective and core values. Based on Schwartz's (2006) theory of basic human values, the characters' core values serve as guiding principles that drive their beliefs, motivations, and actions. The siblings' core values included safety, achievement, and hedonism, which are in the top ten values for both Finnish and Australian people. As visitors completed tasks in the exhibition, their own values were scored; at the end, they learned which core value aligned most closely with the choices that they made and were presented a 'Soul Sibling', or the sibling most like them. In both exhibitions, feedback analysis at the end of the exhibition was also interpreted using a modified version of Amara's (1981) types of future thinkers. It placed all the siblings across the various positions on a soccer field at Heureka and a netball court at MOD., explaining that everybody from the safety-driven goalkeeper to the innovation-driven forwards is needed in the dialogue for shared futures.

In Arizona, the characters' profiles were based on four types of futures thinkers – traditional, innovative, bold, and practical – who also hold different values. The types were introduced to *Mission Future* visitors by the fifth character, a simulated human known as AILI (Artificial Intelligence Learning Investigator). These four types of futures thinkers were included at the exit of Heureka and MOD.'s versions of *Seven Siblings,* but did not define the individual characters like Schwartz's core values did. Essentially, *Mission Future* swapped the emphasis on core values for types of futures thinkers. Near the end of the exhibition, the AILI character presented a short quiz that allowed visitors to explore which type of thinker they might be and explained that we need all different types of thinkers to build the future we want to live in.

By navigating choices and values, visitors to each exhibition saw that it was the combination of the different values and ways of thinking that were important in the development of futures. In this way, the exhibitions embraced the diversity of visitors' perspectives.

Different perspectives shape futures insights

The third approach reflects that the future is negotiated through dialogue, suggesting that we need to be engaged in conversations for our ideas of the future to be valid and useful for future-making. The exhibition encouraged visitors to be open to other perspectives throughout the experience, a process that Wilkinson and Flowers (2022, pp. 75–6) call 'open listening'. Visitors were encouraged to create

space for new conversations about their futures, raising ideas that may not have been considered if not for the exhibition.

When visitors encountered them, the siblings at Heureka and MOD. were negotiating their preferences for the future of a piece of land. The characters' dilemma demonstrated that we all need to be engaged in creating and responding to the future. Visitors also needed to make difficult choices at each siblings' interactive station. These were designed to inspire conversation amongst visitors, forcing debate over which objects should be saved for the future or collaboration to solve a series of puzzles. Visitors' conversations involved negotiating their decisions with each other, explaining why they make choices and ultimately reflecting the core value that the visitor had in common with each of the siblings.

In Arizona, two pairs of siblings were working to understand each other and negotiate their individual and collective futures. Isabela and Lucas were adults who have different perspectives on the future of their family ranch, similar to the storyline in the first two iterations of the exhibition. Ava and Zoe were young interns who were just starting out in careers in the commercial space industry, and were unsure whether to out and work on Earth or in space. In the interactive components, visitors were encouraged to think and talk about which choices they would make if they were in the characters' places. For example, there is a magnetic board where visitors could help Lucas and Isabela plan the future of their ranch, considering the characters' priorities as well as their own. In *Mission Future,* like *Seven Siblings,* both the films and the interactives emphasised that the future is open and that our choices today will determine what life is actually like for later generations.

The future is something that we create together, as a collective, and so it is best negotiated through dialogue. In the exhibition, all problems were framed through the negotiation among characters, which required visitors to engage in conversations with each other throughout their visit. Through these discussions, the exhibitions encouraged visitors to work through the problems together to better enable learning.

Evaluation

Each of the exhibitions was successful in engaging sizable numbers of visitors in futures thinking and scenarios. At Heureka, the exhibition was experienced by 250,000 people. The exhibition dwell time was longer than usual, with 40% of visitors staying longer than an hour. Visitor interviews ($n = 605$) showed that the exhibition increased understanding of the factors that shape our future. Visitors largely agreed that our values have a deep impact on our choices and our choices shape the future. The most popular 'Soul Sibling', based on the choices that visitors made at Heureka, was the safety-driven Julia.

At MOD., the exhibition was interrupted twice by abnormal circumstances, which saw the exploration of the future come to life in the present. The first was the 2019–2020 Black Summer bushfires, which sat alongside the safety-driven sibling Julia, who was creating a bushfire refuge. The exhibition's run was additionally interrupted and then extended by the COVID-19 pandemic, but was ultimately visited

by 47,251 people. The storyline for the care-driven sibling called Alex, a nurse who engages with the future of health, was altered to showcase the future of healthcare with a timeline featuring the pandemic. At the end of the exhibition, visitors were asked to contribute drawings that demonstrated the actions they would take after their visit to help shape the future. During Black Summer, this wall was covered with drawings of fire and support of measures for climate. Exhibition evaluation demonstrated that these key events shaped visitors' experiences of the exhibition. When the exhibition re-opened after lockdowns, visitors reflected on how the pandemic had changed their behaviours to consider others, which at the time included masking and social distancing.

The summative evaluation for *Mission Future* focused on gathering data to understand who used the exhibition, how they used it, and what they learned. At Arizona Science Center, an estimated 522,000 visitors attended the exhibition, mostly in multi-generational groups that included children. Findings indicated that visitors thoroughly enjoyed *Mission Future*. They also showed the exhibition supported visitor understanding about the relationship between STEM (science, technology, engineering, and mathematics) and society, practising futures thinking skills, and feeling more confident in their abilities to participate in making decisions about the future. Overall, the summative evaluation suggested that the design of the exhibition, including the approaches discussed here – experiential futures, multiple perspectives, and negotiation through conversation – contributed to the achievement of the team's goals (Anderson and Harvey-Justiniano 2023).

Conclusion

Seven Siblings from the Future and *Mission Future* each provided immersive and interactive opportunities for visitors of broad age groups to explore place-based future scenarios. Through experiential worldbuilding, characters with diverse values and perspectives, and interactive components, these three exhibitions encouraged conversations and values that helped visitors build their capabilities to imagine new futures. *Seven Siblings from the Future* and *Mission Future* – along with a growing number of other future-focused exhibitions worldwide – engaged communities in important concepts and skills for creating our preferred futures together.

References

AAS, 2012. *Australia's population: shaping a vision for our future*. Theo Murphy High Flyers Think Tank. Canberra: Australian Academy of Science.
Amara, R., 1981. The futures field i: searching for definitions and boundaries. *The Futurist*, 15 (1), 25–29.
Anderson, A., and Harvey-Justiniano, S., 2023. *Mission future: Arizona 2045. Summative evaluation preliminary findings*. Unpublished report. Boston: Museum of Science.
Bishop, P., Hines, A., and Collins, T., 2007. The current state of scenario development: an overview of techniques. *Foresight*, 9 (1), 5–25, Available from: https://doi.org/10.1108/14636680710727516 [Accessed 12 October 2023].
Candy, S., and Dunagan, J., 2016. The experiential turn. *Human Futures*, 26, 26–29.

Das, S., 2015. Using Museum exhibits: an innovation in experiential learning. *College Teaching*, 63(2), 72–82. Available from: https://DOI:10.1080/87567555.2015.1005044 [Accessed 16 October 2023].

Falk, J.H., et al., 2004. Interactives and visitor learning. *Curator: The Museum Journal*, 47: 171–198. Available from: https://doi.org/10.1111/j.2151-6952.2004.tb00116.x [Accessed 16 October 2023].

Mills, B., and Wilner, A., 2022. The science behind 'values': applying moral foundations theory to strategic foresight. *Futures and Foresight Science*, 5(1), e145. Available from: https://doi.org/10.1002/ffo2.145 [Accessed 16 October 2023].

Schwartz, S., 2006. *Basic human values: an overview* [online]. Jerusalem: The Hebrew University of Jerusalem. Available from: https://uranos.ch/research/references/Schwartz_2006/Schwartzpaper.pdf [Accessed 6 October 2023].

Raupach, M.R., et al., 2013. *Negotiating our future: living scenarios for Australia to 2050*. Canberra: Australian Academy of Science. Available from: https://www.science.org.au/publications/negotiating-our-future-living-Scenarios-australia-2050 [Accessed 10 October 2023].

Wilkinson, A., and Flowers, B.S., 2022. Creating the future. *In:* G. Donnelly and A. Montuori, eds. *Routledge handbook for creative futures*. London: Routledge, 74–80.

Voros, J., 2017. Big history and anticipation: Using big history as a framework for global foresight. *In:* R Poli ed. *Handbook of anticipation: theoretical and applied aspects of the use of future in decision making*, Cham: Springer International Cham. Available from: https://link.springer.com/referenceworkentry/10.1007/978-3-319-91554-8_95 [Accessed 10 October 2023]

Zaidi, L., 2019. Worldbuilding in science fiction, foresight and design. *Journal of Futures Studies*, 23 (4), 15–26.

2.21 *Science Fiction*

Voyage to the Edge of the Imagination by the Science Museum in London

Glyn Morgan

Introduction

The stated mission of the United Kingdom's Science Museum Group (SMG), as outlined in the group's 'Strategic Priorities 2022-2030' document, is 'inspiring futures', an aim which underpins the museums values such as sharing authentic stories, revealing wonder, and igniting curiosity (Board of Trustees of the Science Museum 2022). Whilst the terminology and specific aims are bespoke to SMG, the intention and ambitions that underlie them are near universal to any museum that seeks to continually expand its audience and project the significance of its collections into the future, especially those who incorporate temporary activity into their mission alongside permanent galleries.

Science fiction (SF) is a globally significant mass cultural genre, spanning cultures and mediums, but it is also a way of thinking: a blend of storytelling and STEM-based extrapolation that reflects the interests and concerns of the present by projecting narrative into possible futures. The intellectual link between present and future makes science fiction the perfect complement to the work and ambitions of science museums such as those in SMG. *Science Fiction: Voyage to the Edge of Imagination* was a blockbuster-scale exhibition held at the Science Museum in London from October 2022 until July 2023. It has since embarked on an international tour. This case study will offer an overview of the exhibition, its aims and learnings, whilst demonstrating the wider potential of the genre of science fiction as a tool for engaging visitors with scientific topics and thinking about the future.

Charting a course

Science fiction is separated from other forms of narrative by employing a technique that the cultural theorist Darko Suvin called 'cognitive estrangement' (Suvin 1979, p. 15). This distinguishes science fiction from other forms of non-realist storytelling such as fantasy or supernatural horror through its grounding in something resembling plausibility. It is this innate feature, the extrapolation from established truths, which makes SF a valuable intellectual tool with which to think about the world. Another feature that Suvin identifies is the 'novum', he writes that 'SF is distinguished by the narrative dominance or hegemony of a fiction 'novum'

DOI: 10.4324/9781003474975-30

(novelty, innovation) validated by cognitive logic' (p. 79). The novum is the spark of innovation that leaps a science fiction story into the future, into another world. Crucially, it forms an artistic parallel with the progressive search for truth embodied by the scientific method, the processes of invention and refinement of technology, and the generation of new hypotheses and theories.

The genre is broad and poorly contained within scholarly boundaries, let alone the confines of a museum gallery. It has become something of a cliché in science fiction studies that any new work on the topic is required to use at least the first chapter redefining what exactly the author(s) mean by 'science fiction'. The term itself didn't arise until the 1930s, but most agree that the genre can be traced further back to what Hugo Gernsback, the Luxembourgish-American editor, inventor and passionate radio engineer, called 'Scientifiction' in his editorial to the first issue of *Amazing Stories* in 1926, the first magazine dedicated to science fiction (Gernsback 2017, p. 11).

At the most extreme, in highlighting SF's interest in explaining the world, speculating on new possibilities and upon contemporary social commentary, some scholars trace the genre back into antiquity, claiming some of our oldest stories as at least *proto*-science fiction. The term 'proto-science fiction' is not without its detractors, even amongst those who favour a 'long history' of science fiction (Roberts 2011). For the purposes of the exhibition however, it was more helpful to align with scholars such as the writer Brian Aldiss, who identified the root of the genre in the 19th century, 'characteristically cast in the Gothic or post-Gothic mould' (Aldiss 1973, p. 8). For Aldiss the starting point is Mary Shelley's novel *Frankenstein* (1818), and so for our exhibition *Frankenstein* became the earliest source material we referenced. Shelley's novel is a particularly apt place for a science museum to begin its investigations due to its clear framing as a novel about (amongst other things) science and Shelley's own interests in the revolution in scientific understanding that was sweeping Europe in her time. As Joel Levy writes, '[t]he novel and its protagonists embody and interrogate the promise and peril of fields such as electrical science and chemistry, psychology and the philosophy of consciousness' (Levy 2018, p. 3).

Frankenstein also provides one of the exhibition's clearest examples of the relationship between science and SF: not a two-step process of prediction and creation (SF imagines the rocket ship, scientists invent rockets), but as a continual dialogue and exchange of ideas backwards and forwards. In the case of *Frankenstein*, we know that amongst Shelley's inspirations were the experiments being conducted in the late-18th early-19th century with galvanism, or bioelectricity: she references such an experiment by Erasmus Darwin in the introduction to the 1931 second edition. Although only lightly hinted at in the novel itself, electrical experiments become fixed in the public consciousness by the subsequent adaptations, particularly the Universal Studios adaptation of 1931 directed by James Whale and starring Boris Karloff as the now iconic monster. One particularly passionate fan of this adaptation and its sequels was a boy named Earl Bakken. Bakken repeatedly cited the spectacle of these films, 'the creative spark of Dr. Frankenstein's electricity', as being a key factor in him becoming interested in electronics (Bakken 1999, p. 35).

He went on to create the company Medtronic, which remains to this day one of the largest providers of medical electronics in the world. Perhaps his most significant contribution was the invention of the first wearable pacemaker, redefining the utility of pacemaker technology and revolutionising quality of life for those who required one. Thus, we can see an exchange of ideas from Galvanism to Shelley to the film adaptation of Bakken; from there, we can spread further to discuss the influence of medical electronics on the notion of the cyborg as both a scientific concept and a figure of popular imagination. Within the exhibition, this narrative was unspooled using archival photography of a young Bakken, film stills, the first production model of Bakken's pacemaker, and the world's smallest pacemaker to show how far the technology has come (on loan from the Bakken Museum, Minneapolis, and Medtronic, respectively). For the London leg of the exhibition we were also fortunate to be able to borrow one of Boris Karloff's actual costumes from *Bride of Frankenstein* (1935) from the V&A, but it was unfortunately too fragile to tour.

World building

One of the Science Museum's aims with exhibitions is always to reach new audiences, and so with *Science Fiction* we were especially interested in attracting an audience segment who were part of the large fan base for the science fiction genre culturally, but who perhaps were not regular museum visitors, whilst still retaining an accessibility for those with little or no familiarity with the subject. To achieve this, we decided very early in the conception of the project that we wanted to lean into the importance of science fiction as a form of storytelling, and the idea formed to create our own science fiction story within which to tell the exhibition's narrative.

Working with our principal designers, Framestore, we, therefore, conceived of an immersive storytelling experience through which the visitor would encounter the various shapes of the relationship between science and science fiction through objects, 2D design, interactives, and digital media. Such an approach also increased the justification of liberating the content from a chronology: mixing material from different eras of the genre wherever appropriate to illustrate the breadth and depth.

Given that part of the appeal of SF is its ability to transport its fans to other worlds, the idea of setting the exhibition on a spaceship came very early on. Eventually, this coalesced into a tour of an alien spaceship being maintained by an artificial intelligence of unknown origin, the Algorithmic Artificial Neural Network, or ALANN for short. ALANN appeared on video screens throughout the exhibition, introducing each section and other key moments and was played by an actor, Kattreya Scheurer-Smith, augmented with some light-touch visual effects. It was important to us that ALANN have a human face and remain approachable despite being alien and 'Other', as the intention was that visitors create a connection with the character as their guide through the exhibition and through the story in which they find themselves the protagonists.

When entering the temporary exhibition space, visitors board a shuttle that blasts them into orbit. This timed experience (<5 minutes) holds the visitor and includes a

large screen in place of the shuttle's viewing port featuring computer-generated effects of leaving the atmosphere and docking with a strange, almost insectoid ship in orbit: *The Azimuth*. Along the way, ALANN introduces themselves and explains their mission or Prime Directive: 'to examine the objects, items and stories I have collected, and calculate the chances of survival for your species'. Inviting visitors to help them with this directive and involve themselves in the calculations, which 'will be complete by the end of your visit, at which time you will know if you have any future'.

The shuttle then docks with *The Azimuth*. Through a piece of theatre trickery, the visitor exits the shuttle via the same door they used to enter, giving the illusion of having travelled somewhere new. This is achieved through a piece of sliding wall. Once on board the ship, the visitors then move through its different spaces: the cargo bay, the exploration deck (dominated by the ship's warp core: with its pulsing lights and mechanical hum), the bio lab, the computer core, visualisation deck, and the observation deck. In each, the story is advanced, the visitor learning about science and science fiction, and the people who are inspired by both, at the same time as ALANN. All of the labels and messaging, developed with the exhibition's Interpretation Manager Sarah Wood, were written in ALANN's voice, a modification of the standard museum tone that allowed us to be more playful in our approach. It also allowed us to 'Other' the visitors, referring to 'you humans', as if speaking as an outsider to our planet and species. This was particularly helpful when dealing with sensitive issues about how we treat each other, such as when discussing cyborgism and prosthetic limbs: a discussion we centred around a video interview with Tilly Lockey. Tilly is a teen social media influencer who uses two prosthetic arms, she self-identifies as a cyborg and proudly talks about the science-fictional elements of her personality. Adopting ALANN as an interpretative tool when presenting her story allows the exhibition to champion her creativity and uniqueness. Combined with other exhibits and a 'How Cyborg Are You?' interactive quiz, it invites contemplation between figures such as Tilly as a cyborg with her clearly metallic artificial arms and the visitor as a cyborg with the technology they rely on every day: their pacemaker, or even more mundanely their mobile phone or clothing, drawing on Haraway's interpretation that in a modern world shaped by technologies 'we are all [...] in short, cyborgs' (Haraway 2016, p. 7). This outside perspective on the human race is especially apt because it is what the best of SF is all about, a genre that takes us away from the real world (estrangement) in order to allow us to achieve a new perspective and understanding of the world and ourselves (cognitive).

Partway through the journey, ALANN interrupts the tour of the ship to send the visitor through a stargate to visit an alien world and investigate some strange readings. Once on the planet named 6EQUJ5 (a reference to the infamous 'Wow! Signal' – the exhibition is littered with scientific and science fictional references and easter eggs like this), the visitor enters a cave full of swirling lights. This room is mapped with LIDAR, the lights programmed with an algorithmic behaviour based on swarming or flocking behaviours on Earth, the intention being that we can simulate some sort of strange non-anthropomorphic intelligence with which the visitor can interact as the lights form new colours and shapes, following the

humans around the cave. This encounter with 'the Other' being an integral aspect of the SF genre. Whilst this section ran up against many technological challenges in its execution, it served its purpose as a piece of novel engagement with the exhibition experience, positioned between object-rich areas as a way to refresh the visitor experience and modify pacing.

Learning from science fiction

Science fiction has a strange relationship with the future. It is clearly the period in which most of the genre sets its action and this leads many to misinterpret it as being *about* the future, or that it is trying to predict the future. Rather, those who study and work with SF tend to prefer the language of extrapolation or anticipation rather than something so rigid as a prediction. As Sherryl Vint writes, 'at its worst SF can be the literature of all the worst aspects of science – technocraticism, singularity of vision, domination of nature', however, 'at its best it might be considered the literature of science studies – concerned with the social consequences of developments in science and technology, insisting on dialectical exchange between the novum and the larger social world, sensitive to the contingency of knowledge, and open to new ways of seeing and being' (Vint 2011, p. 421). Our ambition was to present the best of the genre and its conversation with science, not to ignore the unevenness of the genre, but to allow it to serve as inspiration and provocation to our visitors.

Science fiction can never accurately predict the future, and we certainly didn't want to do that in our exhibition. Partly because that's a terrible trap for a science museum to fall into, but also because it robs our visitors of agency. We wanted them to feel like there are many possible futures, each represented by a work of science fiction, and far more besides that. An infinite universe of possibilities, and that they may have some small role to play in shaping that future, drawing on science fiction not merely as a genre but as a tool: an analytical way of thinking about the future through narrative. We want our visitors to think like SF writers because as the award-winning writer Nalo Hopkinson puts it:

> the scientific method is also not in the business of prophecy. It tests in order to discover the truth. Science fiction storytellers are indebted to science as we employ the art of fiction to ruminate on what humanity is capable of, for good or ill.
>
> (Hopkinson 2022, p. 13)

This is why, by the time visitors leave the exhibition, ALANN has (after a lot of glitching in a computer core deliberately evocative of HAL's in *2001: A Space Odyssey* [1968] – but less lethal) come to realise that in the case of humanity, its prime directive cannot be fulfilled. Our future is not predictable, at least on any significant scale, because we are not a predictable species. As ALANN says:

> You are contradictory… frustrating… messy… self-obsessed… inspirational… collaborative… inventive… contradictory beings. And yet I find I like you.

Your science and science fiction are equally grounded in this illogical… creative ability to see and explore new worlds, new possibilities, in our minds – and make them a reality. […] I cannot determine your future path. It is yours to choose. Good luck, Humans!

References

Aldiss, B., 1973. *Billion year spree: the history of science fiction*. London: Weidenfeld and Nicolson.

Bakken, E.E., 1999. *One Man's full life*. Minneapolis: Medtronic.

Board of Trustees of the Science Museum, 2022. *Science Museum group: inspiring future 2022-2030*. London: Science Museum Group. Available from: https://www.sciencemuseumgroup.org.uk/wp-content/uploads/2022/06/Inspiring-Futures_2022-2030.pdf [Accessed: 26 October 2023].

Gernsback, H., 2017. Editorial: a new sort of magazine. *In*: R. Latham, ed. *Science fiction criticism*. London: Bloomsbury Academic, 11–12.

Haraway, D.J., 2016. A cyborg manifesto: science, technology, and socialist-feminism in the late twentieth century. *In:* D.J. Haraway, ed. *Manifestly haraway*. Minneapolis: University Of Minnesota Press, 3–90.

Hopkinson, N., 2022. What is science fiction for? *In:* G. Morgan, ed. *Science fiction: voyage to the edge of imagination*. London: Thames & Hudson, 13.

Levy, J., 2018. *Frankenstein and the birth of science*. London: Andre Deutsch.

Roberts, A., 2011. The copernican revolution. *In*: Mark Bould et al., eds. *The Routledge companion to science fiction*. Abingdon: Routledge, 3–12.

Suvin, D., 1979. *Metamorphoses of science fiction: on the poetics and history of a literary genre*. Bern: Peter Lang.

Vint, S., 2011. Science studies. *In*: Mark Bould et al., eds. *The Routledge companion to science fiction*. Abingdon: Routledge, 413–422.

2.22 Experiential futures as a bridge to foresight practice at ArtScience Museum

Honor Harger

Introduction

The mission of ArtScience Museum is to explore the intersection of art, science, culture and technology. We deliver exhibitions and programmes that showcase the work of contemporary artists who push the boundaries of art practice, engage deeply with recent scientific advances and in doing so offer insights into many possible futures.

An important aspect of this work is to engage audiences in actively imagining the future. To do this, we collaborate with creative professionals who work in futures – a set of professional practices encompassing strategic foresight, policy analysis, and design thinking focused on the future. Foresight practitioners consider possible, probable, and plausible futures through careful research and experimentation. However, the impact of this important practice can be difficult to communicate to the public. As futures researchers Candy and Dunagan (2016) have noted, 'for futures studies to impact mainstream culture, it must be capable of bridging the *experiential gulf* between abstract possible futures, and life as it is directly apprehended in the embodied present'.

Galleries and museums are beginning to be recognised by futures thinking and foresight professionals as having a potent power because they can become places to *experience* ideas. Artists and designers are uniquely well placed to create what Candy and Dunagan refer to as *experiential futures* that allow audiences to step into, and be part of, interactive installations and physical environments that provide a dynamic and embodied engagement with possible future scenarios. This type of engagement can generate meaningful public conversations about what kinds of futures are possible and desirable, and what agency the public may have in shaping those futures.

One such example of this form of multi-faceted engagement was the exhibition, *2219: Futures Imagined*, (2219 Futures Imagined 2023) which took place at ArtScience Museum, from November 2019 to August 2020. The exhibition explored how our world might change over the next 200 years, with a particular focus on how climate change might transform the future. It was developed as part of the Singapore Bicentennial in 2019, taking the timeframe of the bicentennial – 200 years – and projecting it forward, to the year 2219.

DOI: 10.4324/9781003474975-31

The exhibition placed visitors in scenarios that explored how our future lives may be impacted by climate change and the loss of our planet's biodiversity. It featured immersive installations, theatrical sets, meditative spaces, interactive artworks, films, prints, and sculptures by over 30 international artists, writers, architects, filmmakers, and designers.

2219 deliberately resisted the utopian and dystopian futures we often see in science fiction and instead focused on what we referred to as 'small futures' – intimate and enduring stories and traditions that are passed down from generation to generation. It invited visitors to reflect on what kind of future they wanted for Singapore and what actions they might take now to bring that future into being.

Curated by the team at ArtScience Museum, the exhibition unfolded over five acts, telling a story over a two-century timescale from the perspective of a narrator living in the year 2219 and looking back through history to the year 2019. Act I began in the present, grounding the visitor in a recognisable moment that provided the conceptual foundations for the journey ahead. Act II transitioned into the mid-21st century, a period characterised by rapidly escalating environmental change, enabling viewers to witness the future from a familiar temporal proximity. Act III moved to the latter part of the 21st century, where the repercussions of the planetary emergency began to manifest more dramatically. Act IV was a speculative foray into the deep future of the 22nd century, a period transformed by surging sea levels. Finally, Act V culminated in the year 2219, where the narrative arc reached a reflective terminus, allowing the narrator – and the audience – to muse upon the interplay of memory, history, and speculative futures.

Designing the future

Spanning nearly 1500 square metres, *2219: Futures Imagined* was a large-scale exhibition containing over 50 artworks, installations and objects. The ambitious, theatrical exhibition designed by Singaporean production company, SpaceLogic, was crucial to bringing the world of *2219* to life. It employed a combination of set-building, film, architecture and graphics to convey a future that contained many familiar aspects of Singapore in the present day. The exhibition's spatial language incorporated industrial and domestic motifs to frame Singapore's historical and future trajectories. The shipping container, a nod to Singapore's maritime legacy, served as a leitmotif, representing the city-state's adaptability and its perennial status as a global nexus. This industrial symbol was contrasted with the intimate domesticity of a Housing Development Board (HDB) apartment and an HDB estate, signifying the quotidian aspect of future urban life, and communicating how the communities of tomorrow were being shaped by climate change. Throughout the exhibition, graphics and films that presented scenarios for Singapore's future, such as the development of green buildings and the expansion of vertical farms, were featured as visible symbols of Singapore's continuous process of preparing for the future.

A history of the future

Structured as a journey through two centuries, the exhibition's first Act, *Arrival*, situated visitors in the present amidst escalating environmental challenges. Despite governmental efforts, such as Singapore's 2019 climate strategy, the exhibition set out a scenario where the global situation worsened (Sustainable Singapore 2019). It envisioned a near future where unchecked technological progress and resource exploitation precipitated an ecological crisis, shaping Singapore's trajectory. This idea was explored through John Akomfrah's *Purple*, an elegiac six-channel video installation that invited sombre reflection on a dying planet.

Act II: Home imagined a scenario where environmental, social, and political shifts redefined life in the mid-21st century. The concept of 'home' evolved in response to ecological pressures, with living spaces adapting for self-sufficiency. International boundaries became less relevant as global challenges demanded collective action. The exhibition suggested that whilst the world of the mid-21st century differed greatly from the decades that preceded it, in Singapore, the familiarity of public housing, shared communal spaces, and continued interest in local issues remained. Being highly adaptable, many Singaporeans were able to make the necessary adjustments needed to survive on a changing planet.

The speculative design collective, Superflux invited visitors inside a Singapore apartment set sometime in the mid-21st century amidst rising sea levels and dwindling food supplies. The immersive installation, titled *Mitigation of Shock* took the form of a full-scale Housing Development Board flat. As visitors navigated the domestic space, they pieced together the lives of the family who lived there, through the books on the shelves, an indoor household farm growing food, the menus of unconventional meals, children's drawings, fragments of radio broadcasts, and a view outside the window, which showed a dramatically changed cityscape.

Meanwhile, *The Strange Times,* by architects WOHA, was a speculative and satirical take on *The Straits Times* newspaper, and offered more details on mid-21st-century Singapore, humorously yet thoughtfully extrapolating the consequences of today's environmental choices into future infrastructure outcomes.

Act III: Underworld contemplated a future where living conditions on Earth's surface had taken a turn for the worse, and the environment was no longer suitable for human societies. Life migrated underground. By 2065, Singapore, with its tradition of forward-thinking urban planning, transitioned its population to an elaborate subterranean city explored in *Subterranean Singapore 2065* by Finbarr Fallon. The installation showcased an architectural marvel equipped with artificial weather systems, yet also hinted at the social and political problems that arise from life underground.

The exhibition speculated that this move underground, while preserving life, introduced a new set of challenges. The scarcity of natural sunlight transformed the relationship between humans and nature, leading to the creation of artificial sanctuaries that served as poignant reminders of lost ecosystems. This was encapsulated in *The Forest Speaks Back II* by Donna Ong, an installation made from green glass bottles that represented the memory of forests that had disappeared. Similarly, *Blooming* by Lisa Park depicted a digital cherry blossom tree that responded

to human touch, symbolising the enduring need for physical human connection. These works suggested ways that nature might be memorialised when it was no longer part of our everyday lived experience and hinted that in this future, trees would take on an almost sacred quality.

As the exhibition continued, it moved into the 22nd century, by which point life, sequestered in underground shelters, had endured. As global systems such as the internet faltered, books once again became the primary source of knowledge and libraries reemerged as the centres of community life. The exhibition showcased one such example, *The Library of Necessary Books*, a cultural repository safeguarding the DIY manuals of the age, Southeast Asian literature, and the *2219 Stories* – a prescient collection of short fiction initiated by poet Alvin Pang during the Singapore Bicentennial, that became a touchstone for future generations, encapsulating the cyclical nature of memory and time.

Act IV: Adaptation was set in 2119, when sea levels had risen significantly around the world, inundating many coastal cities and forcing communities and societies to adopt dramatically different ways of living. In this scenario, adapting to an increasingly oceanic world became critical for survival. As the sea acidified and warmed, it became an ideal habitat for one particular species: jellyfish. An ingenious participatory theatre work by Rimini Protokoll called *win > < win* warned visitors of a future where humans are no longer the dominant species.

The final section of the exhibition, *Act V: Memory,* took place as the 23rd century began. The exhibition surmised that the environment on the surface of the Earth had begun a process of regeneration, after a long period of humanity's absence. As populations returned to the surface, many communities began to uncover archeological artefacts, reconnecting with lost, half-forgotten cultures. As historical relics were recovered and their meanings deciphered, stories passed down through generations started to make sense once more. Singapore, approaching its Quadricentennial, was depicted as rediscovering the strength of its collective memory, learning that the most persistent aspects of civilization are not technological advances, but cultural practices that endure through the ages.

Artists Larry Achiampong, Zarina Muhammad, Amanda Heng, Chen Yanyun, and Priyageetha Dia presented intimate and moving examples of what we referred to as 'small futures' – stories, rituals and traditions that may survive even the most dramatic of social and environmental disruptions. Marriage trysts. Family bonds. Rituals of love that bind generations together over time.

In the final gallery, *Everything But Gold* by Adeline Kueh, bridged past, present and future by transforming personal narratives into hand-crafted paper beads. Exhibition visitors contributed to this living archive by creating their own beads, infusing them with hopes for the future and reinforcing the exhibition's core idea that small, personal acts weave the tapestry of our collective future.

The future meets the present

The futures we imagined in *2219* collided with the present during the exhibition's run in a way we did not expect. The show opened in late November 2019, and by

January 2020, Singapore had its first case of COVID-19, ushering in the era of the pandemic. The exhibition's speculative explorations of a drastically altered future suddenly resonated with pressing urgency as the real world grappled with the seismic shifts of the pandemic. ArtScience Museum adapted swiftly to COVID-19 and, by early February, had implemented rigorous safe management measures, including mandatory temperature checks for visitors, reduced visitor capacity to facilitate safe distancing, and essential personal protective equipment for staff. Both the exhibition and the museum itself became powerful reflections of a world in flux. The lines between the scenarios on display and the reality of a global crisis blurred, rendering the exhibition not only a showcase of potential futures, but a mirror to the present.

Borders closed, and eventually, Singapore went into lockdown with the museum closing in April 2020 with *2219* still in the galleries. When Singapore emerged from its lockdown two months later, *2219* reopened and became a place of reflection for visitors, a space where they could connect the fictional transformations explored in the exhibition with the very real experience they were living through in Singapore. Feedback from visitors frequently touched on how *2219* provided perspective and helped them cope with the uncertainty of the pandemic. We heard some visitors say that they felt a sense of reassurance, that even though the world was in turmoil, Singapore would find a way through, just as it had in the stories woven through the exhibition.

Despite the challenging circumstances, *2219* attracted over 90,000 visitors, primarily Singaporean residents, due to the border closure, a testament to the power of the future to engage the imagination, even in times of crisis.

Shaping new narratives about the future

By mounting an exhibition such as *2219: Futures Imagined*, ArtScience Museum invited visitors to literally and metaphorically step inside potential futures and spend time within them. We posed poignant questions: is this a future you want to inhabit? Is it one you could find a way of surviving within? Could you thrive there? In gently prompting our audience to ponder such questions, we are also making space for a deeper enquiry: what kind of future do you want? And what are you prepared to do today to bring it into being? ArtScience Museum asks these questions because we believe that to have a meaningful future on a planet increasingly threatened by multiple and overlapping environmental challenges, radical change is needed today.

As a director of a museum in the 21st century, I have started to understand that an important part of my role is to create powerful connections between people and their environment. Being able to imagine a planet where people and nature coexist more harmoniously is the first step in bringing it into being. As the influential game designer, Jane McGonigal as cited by Frauenfelder (2016) has said, 'In order to make a change in the world or invent something new, you have to be able to imagine how things can be different'.

Museums can be powerful agents in shaping imagination, through the rigour of science and the emotional power of art. By creating exhibitions like *2219: Futures Imagined*, museums can engage the public to actively imagine more hopeful, fairer and sustainable futures.

Acknowledgements

2219: Futures Imagined was curated by ArtScience Museum. The participants were Alvin Pang (Singapore), John Akomfrah (UK), Sarah Choo (Singapore), Johann Fauzi (Singapore), Hafiz Osman (Singapore), Superflux (UK), WOHA Architects (Singapore), Debbie Ding (Singapore), Robert Zhao Renhui (Singapore), Finbarr Fallon (Singapore), Donna Ong (Singapore), Lisa Park (Korea), Fyerool Darma (Singapore), Gordon Cheung (UK), Rimini Protokoll (Germany), Bao Songyu (Singapore), Shan Hur (Korea), Larry Achiampong (UK), Zarina Muhammad (Singapore), Amanda Heng (Singapore), Chen Yanyun (Singapore), Priyageetha Dia (Singapore), Adeline Kueh (Singapore), Joshua Ip (Singapore), Clara Chow (Singapore), Rachel Heng (Singapore), Judith Huang (Singapore), and Pomeroy Studios (Singapore) and Tristan Jakob-Hoff (New Zealand/UK).

References

2219 Futures Imagined, 2023. [online] ArtScience. Available from: https://www.marina-baysands.com/museum/exhibitions/2219-futures-imagined.html [Accessed 2 November 2023].

Candy, S., and Dunagan, J., 2016. The Experiential Turn. *Human Futures* [online]. Available from: https://www.researchgate.net/publication/311910011_The_Experiential_Turn [Accessed 6 November 2023].

Frauenfelder, M., 2016. *Imagining the Future is Creating the Future* [online]. Urgent Futures. Available from: https://medium.com/institute-for-the-future/imagining-the-future-is-creating-the-future-81b011d16a3 [Accessed 30 October 2023].

Sustainable Singapore, 2019. *Singapore's Climate Action Plan: Take Action Today for a Sustainable Future* [online]. Available from: https://www.mse.gov.sg/resources/climate-action-plan.pdf [Accessed 5 March 2024].

Futures for Futures-Oriented Museums

3.1 Developing the emerging field of future-oriented museums

Kristin Alford

Approaches to enabling futures thinking within museums

There is no one right way to explore the future. But understanding that we might move beyond a narrower set of assumptions and ideas to something richer in conversation with others in a way that deepens our understanding and broadens our perspectives to allow for possibilities is at the heart of effective futures thinking. As outlined in Chapter 1.1, the case studies in this volume have explored different approaches to cultivating futures thinking, in different communities and contexts. They used toolkits and programs as learning frameworks, deployed futures studies theories to design museums, exhibitions and programmes, highlighted key drivers of change, explored futures of mobility, sustainability and technology and drawn on science fiction and alternative images of futures, providing immersive and visceral experiences that help people to imagine something new. All in service of helping communities anticipate and adapt to the rapid pace of change, becoming more flexible, adaptive and able to consider alternative pathways and visions that reframe understanding and possible actions in the present.

The future of museums

While this book has been focussed on how museums might enable futures thinking capabilities in communities, the process of writing it and reflecting on our practices at MOD. also revealed a paradoxical truth about the very institutions themselves – it is impossible to be cultivating futures thinking in communities without also developing futures thinking insights into the museum itself. This brings to mind that the museum has both a role to present futures-oriented exhibits and programmes and use futures approaches to create and chart its own path forward.

When grappling with drivers of change for futures, especially urgent issues like climate change and decolonisation, the museum has a responsibility not just to communicate and educate, but also to reflect on its own practices and actions (Merriman 2024). By engaging in futures thinking, museums will change 'By extending our horizons. We will commit time to explore our collections and programme through futures thinking to ensure we are relevant for the audiences of tomorrow' (Wilkinson n.d.).

DOI: 10.4324/9781003474975-33

A new class of future-oriented museums, an emerging practice

Museums willing to explore their relationship to existing museology and past practices are museums that are willing to take on risks. 'Museums that are taking risks are visitor centric, have participatory experiences, smart technology, a new generation of leaders, and are relevant and inclusive. As they ride the currents of change, they are still retaining their power of legitimacy as repositories of culture (Kuslansky n.d.)'.

So we are seeing, not just new practices, but a whole new class of museums. Emerging future-oriented museums are challenging power, seeking diverse perspectives, and incorporating new practices, with a strong connection to place and a clear sense of purpose.

Power

Future-oriented museums question assumptions about power and who gets to shape the future.

One way we see this is in how museums might be unpicking the colonial roles of museums. This is clearly the case in the exhibitions developed in District 6 that draw on community stories rather than dominant cultures, but we also see this in the way that other museums are reshaping their engagement with First Nations communities including how we approach design at MOD. with our two-way minded principle of showcasing both Aboriginal and Western ways of knowing in the Australian context. Many of these newer institutions eschew collections to prioritise new ways of sharing stories and observations about who we were, are, and could be.

The other thread challenging power is opposition to 'used' techno-utopian futures (Inayatullah 2008). Alternative futures appear in the healing of land and people in the Museum of the Future in Dubai, in the focus on humanity of The Ubuntu Lab and in the telling of science fiction stories from the Global South at Parque Explora.

Perspectives

Future-oriented museums seek to include diverse perspectives. Cross-pollination and collision of ideas were seen as the purpose and future of science museums. Gorman (2020) advocates for exhibits and experiences that bring people from diverse backgrounds together and break down barriers to generate new ideas. In addition to challenging power and dominant culture, these case studies are notable for the way they might include a diverse range of artists' responses to a provocation about the future as in the ArtScience Museum. These institutions are often multidisciplinary, mixing stories and facts such as the Science Museum and Zunkunftmuseum.

They also seek to include people that might be excluded from future-making, with a strong focus on disability access, cultural diversity and LGBTIQ+ inclusion.

They have broad communities of interest and often take on advocacy roles, like we did at MOD., to inform visitors about political action during the 2023 Voice to Parliament Referendum in Australia. It's worth also noting that the leadership of future-oriented museums is reflective of a greater gender diversity.

In the same way that working with futures drives museum leaders to imagine the future of the museum, working with more diverse perspectives opens up new possibilities not only for exhibition and programming, but also for how people within the museum might collaborate and work differently.

Practices

Future-oriented museums incorporate innovative practices and presentations such as the application of technologies and new media beyond the presentation of a collected object. Exhibitions might draw on developing interactive experiences such as in the Futurium and immersive experiences, as demonstrated in the Museum of the Future, and the exhibition *Seven Siblings from the Future* in Heureka, adapted in both MOD. and the Arizona Science Centre. Like many of our peers, at MOD., we have been investing in staff to explore new museum practices in digital interaction and immersive experiences and the adoption of new technologies including game design and mixed realities.

Perhaps another distinction between science centres and future-focused museums is the way in which visitors are invited to participate in or interact with exhibits. Future-focused museums tend to embrace immersive experiences that include aspects of participation, whereas science centres tend to use free-standing exhibits with opportunities for hands-on modification. (Pattison and Dierking 2013). Furthermore the role of gallery staff in futures-oriented museums tends towards facilitated discussions with visitors beyond wayfinding or explanation. This is true for MOD., where we actively encourage our staff to engage in conversations with visitors, about ideas related to futures.

Place

An emerging theme at gatherings for FORMS, was the idea of ancestral futures, noting that while the future doesn't yet exist, it is shaped by patterns of the past. There is an acknowledgment that these patterns and connections to place, including First Nations spiritual connections to place, go back thousands of years. Many of these emerging future-oriented institutions, such as The Anchorage Museum and District 6, amplify this sense of place and connection to their own community histories and identities. The permanent exhibition of *Kuri Kurru* presented at MOD. is an example of helping visitors connect with these histories of place.

Connection to place isn't at the expense of global connectedness. Central to the ideas in The Ubuntu Lab and the climate actions of many of our case studies is the acknowledgment that it is possible and even necessary to be concerned with both the specifically local and the broader view of us as inhabitants of a shared planet (Appiah 2007).

Purpose

Finally, future-oriented museums have a strong sense of purpose, often realised through an exploration of justice and ethics. At MOD., we do this through our *Ethos* programming designed to improve the practice of ethical questioning in both research and the general public, as a way to explore the impact of developing global trends.

From the world's science centres and science museums agreeing to align with the delivery of the Sustainable Development Goals in the Tokyo Protocol (Science Centres World Summit 2017), to the idea of creating new planetary narratives, which was at the core of the early FORMS initiatives (Teixeira and Corrêa-Smith 2023), there are objectives to contribute to making the world a better, fairer, healthier, and safer place. These museums often develop a strong orientation towards climate action, as evidenced in The Climate Museum, The Mind Museum and Anchorage Museum – they are not neutral but also not passive. They agitate for change either with local communities or with people in positions of responsibility as the Museum of the Future does with visiting Heads of State since starting their pops-ups for the World Government Summit.

'If museums want to continue to exist, by being relevant, they will take the ethical path. They will proactively work with communities to shift towards more regenerative and circular economies. They will explore ethical and participatory forms of entrepreneurship. They will provide safe, inclusive spaces for envisaging possible futures' (McKenzie n.d.).

Next steps for future-oriented museums

There is change happening – and the activities of the last 10 years have seen new types of institutions emerge with a futures-orientation. The field of future-oriented museums is still establishing itself and, at the moment, is marked by a range of different approaches. It is too early to be establishing standards, and it's likely not appropriate to develop essential items with these museums' repertoires. However, it is important to evaluate the delivery of objectives, and for museums to share what is working and how, and what kind of impact they are having on improving community capabilities in futures thinking.

Future-oriented museums are diverse and reflective of their communities. They are developing in a different context to science centres. These case studies provide glimpses into futures work across a range of sizes of institutions', geographical, and cultural contexts. As well as innovation in museum practice and the adoption of new technologies, a future-orientation by its nature will also drive innovation in this field, already signalled by the development of the model for The Ubuntu Lab. There will be new forms of cultural institutions that allow for communities to imagine and share stories about their futures, and the field should be open to embracing those developments.

This futures-orientation, and the building of capacity in communities is important because of the rapid change and interconnected threads of complexity we are

experiencing. People need to find ways to imagine alternatives, reframe current perceptions and identify new ways of collaborating to adapt to these emergent challenges.

Holding a community's hopes and dreams for the future may sometimes seem easier than holding contested views of the past, but all this work requires care and strength. There is great value in sharing ideas, deepening knowledge and challenging practices for delivering greater impact, and the support of peer leadership networks is vital in this space. This book is one of the contributions to developing new leadership for cultivating futures thinking through museums.

References

Appiah, K.A., 2007. *Cosmopolitanism: ethics in a world of strangers*, Issues of Our Time. New York City: W. W. Norton & Company.

Gorman, M.J. 2020. *Idea colliders: the future of science museums*. Cambridge: MIT Press.

Kuslansky, E., n.d. A framework for culture in the 21st Century, The Future Museum Project: add your voice to the future of museums., Museum iD. Available from: https://museum-id.com/futuremuseum-project/ [Accessed 21 January 2024].

Inayatullah, S., 2008. Six pillars: futures thinking for transforming. *Foresight*, 10 (1), 4–21.

Merriman, N., 2024. The role of museums and galleries in addressing the climate and ecological crisis. *In*: N. Merriman, ed. *Museums and the climate crisis*. London: Routledge, 1–14.

McKenzie, B., n.d. Museums must take the ethical path, The Future Museum Project: add your voice to the future of museums., Museum iD. Available from: https://museum-id.com/futuremuseum-project/ [Accessed 21 January 2024].

Pattison, S.A., and Dierking, L.D., 2013. Staff-mediated learning in museums: a social interaction perspective, *Visitor Studies*, 16 (2), 117–143, https://doi.org/10.1080/10645578.2013.767731

Science Centres World Summit, 2017. *Tokyo Protocol* [online]. Available from: https://scws2017.org/tokyo_protocol/ [Accessed 5 March 2024].

Teixeira, A.P., and Corrêa-Smith, R., 2023. *FORMS: challenges and opportunities for a network at the intersection of futures thinking and museum practice*. Unpublished.

Wilkinson, L., n.d. Systemic problems restraining the impact of museums, The Future-Museum Project: add your voice to the future of museums., Museum iD. Available from: https://museum-id.com/futuremuseum-project/ [Accessed 21 January 2024].

Glossary

Design Fiction The practice of creating tangible prototypes belonging to possible near futures to provoke ideas about what might happen.

Experiential Futures The set of approaches that provide for people to experience versions of the futures through storytelling, often using multisensory and multimedia methods.

Foresight Encompassing proactive and future-oriented processes, foresight involves exploring and anticipating potential future changes and challenges, emphasising proactive actions to shape the future.

Futures The term used to encompass multiple options for how the future might be perceived or unfold.

Futures-Focused or Futures-Oriented Both these terms are used to indicate a purpose that prompts ideas about the future. It may be that futures-focused is more deliberately engaging with images of the future or creating specific actions towards the future, whereas futures-oriented has a broader base in the ideas that are presented, and it may be to prompt futures thinking more generally. Given these terms have no formal agreed definition, the context within case studies has been left to the authors' expression and should be read in that context.

Futures Literacy The capacity to understand, interpret, and use the knowledge and tools of futures studies, encompassing the skills, competencies, and literacies required to navigate and engage with the future effectively. Futures Literacy (FL) is a term used by UNESCO to refer to a set of futures skills and capabilities.

Futures-Oriented Museums Museums including science centres and other cultural institutions that are engaging their audiences with ideas about futures.

Futures-Oriented Museum Synergies or FORMS A network at the intersection of futures thinking and museum practice, initiated by MOTI Foundation in 2019. FORMS has evolved into a collaborative network, bringing together a diverse and global group of individuals with an emphasis on museum directors to explore the evolving role of museums as catalysts for the emergence of alternative ways to imagine and engage with futures. At its core, UNESCO's FL framework serves as a compass for how FORMS itself evolves as a network, and as a practical and conceptual approach that can inform museum practice.

Futures Studies An interdisciplinary field encompassing the systematic study of possible futures, including the approaches and methodologies informing futures thinking. Relevant approaches include participatory futures, speculative design, and experiential futures.

Futures Thinking A cognitive approach and mindset involving the consideration and exploration of potential futures and their implications, engaging with complex, long-term perspectives to anticipate and prepare for various possibilities.

Participatory Futures The inclusion of public perspectives in shaping alternative and preferred futures.

Speculative Design Speculative design encourages imaginative thinking to visualise novel alternatives and change our understanding of reality.

STEM The disciplines of science, technology, engineering and mathematics in the context of being taught through hands-on learning applied to solving real-world challenges.

Index